POLITICAL

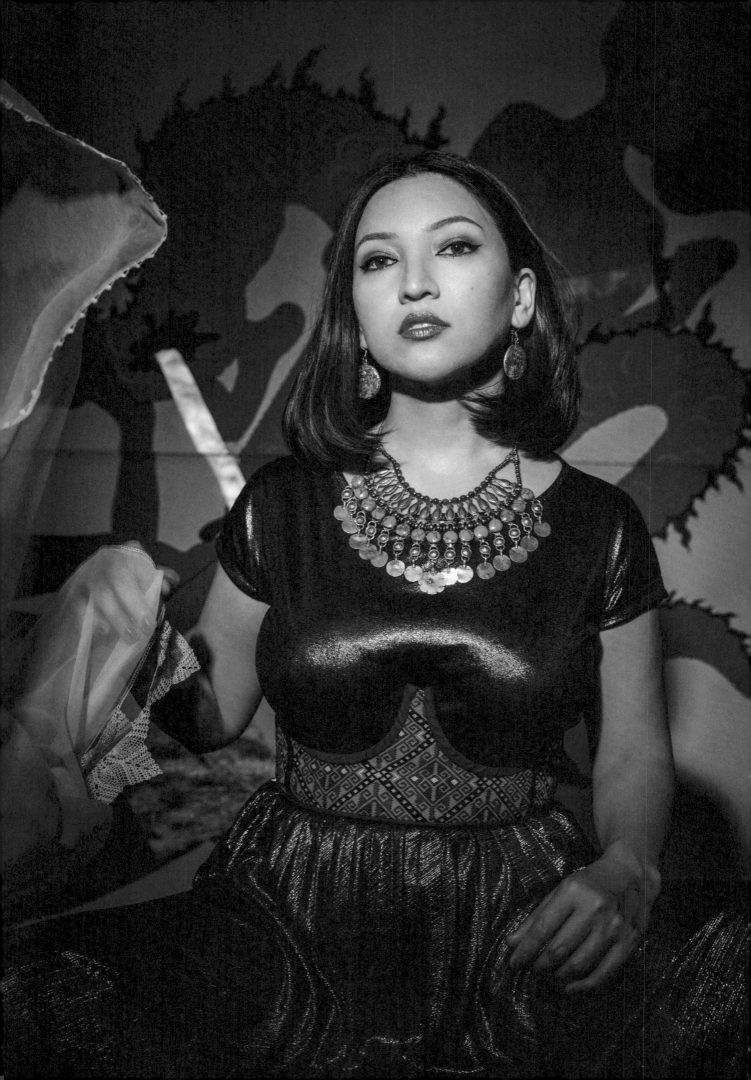

KUBRA KHADEMI

edited by | herausgegeben von | sous la direction de
HANNA G. DIEDRICHS GENANNT THORMANN

POLITICAL BODIES

HIRMER

mpk
MUSEUM PFALZGALERIE KAISERSLAUTERN

CONTENTS INHALT TABLE DES MATIÈRES

Free is the person, who is not hurt
by the insults of others, and a
person who does not insult those who
deserve it, is a hero. — Rumi

An email, a telephone call from Paris: "Have you ever heard of Kubra Khademi?" I had to admit "Not so far" and learned about the Afghan artist who had been living in Paris, where she was doing highly committed work—both artistically and humanly—on the image of women, for Afghan women and artists, since 2015. Bettina Wohlfarth, who contributes an interview with Kubra Khademi to this publication, was so convinced and enthusiastic about her discovery that I asked her for more information material. All of the works deal with the female body—in various poses, with different attributes. Scenes from the Bible or Qur'an, such as Jonah in the belly of the whale, or Moses parting the Red Sea, were transformed and depicted with a female figure. A strong feministic approach, the political dimension of which becomes apparent as soon as one deals with the image and situation of Afghan women in Khademi's homeland. Other works by the artist Khademi play with the content and language of the Persian poet and mystic Rumi (1207-1273), quote works from European art history (Manet's *Olympia*), or illustrate Afghan figures of speech. Many of them seem to be puzzling to us because, initially,

Frei ist der, den die Beleidigungen
der Menschen nicht schmerzen,
und ein Held ist, wer den nicht beleidigt,
der es verdient hätte. — Rumi

Eine Mail, ein Telefonat aus Paris: „Hast Du schon einmal von Kubra Khademi gehört?"
„Noch nicht", musste ich zugeben und erfuhr von einer afghanischen Künstlerin, die seit
2015 in Paris lebt und dort eine sowohl künstlerisch als auch menschlich hoch enga-
gierte Arbeit am Bild der Frau, für afghanische Frauen und Künstlerinnen leistet. Bettina
Wohlfarth, die zu dieser Publikation ein Interview mit Kubra Khademi beiträgt, war so
überzeugt und begeistert von ihrer Entdeckung, dass ich sie um Informationsmaterial
bat. In allen Werken der Künstlerin geht es um Frauenkörper - in unterschiedlichen
Posen, mit verschiedenen Attributen. Biblische beziehungsweise dem Koran entnom-
mene Szenen wie zum Beispiel Jona im Bauch des Walfisches oder Moses, der das ägyp-
tische Meer zerteilt, werden transformiert und mit einer weiblichen Figur dargestellt. Ein
starker feministischer Ansatz, dessen politische Dimension sich erschließt, sobald man
sich mit dem Bild und der Situation von Frauen in Khademis Heimat beschäftigt. Andere
Werke der Künstlerin spielen mit Inhalt und Sprache des persischen Dichters und
Mystikers Rumi (1207-1273), sie zitieren Werke aus der europäischen Kunstgeschichte

Est libre celui que les offenses des
hommes ne blessent pas, est un héros
celui qui n'offense pas l'individu qui
l'aurait mérité. — Rûmî

Un mail, puis un coup de fil de Paris : « Tu as déjà entendu parler de Kubra Khademi? »
« Pas encore », ai-je dû admettre. C'est ainsi que j'ai appris l'existence d'une artiste
afghane vivant depuis 2015 à Paris, où elle mène un travail très engagé, artistiquement
et humainement, sur l'image de la femme, toujours en faveur des femmes et des artistes
afghanes. Bettina Wohlfarth, à qui l'on doit pour la présente publication une interview
de Kubra Khademi, était tellement convaincue et enthousiaste de sa découverte que
je lui ai demandé davantage d'informations. Toutes les œuvres illustrent des corps de
femmes — dans différentes poses, avec différents attributs. Des scènes bibliques ou
tirées du Coran, comme Jonas dans le ventre de la baleine ou Moïse séparant la mer
d'Égypte, sont transformées et représentées avec une figure féminine. Une approche
féministe forte, dont la dimension politique se révèle aussitôt lorsque l'on s'intéresse à
l'image et à la situation des femmes afghanes dans leur pays. D'autres œuvres de l'artiste
Kubra Khademi jouent avec le contenu et la langue du poète et mystique persan Djalâl
ad-Dîn Rûmî (1207-1273), elles citent l'histoire de l'art européenne (l'*Olympia* de Manet)

it is difficult to decipher their origins. At the same time, they convey the seriousness, the concern, of the artist to provide "her women"—and probably also herself—with a space: a free space in which they can be present and justified with their activity and self-conception in all situations in her drawings and paintings.

It fit in well that I had offered a very highly motivated curator, Hanna G. Diedrichs genannt Thormann, an exhibition of her own choice. When I introduced her to the material on Kubra Khademi, she made her own research and found the subject very appealing. It coincided with her interest in feminist matters and her desire for more diversity in the museum.

We were able to establish contact with Éric Mouchet, Khademi's gallerist in Paris. We invited him and the artist to become aware of the Museum Pfalzgalerie Kaiserslautern and were delighted to be able to welcome them, as well as Marguerite Courtel and Michael Honecker, members of the gallery's staff, and Maria-Carmela Mini, Khademi's agent for performances, in September 2021. Together, we soon reached the decision to realize an exhibition at the mpk with an accompanying catalogue. This was to be the artist's first exhibition in a museum. We then visited Khademi's gallery together with the artist. As part of this journey, we attended her performance at the Musée d'Art Moderne de Paris (cat. 43). Here we were able to experience the power of destruction: Dressed in the wide robes of a shaman, Khademi tore up a series of gouache drawings she had previously painted. A performance, similar to a concert, that focused on the images she had created and then made them disappear. As it appears to me, this is a typical gesture of the energetic artist here demonstrating her power both as a creator and a destroyer.

In a practice that has so far not been used in our museum and is therefore unusual and surprising, the catalogue for this exhibition is being written in the so-called

(Manets *Olympia*) oder verbildlichen afghanische Redewendungen. Zahlreiche von ihnen erscheinen uns rätselhaft, weil wir ihre Quellen zunächst nicht zu entschlüsseln vermögen. Gleichwohl vermitteln sich die Ernsthaftigkeit, das Anliegen der Künstlerin, „ihren Frauen", und wohl auch sich selbst, mit ihren Zeichnungen und Gemälden Raum zu geben, einen freien Platz, auf dem sie mit ihrem Tun und ihrem Selbstverständnis in allen Situationen anwesend und gerechtfertigt sein dürfen.

Es fügte sich, dass ich einer sehr engagierten Mitarbeiterin, Hanna G. Diedrichs genannt Thormann, eine von ihr zu wählende Ausstellung angeboten hatte. Als ich ihr die Materialien zu Kubra Khademi vorstellte, war sie – nach einigen eigenen Recherchen – dem Thema sehr zugetan. Es trifft auf ihr Interesse an feministischen Fragestellungen und ihrem Anliegen nach mehr Diversität im Museum.

Es gelang uns, Kontakt zu Éric Mouchet, Khademis Galerist in Paris, herzustellen. Wir luden ihn und die Künstlerin ein, das Museum Pfalzgalerie Kaiserslautern kennenzulernen, und durften uns schon im September 2021 über deren Besuch freuen. Begleitet wurden sie von den Mitarbeiterinnen der Galerie, Marguerite Courtel und Michael Honecker, sowie von Maria-Carmela Mini, Khademis Agentin für Performances. Gemeinsam kamen wir rasch zu dem Entschluss, eine Ausstellung im mpk mit begleitendem Katalog zu realisieren. Es sollte die erste museale Einzelausstellung der Künstlerin werden. Ein Besuch mit der Künstlerin in ihrer Galerie folgte. Im Rahmen dieser Reise haben wir an ihrer Performance im Musée d'Art Moderne de Paris teilgenommen (Kat. 43). Wir konnten hier die Kraft der Zerstörung erleben: Khademi zerriss im weiten Gewand einer Schamanin eine Reihe von ihr zuvor angefertigter Gouachezeichnungen. Eine Performance, die einem Konzert vergleichbar die betroffenen Bilder in den Fokus rückte und sie dann verschwinden ließ. Eine wie mir scheint recht typische Geste für die energievolle Künstlerin, die hier ihre Macht sowohl als Schöpferin wie auch als Zerstörerin demonstrierte.

ou mettent en images des expressions afghanes. Beaucoup nous semblent énigmatiques, parce que nous ne sommes pas à même d'en décrypter les sources. Néanmoins, elles transmettent tout le sérieux et le dessein de l'artiste : donner, à travers ses dessins et ses peintures, de l'espace à « ses femmes », et sans doute aussi à elle-même – un espace libre où elles peuvent être présentes et légitimées, dans toutes les situations, par leur manière d'agir et d'être elles-mêmes. Il s'est avéré que j'ai proposé à une collaboratrice très engagée, Hanna G. Diedrichs genannt Thormann, une exposition dont elle aurait le choix. Lorsque je lui ai présenté les documents relatifs à Kubra Khademi, elle s'est montrée – après quelques recherches personnelles – très intéressée par le sujet, lequel rejoint son intérêt pour les questions féministes et son souci d'une plus grande diversité dans les musées.

Nous avons pu ensuite entrer en contact avec Éric Mouchet, le galeriste de Khademi à Paris. Nous l'avons invité, ainsi que l'artiste, à découvrir le Museum Pfalzgalerie Kaiserslautern et dès septembre 2021, nous avons eu le plaisir de les recevoir, accompagnés de Marguerite Courtel et Michael Honecker, qui travaillent eux aussi à la galerie, ainsi que Maria-Carmela Mini, la productrice de Khademi pour les performances. Ensemble, nous sommes rapidement parvenus à la décision de réaliser une exposition au mpk avec catalogue. Ce devait être la première exposition personnelle de l'artiste dans un musée. Puis il y a eu notre visite à la galerie parisienne et, par la même occasion, nous avons assisté à une des performances de l'artiste au Musée d'Art Moderne de Paris (cat. 43). Là, nous avons pu découvrir la puissance de la destruction : Khademi, vêtue d'une ample robe de chamane, déchirait une série de ses propres gouaches, peintes auparavant. Une performance comparable à un concert, qui mettait l'accent sur les images concernées avant de les faire disparaître. Un geste assez typique, me semble-t-il, de cette artiste pleine d'énergie, qui démontre ici son pouvoir à la fois créateur et destructeur.

generic feminine. This corresponds with the curator's desire for this project: "Our language is also male-oriented, texts are usually written in the generic masculine, in which women are taken into account but remain barely visible," as well as that of the artist. Khademi explained to us that (in spite of the patriarchal structures) the language of her homeland is gender-neutral and that she was shocked to discover just how masculine the language was in so much freer and more open France.

My thanks go to Kubra Khademi, the whole team at the Galerie Eric Mouchet, and Maria-Carmela Mini for their open-minded, constructive, and friendly collaboration. Bettina Wohlfarth has my gratitude for providing the impulse and further support for this project. Of course, all of the lenders are to be thanked—without them, it would have not been possible to realize the exhibition on the scope desired—as are the authors, who shed light on specific aspects of Khademi's work and in this way contribute to its understanding. I thank Hanna Diedrichs for the enthusiasm with which she tackled the project, and the care with which she oversaw and implemented it. In addition, I am grateful to all of the members of the staff of the mpk who have contributed to the success—and continue to do so—as well as my successor, Steffen Egle, who immediately and gladly accepted the project that is taking place under his directorship.

BRITTA E. BUHLMANN
Former Director of the Museum Pfalzgalerie Kaiserslautern

In einer für unser Museum bisher nicht üblichen und deshalb wohl ungewohnten und überraschenden Praxis ist der Katalog zur Ausstellung im sogenannten generischen Femininum verfasst. Dies entspricht sowohl dem projektbezogenen Wunsch der Kuratorin – „Auch unsere Sprache ist männlich geprägt, generell werden Texte im generischen Maskulinum verfasst, in dem Frauen wohl mitgedacht werden, aber kaum sichtbar sind" – als auch dem der Künstlerin. So klärte Khademi uns darüber auf, dass die Sprache ihrer Heimat (trotz der patriarchalen Strukturen) geschlechtsneutral ist und sie schockiert war zu erfahren, welch maskuline Sprache im so deutlich freieren und offeneren Frankreich gepflegt wird.

Mein Dank gilt Kubra Khademi, allen zum Team der Galerie Eric Mouchet zählenden Persönlichkeiten und Maria-Carmela Mini für die aufgeschlossene, konstruktive und freundschaftliche Zusammenarbeit. Bettina Wohlfarth danke ich für ihren Impuls und die weitere Unterstützung des Projektes. Gedankt sei selbstverständlich allen Leihgeberinnen, ohne die wir die Ausstellung nicht im gewünschten Umfang hätten realisieren können, sowie den Autorinnen, deren Beiträge spezifische Werkaspekte besonders beleuchten und so dem Verständnis dienen. Hanna Diedrichs danke ich für die Begeisterung, mit der sie das Projekt aufgegriffen hat, und die Sorgfalt, mit der sie es betreut und umgesetzt hat. Danke sage ich darüber hinaus allen im mpk beteiligten Mitarbeiterinnen, die zum Gelingen beigetragen haben und beitragen, wie auch meinem Nachfolger Steffen Egle, der das Projekt, das in seine Amtszeit fällt, sofort erfreut akzeptierte.

BRITTA E. BUHLMANN
Ehemalige Direktorin Museum Pfalzgalerie Kaiserslautern

Le catalogue de l'exposition est rédigé au féminin dit générique, ce qui constitue pour notre musée une pratique inhabituelle et surprenante. Cela correspond d'une part au souhait de la curatrice en lien avec le projet : « Notre langue est également marquée par le masculin, les textes sont généralement rédigés au masculin générique, dans lequel les femmes sont certes prises en compte mais guère visibles » – et de l'autre à celui de l'artiste. Khademi nous a expliqué que la langue de son pays d'origine est neutre (en dépit des structures patriarcales) et qu'elle a été choquée d'apprendre l'usage dominant du masculin dans un pays comme la France pourtant nettement plus libre et ouvert.

Je remercie Kubra Khademi, toute l'équipe de la Galerie Eric Mouchet et Maria-Carmela Mini pour leur collaboration constructive et amicale. Je remercie Bettina Wohlfarth d'avoir impulsé le projet et de l'avoir soutenu par la suite. Je remercie bien entendu toutes celles et ceux qui nous ont prêté des œuvres, sans lesquelles nous n'aurions pu réaliser l'exposition dans l'ampleur souhaitée, ainsi que les autrices qui ont éclairé les aspects spécifiques de ce travail et aidé ainsi à sa compréhension. Je remercie Hanna Diedrichs pour son enthousiasme et tout le soin apporté au suivi et à la réalisation de cette entreprise. Je remercie également toutes les collaboratrices du mpk qui ont contribué et contribuent à la réussite de ce projet, ainsi que mon successeur, Steffen Egle, qui a accepté aussitôt, et avec plaisir, de l'inscrire dans le cadre de son mandat.

BRITTA E. BUHLMANN
Ancienne directrice Museum Pfalzgalerie Kaiserslautern

As the new director of the Museum Pfalzgalerie Kaiserslautern (mpk), I am delight-ed to be able to open the first solo exhibition of Kubra Khademi's work to be shown in an institution of this kind worldwide—and as the first project in my term in this position. The exhibition establishes a connection to issues that are very close to my heart: Creating art from the lifeworld of people is one of the most significant matters I am concerned with. This goes hand in hand with the concept of a museum as a place where the subjects affecting society can be talked about, reflected on, and illuminated from new perspectives—and that, through the mirror of art. The exhibition provides a wonderful opportunity to enter into an exchange on the role of museums, and cultural institutions in general, in order to consider how the mpk can establish itself even more firmly as a place of dialogue of this kind.

My special thanks go to my predecessor, Britta E. Buhlmann, who brought Kubra Khademi to Kaiserslautern and by doing so created an opportunity for a series of in-tense conversations. With Khademi, we present the stringent as well as multifaceted work of an important young artist which poses many questions to the public. This is an art that at first glance seduces the viewer with the lightness and simplicity of its stylistic means but which at second glance packs a punch. Here, Kubra Khademi deals with diffi-cult, fundamental themes presented in a wide variety of media: issues of suppression, of the emancipation from patriarchal relationships, of perceptions of women, of fears that take on shape in the form of mythical figures, of identity, of the homeland, and of migration. I am looking forward to the many conversations that will develop around this work for which we, as a museum, will provide the forum. That is why I would like to thank the artist Kubra Khademi for her courage and openness in presenting her work in our house and, in this way, taking another step into the public eye.

I am also extremely grateful to Hanna G. Diedrichs genannt Thormann, who—in collaboration with the artist—realized the project with the necessary sensitivity and

Es erfüllt mich mit großer Freude, als neuer Direktor des Museums Pfalzgalerie Kaiserslautern Kubra Khademis weltweit erste museale Einzelausstellung eröffnen zu dürfen – als erstes Projekt, das in meine Amtszeit fällt. Die Schau schlägt eine Brücke zu Themen, die mir besonders am Herzen liegen: Kunst von den Lebenswelten der Menschen aus zu erzählen – das ist eines der wesentlichen Anliegen, die ich verfolge. Damit einher geht eine Vorstellung vom Museum als einem Ort, an dem gesellschaftliche Themen besprochen, reflektiert und aus neuen Perspektiven beleuchtet werden können – und das im Spiegel der Kunst. Die Ausstellung ist ein wunderbarer Anlass, um über diese Rolle von Museen, und Kulturinstitutionen generell, in den Austausch zu kommen, um darüber nachzudenken, wie das mpk als ein solcher Ort des Dialogs weiter etabliert werden kann.

Mein ganz besonderer Dank gilt meiner Vorgängerin Britta E. Buhlmann, die Kubra Khademi nach Kaiserslautern geholt und damit einen vielschichtigen Gesprächsanlass geschaffen hat. Mit Khademi präsentieren wir dem Publikum das stringent-facettenreiche Werk einer wichtigen jungen Künstlerin, das viele Fragen aufwirft. Eine Kunst, die auf den ersten Blick mit ihrer Leichtigkeit und einer Einfachheit stilistischer Mittel verführt; die es auf den zweiten Blick aber in sich hat. Es sind schwere und grundsätzliche Themen, welche Kubra Khademi hier verhandelt, vorgetragen in einer Vielfalt von Medien. Es geht um Unterdrückung, um die Emanzipation aus patriarchalen Verhältnissen, um Frauenbilder, um Ängste, die in mythischen Figuren Gestalt annehmen, um Identität, Heimat und Migration. Ich freue mich auf die vielfältigen Gespräche, die rund um dieses Werk entstehen und für die wir als Museum das Forum bieten werden. So danke ich der Künstlerin Kubra Khademi für den Mut und die Offenheit, ihr Werk gerade in unserem Haus zu zeigen und damit einen weiteren Schritt in die Öffentlichkeit zu gehen.

Mein großer Dank gilt ferner Hanna G. Diedrichs genannt Thormann, die als Kuratorin das Projekt im Austausch mit der Künstlerin mit der notwendigen Sensibilität und

En tant que nouveau directeur du musée Pfalzgalerie de Kaiserslautern, je suis très heureux de pouvoir inaugurer la toute première exposition personnelle de Kubra Khademi dans un musée. C'est aussi le premier projet de mon mandat. L'exposition fait le lien avec des thèmes qui me tiennent particulièrement à cœur : raconter l'art à partir du monde dans lequel vivent les gens, voilà l'une de mes préoccupations majeures. Et cela va de pair avec une conception du musée où des sujets sociétaux peuvent être débattus, questionnés et éclairés sous des angles nouveaux — mais aussi dans le miroir de l'art. L'exposition est une merveilleuse occasion d'échanger sur ce rôle des musées, et des institutions culturelles en général, et d'envisager la manière dont le mpk peut continuer à s'établir comme un lieu de dialogue.

Je tiens à remercier notamment ma prédécesseuse, Britta E. Buhlmann, qui a fait venir Kubra Khademi à Kaiserslautern et suscité ainsi une discussion aux facettes multiples. Avec Khademi, elle présente au public l'œuvre saisissante et complexe d'une jeune artiste importante, avec les nombreuses questions que ce travail soulève. Un art qui, au premier abord, séduit par sa légèreté et la simplicité des moyens stylistiques, mais qui, au fond, a beaucoup plus à dire. Kubra Khademi aborde ici des thèmes graves, cruciaux, présentés à travers une grande variété de médias. Il y est question d'oppression, d'émancipation des rapports patriarcaux, d'images de la femme, d'identité, de patrie et de migration, de peurs qui s'incarnent dans des figures mythiques. Je me réjouis des débats qui vont émerger autour de cette œuvre et auxquels notre musée offre un forum. Aussi je remercie l'artiste Kubra Khademi d'avoir eu le courage et la liberté de montrer son œuvre précisément dans notre institution, faisant ainsi un pas de plus vers le public.

Je tiens également à remercier Hanna G. Diedrichs genannt Thormann, qui, en tant que commissaire d'exposition, a merveilleusement réalisé ce projet et échangé avec

exceptional feeling for the mediation of the themes in such a wonderful way. She has created a pertinent exhibition that will make a contribution to further enhancing the Museum Pflalzgalerie as a location for affairs of current concern. And that in addition to a comprehensive catalogue which will provide a broad overview of Kubra Khademi's work for the first time. The authors Philippe Dagen, Salima Hashmi, and Bettina Wohlfarth are also to be thanked for their illuminating contributions, as are Hirmer Publishers, and the graphic designer Petra Ahke for the excellent collaboration. The entire staff of the mpk have all contributed to the execution of this project. And that is the reason that I would like to personally express my gratitude to Sören Fischer, Markus Heid, Benjamin Košar, Stefan Kraft, Svenja Kriebel, Andreas Kusch, Harald Lange, Reinhard Müller, Natalie Rothmann, Annette Reich, Bernd Riehmer, and Margarete Schneider, as well as the house's supervisory and information teams.

The project would not have been possible without the idealistic and financial support of our supporters and partners: therefore, my thanks to the Chairperson of the Bezirkstag Pfalz (District Parliament Palatinate), Theo Wieder, on behalf of the Bezirksverband Pfalz (District Association Palatinate), for having made this project possible.

In addition, I would like to thank the Galerie Eric Mouchet and Latitudes Contemporaines, the Stiftung Rheinland-Pfalz für Kultur (Rheinland-Pfalz Foundation for Culture), the Institut français Deutschland, the ZukunftsRegion Westpfalz e. V. (FutureRegion Western Palatinate), the Equal Opportunities Office of the Bezirksverbands Pfalz, and the Freunde des Museums Pfalzgalerie Kaiserslautern (Friends of the mpk), as well as all the regional and cooperative partners for their financial and practical support in the realization of this exhibition and catalogue.

STEFFEN EGLE
Director Museum Pfalzgalerie Kaiserslautern

einem außerordentlichen Gespür für die Vermittlung der Themen in wunderbarer Weise umgesetzt hat. Sie hat eine relevante Ausstellung realisiert, die dazu beiträgt, das Museum Pfalzgalerie als Ort für aktuelle Themen weiter zu profilieren. Und das zusätzlich mit einem umfangreichen Katalog, der erstmals einen breiten Überblick über das Werk Kubra Khademis gibt. Den weiteren Autorinnen Philippe Dagen, Salima Hashmi und Bettina Wohlfarth danke ich für ihre erhellenden Beiträge, ebenso dem Hirmer Verlag, der Grafikerin Petra Ahke sowie dem Übersetzerinnen- und Lektorinnen-Team für die gute Zusammenarbeit. Zur Umsetzung haben alle Mitarbeiterinnen des mpk beigetragen. Daher möchte ich namentlich danken: Sören Fischer, Markus Heid, Benjamin Košar, Stefan Kraft, Svenja Kriebel, Andreas Kusch, Harald Lange, Reinhard Müller, Natalie Rothmann, Annette Reich, Bernd Riehmer und Margarete Schneider sowie dem Aufsichts- und Vermittlungsteam des Hauses.

Das Projekt wäre nicht möglich gewesen ohne die ideelle und finanzielle Unterstützung unseres Trägers und unserer Partnerinnen: So danke ich dem Vorsitzenden des Bezirkstags der Pfalz, Theo Wieder, stellvertretend für den Bezirksverband dafür, dass er dieses Projekt ermöglicht hat. Darüber hinaus danke ich der Galerie Eric Mouchet und Latitudes Contemporaines, der Stiftung Rheinland-Pfalz für Kultur, dem Institut français Deutschland, der ZukunftsRegion Westpfalz e. V., dem Gleichstellungsbüro des Bezirksverbands Pfalz, den Freunden des Museums Pfalzgalerie Kaiserslautern sowie allen weiteren regionalen Sponsorinnen und Kooperationspartnerinnen für ihre finanzielle und praktische Unterstützung bei der Realisierung von Ausstellung und Katalog.

STEFFEN EGLE
Direktor Museum Pfalzgalerie Kaiserslautern

l'artiste, avec toute la sensibilité nécessaire et un goût extraordinaire pour la médiation thématique. Ce faisant, elle a mené à bien une exposition pertinente qui contribue à définir le Museum Pfalzgalerie davantage encore comme un lieu dédié aux sujets d'actualité. S'y ajoute également un catalogue très complet qui, pour la première fois, offre un large aperçu de l'œuvre de Kubra Khademi. Je remercie les autrices et auteur, Philippe Dagen, Salima Hashmi et Bettina Wohlfarth, pour leurs contributions éclairantes, ainsi que les Éditions Hirmer, la graphiste Petra Ahke, les traductrices et l'équipe éditoriale pour leur bonne collaboration. Toute l'équipe du mpk a apporté son soutien et je remercie nommément : Sören Fischer, Markus Heid, Benjamin Košar, Stefan Kraft, Svenja Kriebel, Andreas Kusch, Harald Lange, Reinhard Müller, Natalie Rothmann, Annette Reich, Bernd Riehmer et Margarete Schneider, ainsi que les personnes en charge de la surveillance et de la médiation culturelle.

Le projet n'aurait pas vu le jour sans le soutien idéel et financier de notre organisme de tutelle et de nos partenaires : je remercie Theo Wieder, président du Bezirkstag du Palatinat, au nom du Bezirksverband, d'avoir rendu tout cela possible. J'adresse également toute ma reconnaissance à la Galerie Eric Mouchet et Latitudes Contemporaines, la Stiftung Rheinland-Pfalz für Kultur, l'Institut français Deutschland, la ZukunftsRegion Westpfalz e. V., le bureau de l'égalité du Bezirksverband Pfalz, les Amis du Museum Pfalzgalerie Kaiserslautern, ainsi que toutes les autres sponsors et partenaires de coopération pour leur soutien financier et pratique lors de la réalisation de l'exposition.

STEFFEN EGLE
Directeur Museum Pfalzgalerie Kaiserslautern

HANNA G. DIEDRICHS
GENANNT THORMANN

A feminine universe, completely free of shame and full of self-determination—Kubra Khademi addresses aspects of everyday (female) life in her art, sometimes even intimate and tabooed matters. Her works on paper show simply drawn female bodies, always depicted in a matter-of-fact, relaxed form, independent of what they are actually doing. Inspired by motifs from her own biography, the history of art, religion, mythology, and politics, she investigates her personal life story, her wounds and lack of freedom as a woman. And she takes people out of their comfort zone.

The title of the exhibition and catalogue reflects various dimensions of the politicization of the body in Khademi's work: It highlights the charging of the female body in the struggle against, and for, gender justice, and to the concrete use of the naked female body in art as a feminist-political means. It is a matter of images of bodies and women, as well as of (Afghan) migration and identity. Kubra Khademi advocates seeing the female body in an unburdened way, adding new ways of looking at traditional motifs, and providing society with other images. She presses for social change.

The Afghan artist, who has been living in France for the past seven years now, in 2022, concentrates on questions of female identity in a male-dominated society, on questions of homeland, experiences of flight, and feminist resistance in exile. Fundamentally, her starting points are personal experiences, patriarchal politics, and the sociopolitical events taking place in Afghanistan today. Khademi studied fine arts in Kabul and Lahore, as well as art history in Paris.[1] Her gouaches on paper—in particular—show the female body in all its facets, often in a way that is full of humor and unagitated, but still seen as provocative by many. In addition, she develops impressive performances that thematize her own physical experiences and have a strong emotional impact on her audience.[2] In recent times, Khademi has increasingly worked with photographic and digital techniques, as well as embroidery and textiles, or a combination of various media.

Women often find themselves on the front line in their everyday lives; this is not necessarily in the direct sense of military conflict, but they can find themselves in the

Ein feminines Universum, frei von Scham und voller Selbstbestimmung – Kubra Khademi greift in ihrer Kunst Aspekte des (weiblichen) Alltags auf, mitunter auch Intimes und Tabuisiertes. Ihre Malereien auf Papier zeigen einfach gestaltete Frauenkörper, immer in einer selbstverständlichen, gelassenen Darstellungsform, unabhängig davon, was sie gerade tun. Inspiriert von Motiven aus ihrer Biografie, aus Kunstgeschichte, Religion, Mythologie und Politik erforscht sie ihre persönliche Geschichte, ihre Verletzungen und Unfreiheiten als Frau. Und holt damit Menschen aus ihrer Komfortzone.

Der Titel der Ausstellung und des Katalogs reflektiert verschiedene Dimensionen der Politisierung des Körpers in Khademis Werken: Er verweist auf die Aufladung des weiblichen Körpers im Kampf gegen und für Geschlechtergerechtigkeit und auf den konkreten Einsatz des unbekleideten weiblichen Körpers in der Kunst als feministisch-politisches Mittel. Es geht um Körper- und Frauenbilder, aber auch um (afghanische) Migration und Identität. Kubra Khademi plädiert dafür, den weiblichen Körper unbelastet zu sehen, tradierten Motiven neue Betrachtungsweisen hinzuzufügen und der Gesellschaft andere Bilder zur Seite zu stellen. Sie drängt auf gesellschaftlichen Wandel.

Die afghanische Künstlerin, die 2022 seit sieben Jahren in Frankreich lebt, konzentriert sich auf Fragen der weiblichen Identität in einer männlich geprägten Gesellschaft, Fragen von Heimat und Fluchterfahrung und des feministischen Widerstands im Exil. Ihre Ausgangspunkte sind im Wesentlichen persönliche Erfahrungen, patriarchale Politik und aktuelle gesellschaftspolitische Ereignisse in Afghanistan. Khademi studierte Bildende Kunst in Kabul und Lahore sowie Kunstgeschichte in Paris.[1] Vor allem ihre Gouachen auf Papier zeigen oft humorvoll, unaufgeregt und doch für viele provokativ den weiblichen Körper in all seinen Facetten. Darüber hinaus entwickelt sie eindrückliche Performances, die eigene körperliche Erfahrungen thematisieren und eine starke emotionale Wirkung auf ihr Publikum ausüben.[2] In jüngster Zeit arbeitet Khademi vermehrt auch mit fotografischen und digitalen Techniken, Stickereien und Textil oder der Kombination verschiedener Medien.

Un univers féminin, dépourvu de honte, tout en autodétermination – dans son art, Kubra Khademi aborde les aspects, y compris intimes et tabous, du quotidien (des femmes). Ses peintures sur papier montrent des corps simplement dessinés, toujours dans une forme de représentation évidente et sereine, indépendamment de ce que ces femmes sont en train de faire. Inspirée de sa propre biographie, des motifs de l'histoire de l'art, de la religion, de la mythologie et de la politique, elle explore son vécu, ses blessures et les privations de liberté infligées aux femmes. Ce faisant, elle fait sortir les gens de leur zone de confort.

Le titre de l'exposition et du catalogue reflète les différentes dimensions que la politisation du corps revêt dans les œuvres de Khademi : il évoque la charge du corps féminin dans la lutte contre et pour l'égalité des sexes, ainsi que l'utilisation concrète du corps féminin dévêtu dans l'art, comme moyen politique et féministe. Il s'agit là d'images du corps et de la femme, mais aussi de migration (afghane) et d'identité. Kubra Khademi plaide pour que le corps féminin soit vu sans *a priori*, pour que de nouveaux modes d'observation s'agrègent aux motifs traditionnels et pour que d'autres images soient proposées à la société. Elle en appelle avec insistance aux changements sociétaux.

L'artiste afghane, qui vit maintenant en France depuis sept ans, s'intéresse avant tout aux questions de l'identité féminine dans une société dominée par les hommes, aux questions de patrie, de fuite, d'asile et de résistance féministe en exil. Elle part là essentiellement de ses expériences personnelles, mais aussi de la politique patriarcale et des événements sociopolitiques actuels en Afghanistan. Khademi a étudié les arts plastiques à Kaboul et à Lahore puis l'histoire de l'art à Paris[1]. Ses gouaches sur papier, notamment, montrent le corps féminin sous toutes ses facettes, imperturbablement et souvent avec humour, d'une manière perçue par pour beaucoup comme provocante.

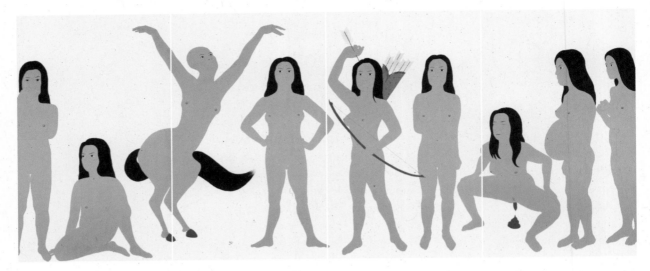

1 خط مقدم, *Front Line*, 2020 (Cat. | Kat. 1)

forefront in fundamental activities, as the artist explains about her work *Front Line* (fig. 1, cat. 1).³ The art piece from the year 2020, in an elongated horizontal format, shows nine larger-than-life, naked female figures forming a line alongside one another. The compound word *front line* derives from the Latin word *frōns/frontis* meaning "forehead" or "front." The concept in the military context refers to the front row of a deployed army or of the fighting troops: those who are the first to be hit in a military conflict. The term can also refer to a group offering resistance to somebody or something, a group that is fiercely committed to a goal. It is a matter of the ongoing duty to make a stand against hostility toward women.

The work depicts a pregnant woman, a female centaur, women in the pose of thinkers or superheroines, a crouched woman defecating, and a female warrior holding a bow pulling an arrow out of her quiver. The two women cut off by the edges of the painting indicate that this "front line" actually continues endlessly. In their—mainly upright—relaxed stance, turned openly toward the viewers,⁴ these women appear to be confident, aware of themselves. Although their bodies are painted in a reduced manner, nothing is hidden. Khademi's depiction draws mundane, common, intimate, or hushed-up moments of everyday life to the center of attention. She confronts the audience with internalized role models and personal or cultural taboos—such as the explicitly shown defecation. The artist claims that women are too frequently seen as dirty by society but are supposed to be pure. And she stresses that, in Afghan society, the choice of becoming pregnant, or not, hardly exists. She describes her work as "a fight against the history and a system protected by religion."⁵ What does it feel like to stand in front of this row of women? Some of them are looking directly at us out of their clear eyes. Created using simple means, but still remarkably present, their gaze challenges us to take a stand.

Khademi always paints her figures in the same way: finely contoured, hardly detailed, and limited to a few tints, usually without any gradations in brightness. The palette is fundamentally restricted to the light ochre of the bodies and the blackish-brown of the hair,

Frauen gerieten im täglichen Leben leicht an die Frontlinie; nicht zwangsläufig im direkten Sinn eines militärischen Kriegs, doch in grundlegenden Handlungen befänden sie sich quasi immer an vorderster Front, erklärt die Künstlerin zu ihrem Werk *Front Line* (Abb. 1, Kat. 1).[3] Die Arbeit aus dem Jahr 2020 zeigt überlebensgroß im langgezogenen Querformat neun unbekleidete weibliche Figuren, die nebeneinander angeordnet eine Reihe bilden. Die Wortzusammensetzung „Frontlinie" leitet sich von dem lateinischen Wort „frōns/frontis" für „Stirn" oder „Vorderseite" ab. Der Begriff aus dem militärischen Kontext verweist auf die vordere Reihe einer angetretenen Armee oder die vorderste Linie der kämpfenden Truppe. Also diejenigen, die es im Fall einer kriegerischen Aus-einandersetzung zuerst trifft. Der Begriff meint aber auch eine Gruppe, die jemandem oder einer Sache Widerstand entgegensetzt und sich kämpferisch für etwas engagiert. Es geht um die tägliche Aufgabe, sich Frauenfeindlichkeit entgegenzustellen.

Im Werk sind eine Schwangere, eine Zentaurin, Frauen in Denkerinnen- oder Super-heldinnenpose, eine Frau in hockender Haltung beim Stuhlgang und eine Kriegerin mit Bogen, die gerade einen Pfeil aus ihrem Köcher zieht, zu sehen. Die beiden von den seit-lichen Bildrändern angeschnittenen Frauen deuten an, dass diese „Frontlinie" unend-lich weitergeht. In ihrer vorwiegend aufrechten, entspannten und den Betrachterinnen[4] offen zugewandten Haltung zeigen sich die Frauen souverän, sich ihrer selbst bewusst. Ihre reduziert gemalten Körper verbergen nichts. Khademis Darstellung holt beiläufige, gewöhnliche, intime oder totgeschwiegene Momente des Alltags ins Zentrum der Auf-merksamkeit. Sie konfrontiert das Publikum mit internalisierten Rollenbildern oder per-sönlichen respektive kulturellen Tabus – wie etwa dem unverhohlen gezeigten Toiletten-gang. Die Künstlerin spricht davon, dass Frauen von der Gesellschaft zu oft als schmutzig angesehen werden, aber rein sein sollen. Und sie betont, dass in der afghanischen Kultur etwa die freie Wahl, schwanger zu werden oder eben nicht, kaum existiert. So beschreibt sie ihre Arbeit als einen „Kampf gegen die Geschichte und ein System, das von der Reli-gion geschützt wird."[5] Wie fühlt es sich an, dieser Reihe von Frauen gegenüberzustehen?

Elle met également en place des performances saisissantes qui abordent ses propres expériences physiques et ont un fort impact émotionnel sur son public[2]. Ces derniers temps, Khademi travaille de plus en plus avec des techniques photographiques et numériques, la broderie et le textile ou la combinaison de médias divers.

Au quotidien, les femmes se retrouvent facilement sur la ligne de front ; pas tant au sens premier qui renvoie à la guerre, mais dans les activités de base : là, elles se retrouvent presque toujours en première ligne, explique l'artiste à propos de son œuvre *Front Line* (ill. 1, cat. 1)[3]. L'œuvre de 2020 montre, dans un format horizontal gigantesque et tout en longueur, neuf figures féminines dénudées, disposées côte à côte pour former une ligne. L'expression « ligne de front » est formée à partir du latin *frōns/frontis*. Ce terme issu du langage militaire fait référence à la première ligne d'une armée qui avance ou d'une troupe de combat – c'est-à-dire aux individus qui, en cas de conflit armé, sont touchés en premier. Mais il désigne aussi un groupe qui s'oppose à quelqu'un ou à une cause et qui lutte pour quelque chose. C'est un combat de tous les jours d'aller contre la misogynie.

Dans l'œuvre, on voit une femme enceinte, une centauresse, des femmes dans des poses de penseuses ou de super-héroïnes, une femme accroupie en train de déféquer, une guerrière avec un arc qui vient de tirer une flèche de son carquois. Les deux femmes rognées par les bords latéraux de l'image suggèrent que cette « ligne de front » se poursuit à l'infini. Dans leur posture, principalement droite, détendue et ouvertement tournée vers les spectatrices[4], ces femmes ont de l'aplomb, une forte conscience d'elles-mêmes. Leurs corps peints de manière élémentaire ne cachent rien. La représentation de Khademi capte des moments anecdotiques, ordinaires, intimes, ou passés sous silence dans la vie quotidienne. Elle confronte le public à des stéréo-types intériorisés ou à des tabous personnels et culturels – comme, par exemple, le fait montré sans détour d'aller aux toilettes. L'artiste évoque le fait que les femmes sont trop

2 بیست سال گناه, *Twenty Years of Sin*, 2016 (Cat. | Kat. 19)

as well as some complementary tones for added figurative elements. The two-dimensionality of the bodies is reminiscent of early murals, Persian miniature paintings, and Japanese prints;[6] their occasionally naïve appearance also reminds the viewer of comics or children's drawings. The painted women are shown alone or in small to large groups, mainly on a single plane, with no attributes—or only a few, such as a bow and arrow—and are placed centrally in the picture. There is no hair on their bodies, with the exception of the head and eyebrows: personal characteristics, such as physical peculiarities or explicit indications of age, are usually absent, if one overlooks the slight variations in the forms of the bodies and hairstyles. Usually, young women are shown whose female body forms are often only slightly developed—around the hips, for instance—and sometimes appear childlike (see cat. 8). Apart from the female figures, Khademi almost always leaves the picture support unworked. In this way, she provides the women with space, both artistically and metaphorically.[7]

Their strength lies in their simplicity: Khademi's figures achieve their universality through their reduction to the essential. Almost without faces, without wounds or clothing to construct an identity, and in the rather stereotypic way they are shown, these women represent much of their gender. The focus is not placed on their individual fates. Instead, the figures become projection surfaces. The artist makes a case for femininity in all of its diversity; the visualization and unimpeded development of womanhood itself. For Khademi, these bodies are neither naked nor exposed; they are quite simply bodies. They represent women who live their femininity in everyday life without any feelings of shame or guilt.

As her inaugural moment, the artist describes a visit to a women's hammam together with her mother at the age of five. For the first time, she observed the many unclothed women in fascination. From memory, she then made an innocent child's drawing, but an impulse made her hide it. Her mother found the picture, confronted her with it, tore it up, and punished her daughter: "I've forgotten the pain of it, but I haven't forgotten

Einige von ihnen blicken uns aus klaren Augen direkt an. Mit einfachen Mitteln und doch sehr präsent gestaltet, fragt ihr auffordernder Blick nach unserer Haltung.

Khademi malt ihre Figuren stets gleich: fein konturiert, kaum detailliert und auf wenige Farbtöne, meist ohne Helligkeitsabstufungen, begrenzt. Die Farbpalette beschränkt sich im Wesentlichen auf das helle Ocker der Körper und das Schwarzbraun der Haare sowie einige ergänzende Töne für beigefügte Bildelemente. Die flächige Zweidimensionalität der Körper erinnert an frühe Wandmalereien, persische Miniaturmalerei oder japanische Drucke;[6] in ihrer mitunter naiven Anmutung und klaren Reduktion aber auch an Comics oder Kinderzeichnungen. Die gemalten Frauen befinden sich einzeln oder in kleinen bis größeren Gruppen überwiegend auf einer Bildebene, ohne oder mit nur wenigen Attributen (z. B. Pfeil und Bogen) sind sie zentral ins Bild gesetzt. Abgesehen von Kopfhaar und Augenbrauen sind die Körper haarlos; mit Ausnahme leicht variierender Körperformen und Frisuren fehlen zumeist persönliche Merkmale wie etwa körperliche Eigenheiten oder eindeutige Zeichen des Alters. Gezeigt werden vor allem jüngere Frauen, deren weibliche Körperformen, etwa an den Hüften, oft wenig ausgeprägt sind und die gelegentlich kindlich wirken (vgl. Kat. 8). Abgesehen von den Frauengestalten lässt Khademi den verwendeten Bildträger fast immer unbearbeitet. So gibt sie den Frauen gestalterisch wie metaphorisch Raum.[7]

In ihrer Einfachheit liegt die Stärke: Durch die Reduzierung auf das Wesentliche werden Khademis Figuren allgemeingültig. Nahezu ohne Geschichte, ohne Verletzungen oder identitätskonstruierende Kleidung und in ihrer eher stereotypen Darstellung stehen diese Frauen für viele ihres Geschlechts. Der Fokus liegt nicht auf dem Einzelschicksal. Stattdessen werden die Gestalten zur Projektionsfläche. Die Künstlerin plädiert für Weiblichkeit in ihrer ganzen Vielfalt; die Sichtbarmachung und freie Entfaltung des Frauseins an sich. Für Khademi sind diese Körper weder nackt noch entblößt, sondern schlicht Körper. Sie stehen für Frauen, die ihre Weiblichkeit im Alltag ohne Scham- oder Schuldgefühl leben.

souvent considérées comme sales par la société, alors qu'elles devraient être pures. Et elle souligne que, dans la culture afghane, refuser ou accepter librement la grossesse n'existe guère. Son travail, elle le décrit comme un « combat contre l'histoire, contre un système protégé par la religion[5] ». Que ressent-on face à cette série de femmes ? Certaines d'entre elles nous fixent de leurs yeux clairs. Par une facture très simple mais très présente, leur regard interpelle, il questionne notre attitude.

Khademi peint toujours ses personnages de la même manière : des contours fins, peu détaillés et limités à quelques teintes, généralement sans nuances de luminosité. La palette se restreint essentiellement à l'ocre clair des corps et au brun foncé des cheveux, ainsi qu'à quelques couleurs pour les éléments picturaux supplémentaires. La planéité des corps évoque d'anciennes peintures rupestres, des miniatures persanes ou des estampes japonaises[6], mais aussi, par son aspect parfois naïf et nettement réductif, des bandes dessinées ou des dessins d'enfants. Les femmes peintes se trouvent sur un niveau de représentation, seules ou dans des groupes plus ou moins grands, sans attributs ou très peu (arc et flèches par exemple), elles sont placées au centre de l'image. Hormis les cheveux et les sourcils, les corps sont imberbes. À l'exception de formes corporelles et de coiffures qui varient légèrement, les caractéristiques individuelles – traits physiques ou signes manifestes de l'âge – font généralement défaut. Ce sont surtout des femmes jeunes, dont les formes féminines, comme les hanches, sont peu prononcées et parfois presque enfantines (voir cat. 8). Excepté ces figures, Khademi ne travaille presque jamais le support utilisé. Elle laisse ainsi de l'espace aux femmes, artistiquement et métaphoriquement[7].

C'est leur simplicité qui fait leur force : en se réduisant à l'essentiel, les personnages de Khademi deviennent universels. Quasiment sans histoire, sans blessures ni vêtements construisant l'identité et dans leur représentation plutôt stéréotypée, ces femmes illustrent beaucoup de leurs congénères. L'accent n'est pas mis sur le destin individuel,

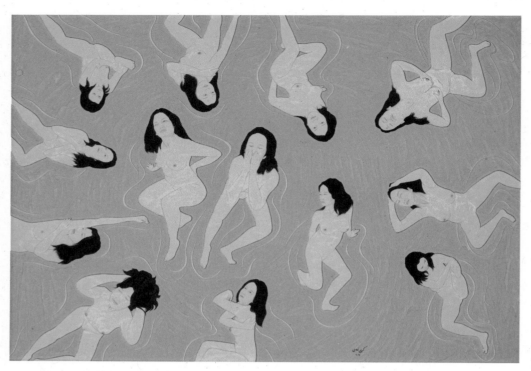

3 *Washing the Sins*, 2019 (Cat. | Kat. 20)

the feeling of guilt she gave me. [...] I am so happy that there is no guilt anymore. We have to celebrate living without any guilt."[8] Many years later, in 2016, she reconstructed the motif that now shows a group of gloomy women with lowered heads and called it *Twenty Years of Sin* (fig. 2, cat. 19). This was followed in 2019 by a multiple self-portrait, *Washing the Sins* (fig. 3, cat. 20), showing thirteen depictions of the artist's body, seen from above, swimming free in blue water.

COMPLETELY NORMAL NAKED WOMEN, OR: ART AS A POLITICAL TOOL?

Being a woman can mean many things. Kubra Khademi paints motifs of classic female life situations: from being born, over menstruation, to giving birth, and to menopause; women dancing, defecating, or fighting; girls who curiously explore their bodies; women masturbating or engaged with others in sexual play or intercourse. Many of these activities, some of which are primeval, are never—or only rarely—present in public visual imagery; Khademi reveals the depicted situations with an exceptionally nonchalant gesture.

She deals with the themes of sexuality and eroticism in, among others, the intermedial series *From the Two Page Book* in a (written) visual confrontation with the tradition of a form of humorous and erotic poetry from South Asia: In this series, she combines painting and passages of text in gold-colored calligraphy showing writings by Rumi (1207–1273), one of the most important Persian-language poets of the Middle Ages, or the Iranian poetess Forough Farrokhzad (1935–1967), who defied the conventions of a patriarchal society. Alongside this, well-known sayings, and the discrepancy between the decent language used in the public sphere and the (taboo-breaking) personal conversations between women who are close to one another, play a role. The picture that gives the series its title shows a naked woman on all fours from behind (fig. 4, cat. 51). She is kneeling on a dark blue carpet with appliqués of golden stars. Her prominent haunches, which she

Als Initialmoment ihrer Arbeit beschreibt die Künstlerin den Besuch in einem Frauen-Hammam mit ihrer Mutter im Alter von fünf Jahren. Zum ersten Mal bestaunte sie fasziniert die vielen unbedeckten Frauen. Aus der Erinnerung fertigte sie damals eine unschuldige Kinderzeichnung an, die sie aus einem Impuls heraus jedoch versteckte. Ihre Mutter fand das Bild, konfrontierte sie damit, zerriss die Zeichnung und bestrafte ihre Tochter: „Ich habe den körperlichen Schmerz vergessen, aber nicht das Gefühl von Schuld und Scham, das sie mir gab. […] Ich bin so froh, dass es keine Schuldgefühle mehr gibt. Wir müssen das Leben ohne Schuldgefühle feiern."[8] Viele Jahre später, 2016, rekonstruierte sie das Motiv, das nun eine Gruppe von Frauen mit bedrückt gesenkten Köpfen zeigt, und nannte es *Twenty Years of Sin* (Abb. 2, Kat. 19). 2019 folgte mit *Washing the Sins* (Abb. 3, Kat. 20) ein mehrfaches Selbstporträt, in dem von oben gezeigt 13 Körper der Künstlerin frei in blauem Wasser schwimmen.

GANZ NORMALE NACKTE FRAUEN, ODER: KUNST ALS POLITISCHES WERKZEUG?

Frausein kann vieles bedeuten. Kubra Khademi malt Motive klassisch weiblicher Lebenssituationen: von der Geburt über die Monatsblutung bis zum Gebären und zur Menopause, Frauen beim Tanz, beim Stuhlgang oder im Kampf; Mädchen, die neugierig ihren Körper erkunden, und masturbierende Frauen oder solche im gemeinsamen sexuellen Spiel. Viele der zum Teil urmenschlichen Handlungen sind in der öffentlichen Bildsprache selten bis nie präsent – Khademi legt die dargestellten Situationen mit einer sehr lässigen Geste offen.

Die Themen Sexualität und Erotik bearbeitet sie unter anderem in der intermedialen Serie *From the Two Page Book* in einer (schrift-)bildlichen Auseinandersetzung mit der Tradition einer humorvollen und erotischen Poesie Südasiens: In der genannten Serie kombiniert sie Malerei mit Textpassagen in goldfarbener Kalligrafie aus Texten von

les personnages deviennent plutôt surface de projection. L'artiste fait valoir la féminité dans toute sa diversité – visibilité et libre épanouissement de l'essence féminine. Pour Khademi, ces corps ne sont ni nus ni dénudés, mais tout simplement des corps. Ils représentent des femmes qui vivent leur féminité au quotidien, sans honte ni culpabilité.

L'artiste décrit la visite d'un hammam avec sa mère, à l'âge de cinq ans, comme le moment fondateur de son travail. Pour la première fois, elle voyait toutes ces femmes non couvertes. Suite à ça, elle a réalisé, de mémoire et innocemment, un dessin d'enfant, que dans son élan elle a préféré cacher. Mais sa mère l'a retrouvé, le lui a mis sous les yeux puis déchiré avant de punir sa fille : « J'ai oublié la douleur physique, mais pas le sentiment de culpabilité et de honte qu'elle m'a insufflé. [...] Je suis tellement contente qu'il n'y ait plus de sentiment de culpabilité. Il faut célébrer la vie sans culpabilité[8]. » Bien des années plus tard, en 2016, elle a reconstitué le motif, qui montre désormais un groupe de femmes aux têtes baissées et oppressées, et elle l'a intitulé *Twenty Years of Sin* (ill. 2, cat. 19). En 2019 a suivi *Washing the Sins* (ill. 3, cat. 20), un autoportrait multiple dans lequel, vus d'en haut, treize corps de l'artiste flottent librement dans une eau bleue.

DES FEMMES TOUT SIMPLEMENT NUES – OU L'ART COMME OUTIL POLITIQUE ?

Être femme signifie beaucoup de choses. Kubra Khademi peint des situations féminines classiques : de la naissance à l'accouchement, en passant par la menstruation et la ménopause, des femmes qui dansent, défèquent ou se battent ; des jeunes filles qui explorent leur corps avec curiosité et des femmes qui se masturbent ou s'adonnent à des jeux sexuels collectifs. Ces actes, en partie ancestraux, sont rarement, voire jamais, présents dans l'imagerie publique – Khademi les révèle dans un geste désinvolte.

Elle aborde les thèmes de la sexualité et de l'érotisme, notamment dans la série intermédiale *From the Two Page Book*, en confrontant la représentation (et l'écrit) avec la tradition d'une poésie humoristique et érotique d'Asie du Sud : elle combine ainsi

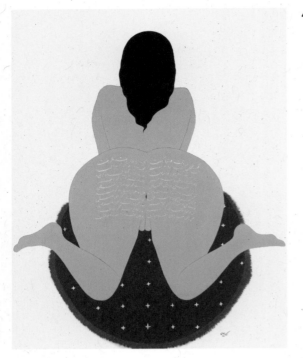

presents to the viewer, resemble the double pages of an open book. Calligraphic signs are placed on her two buttocks in ten-line full justification. It is said that the artist's mother provided the inspiration for the title of this work, *The Two Page Book*: An ironic term of speech that she uses to say that, when men set up ridiculous rules, these rules probably originate from their backsides, lies hidden behind the motif.[9] A subgroup of this series, *Deviant Vision* (cat. 56–61) places the sexualizing view on the female body in the center of focus: In contrast to the women that she usually portrays full-figure, here, Khademi shows details. She presents body openings; markedly sexually laden sections, or parts of the body that sometimes resemble the folds of a vulva. Through the focused image sections and the stressing of certain poses, she reveals the voyeuristic glimpses of women who interpret their bodies as (sexual) objects.

Being born or giving birth, in various contexts, also plays a significant role in Khademi's work. Gouaches from the series *Birth Giving* (2020, cat. 8–15) mainly show individual women giving birth: Crouching, lying, or standing, they bring a camel, a sheep, a chicken, a horse—and a girl—into the world. The animals mentioned are primarily domesticated in Afghanistan. Here, Khademi draws a parallel to the treatment of women. She also underlines the degradation of women as "birth machines"—and the focus placed on fertility as their seemingly greatest value—that they are still reduced to in many parts of the world.

In other works, the artist deals with established stories and the time-honored images associated with them. She looks for stereotype behavior patterns in the traditional tales of the environment surrounding her—regardless of whether this is Afghanistan or Paris. Women are customarily destined to play a passive role; the main parts are usually reserved for men. This is different with Khademi: In her series *Ordinary Women* (2020),

Rumi (1207–1273), einem der bedeutendsten persischsprachigen Dichter des Mittelalters, oder der iranischen Dichterin Forough Farrokhzad (1935–1967), die sich den Konventionen der patriarchalen Gesellschaft widersetzte. Daneben spielen auch geläufige Sprichwörter oder die Diskrepanz zwischen der gesitteten Sprache in der Öffentlichkeit und (tabubrechenden) persönlichen Gesprächen unter einander vertrauten Frauen eine Rolle. Das titelgebende Bild der Serie zeigt eine Frau im Vierfüßlerstand nackt von hinten (Abb. 4, Kat. 51). Sie kniet auf einem dunkelblauen Teppich mit kleinen goldenen Sternapplikationen. Ihr ausladendes Gesäß gleicht der Doppelseite eines aufgeschlagenen Buches, das sie den Betrachterinnen präsentiert. Auf ihren beiden Pobacken sind in zehnzeiligem Blocksatz kalligrafische Zeichen aufgebracht. Die Mutter der Künstlerin soll diese zum Titel der Arbeit *The Two Page Book* inspiriert haben: Hinter dem Motiv steckt eine verborgen ironische Redewendung, die sie gebraucht, wenn Männer unsinnige Regeln aufstellen, mit dem Sinn, dass diese Regeln wohl deren Allerwertestem entstammten.[9] Eine Untergruppe dieser Werkserie, *Deviant Vision* (Kat. 56–61), stellt den sexualisierenden Blick auf den weiblichen Körper explizit in den Mittelpunkt: Entgegen den sonst vor allem ganzfigurig dargestellten Frauen zeigt Khademi hier Details. Sie präsentiert Körperöffnungen, besonders sexuell aufgeladene Partien oder Teile des Körpers, die zuweilen im Hautfaltenwurf eine Vulva nachbilden. Durch den fokussierenden Bildausschnitt und die Betonung bestimmter Posen legt sie voyeuristische Blicke auf Frauen offen, die deren Körper als (sexuelle) Objekte lesen.

Geboren werden oder Gebären spielt in Khademis Kunst in unterschiedlichen Kontexten ebenfalls eine wichtige Rolle. So zeigen Gouachen aus der Serie *Birth Giving* (2020, Kat. 8–15) vor allem einzelne Gebärende: In hockender, liegender oder stehender Haltung bringen sie etwa ein Kamel, ein Schaf, ein Huhn, ein Pferd oder auch ein Mädchen zur Welt. Die genannten Tiere sind in Afghanistan vornehmlich domestiziert. Khademi zieht hier eine Parallele zu den Frauen. Auch stellt sie die Herabsetzung der Frauen als

la peinture avec des passages de texte en calligraphie dorée tirés de textes de Rûmî (1207–1273), l'un des poètes majeurs de langue persane au Moyen Âge, ou de la poétesse iranienne Forough Farrokhzad (1935–1967), qui brava les conventions de la société patriarcale. Interviennent aussi des proverbes courants ou des décalages entre le langage soutenu en public et des conversations familières (sans tabous) tenues par des femmes. Le tableau qui donne son titre à la série montre une femme nue de dos, accroupie sur un tapis bleu foncé sur lequel sont appliquées de petites étoiles dorées (ill. 4, cat. 51). Ses fesses évasées, sur lesquelles sont écrites dix lignes de calligraphie, ressemblent à la double page d'un livre ouvert qu'elle présente aux spectatrices. C'est la mère de l'artiste qui lui aurait inspiré le titre de l'œuvre *The Two Page Book*, expression ironique qu'elle utilise quand les hommes édictent des règles absurdes pour signifier qu'elles sortent sans doute de leur arrière-train[9]. Un sous-groupe de cette série d'œuvres, *Deviant Vision* (cat. 56–61), met explicitement l'accent sur le regard sexualisant porté sur le corps féminin : contrairement aux femmes représentées habituellement en entier, Khademi montre ici des détails : des orifices corporels, des parties particulièrement chargées sexuellement, qui reproduisent parfois une vulve dans les plissures de la peau. Par le cadrage qui accentue certaines poses, elle dévoile les regards voyeuristes sur les femmes et la lecture comme objets (sexuels) qui est faite de leur corps.

À différents égards, la naissance ou l'accouchement jouent également un rôle important dans l'art de Khademi. Les gouaches de la série *Birth Giving* (2020, cat. 8–15) montrent surtout des parturientes individuelles : accroupies, couchées ou debout, elles mettent au monde un chameau, un mouton, une poule, un cheval ou même une fille. En Afghanistan, ces animaux sont principalement domestiqués et Khademi les met ici en parallèle avec les femmes. Elle pointe également comment celles-ci sont rabaissées à des « machines à accoucher », comment leur fécondité est érigée en valeur soi-disant suprême, encore aujourd'hui, dans de nombreuses régions du monde.

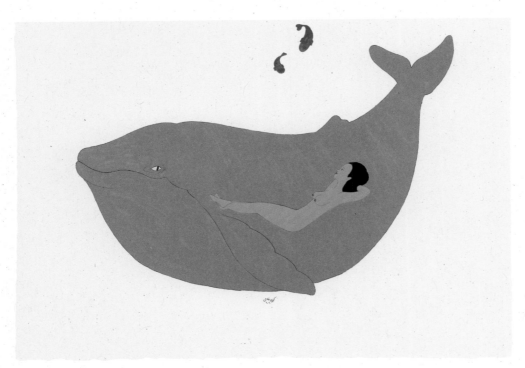

5 بدون عنوان, *Untitled #16*, 2020 (Cat. | Kat. 25)

a woman parts the sea instead of Moses (cat. 28 and title), and a female prophet takes the place of the Islamic prophet Suleiman on the flying carpet (cat. 22). The reversal of roles makes it clear that women are naturally expected to be in the second row— both historically and in the present day. Many figures are taken from the Qur'an but can also be found in the Jewish and Christian traditions. For example, she compares the Muslim story of Junus in the belly of the whale with the biblical Jonah (fig. 5, cat. 25). And a woman with a lamb in her arms creates an association with Jesus as the Good Shepherd in Western eyes (cat. 27). Some might consider it an affront for Christian symbolism when Mary mourns a daughter instead of her son Jesus in a depiction of the Pietà (cat. 29).

The artist purposely deconstructs classical male-female role models as reflected in Eurocentric art history. The unknown in the well known makes one sit up and take notice. She adapts images that are widely familiar or famous. For instance, when she quotes Édouard Manet's scandalous painting *Olympia* (1863): The artist painted a naked woman—not a mythological figure, which was the accepted form for a depiction of a nude, but a contemporary person and probably even a sex worker—looking directly at the viewer. Khademi transforms this motif into a double portrait of her mother and herself (2020, fig. 6, cat. 64). Here, the artist herself takes on the role of Olympia lying on gold foil with an orchid in her hair. Her mother stands behind the suggested bed, turns to her reclining daughter, and hands her a red flower.

„Geburtsmaschinen" heraus und die Fokussierung auf ihre Fruchtbarkeit als scheinbar höchsten Wert, auf den sie in vielen Teilen der Welt bis heute reduziert werden.

In anderen Werken beschäftigt sich die Künstlerin mit etablierten Erzählungen und den damit verbundenen, althergebrachten Bildern. Sie sucht in überlieferten Geschichten der sie umgebenden Umwelt, sei es Afghanistan oder Paris, nach stereotypen Verhaltensformen. Frauen wird hier normalerweise eine passive Rolle zugedacht, tragende Figuren sind zumeist Männern vorbehalten. Anders bei Khademi: In ihrer Werkserie *Ordinary Women* (2020) lässt sie statt Moses eine Frau das Meer teilen (Kat. 28 u. Titel) und macht aus dem islamischen Propheten Suleiman eine auf dem Teppich fliegende Prophetin (Kat. 22). Der Rollentausch lässt deutlich zutage treten, wie selbstverständlich Frauen – historisch wie aktuell – in der zweiten Reihe gedacht werden. Viele Figuren sind dem Koran entnommen, aber auch in der jüdischen und christlichen Tradition zu finden. So gleicht etwa die muslimische Geschichte von Junus im Bauch des Wals jener des biblischen Buchs Jona (Abb. 5, Kat. 25). Und eine Frau mit einem Lamm auf ihrem Arm weckt für den westlichen Blick Assoziationen zu Jesus als Hirten (Kat. 27). Einen Affront gegenüber christlicher Symbolik mögen manche sehen, wenn in einer Pietà-Darstellung (Kat. 29) Maria statt ihres Sohnes Jesus eine Tochter beweint.

Die Künstlerin dekonstruiert bewusst klassische Mann-Frau-Rollenbilder, wie sie sich auch in der eurozentristischen Kunstgeschichte widerspiegeln. Das Unbekannte im Vertrauten lässt aufmerken. Stets sind es berühmte Bilder, die sie aufgreift. So etwa im Zitat des skandalträchtigen Gemäldes *Olympia* (1863) von Édouard Manet: Der Künstler malte eine nackte Frau – und zwar keine mythologische Gestalt als akzeptierte Form einer Aktdarstellung, sondern eine zeitgenössische Figur, vermutlich sogar eine Sexarbeiterin –, die dem Publikum direkt ins Gesicht blickt. Khademi verwandelt dieses Motiv in ein Doppelporträt von ihrer Mutter und sich selbst (2020, Abb. 6, Kat. 64). Die Künstlerin nimmt hier die Rolle der auf Blattgold gebetteten Olympia mit Orchidee im

Dans d'autres œuvres, l'artiste s'intéresse aux récits établis et aux images ancestrales qui leur sont associées. Elle cherche dans les histoires transmises par l'univers autour d'elles, que ce soit l'Afghanistan ou Paris, des formes comportementales stéréotypées. La femme y est généralement cantonnée à un rôle passif, tandis que l'homme est porteur. Il en va autrement chez Khademi : dans sa série *Ordinary Women* (2020), c'est une femme et non Moïse qui ouvre la mer (cat. 28 et titre) et c'est une prophétesse et non le prophète islamique Sulayman qui vole sur un tapis (cat. 22). L'inversion des rôles montre clairement à quel point les femmes – dans l'histoire comme de nos jours – sont naturellement imaginées au second rang. De nombreuses figures sont tirées du Coran, mais on les retrouve également dans les traditions juive et chrétienne. Le récit musulman de Junus dans le ventre de la baleine ressemble ainsi à celui de la Bible avec Jonas (ill. 5, cat. 25). Et la femme qui porte un agneau dans ses bras éveille au regard occidental des associations avec Jésus en berger (cat. 27). D'aucuns pourraient voir un affront à la symbolique chrétienne dans la représentation d'une pietà (cat. 29) où Marie pleure une fille au lieu de son fils Jésus.

L'artiste déconstruit délibérément les rôles classiques de l'homme et de la femme, tels que les reflète l'eurocentrisme dans l'histoire de l'art. L'inconnu dans le familier retient l'attention, les images qu'elle reprend sont toujours connues. Prenons par exemple la citation du tableau à scandale *Olympia* (1863) d'Édouard Manet : l'artiste a peint une femme nue – non pas une figure mythologique, forme acceptée de la représentation du nu, mais un personnage contemporain, probablement même une travailleuse du sexe – qui regarde le public droit dans les yeux. Khademi transforme ce motif en un double portrait de sa mère et d'elle-même (2020, ill. 6, cat. 64) : l'artiste endosse le rôle d'Olympia, couchée sur une feuille d'or, avec une orchidée dans les cheveux. Derrière le lit suggéré se tient la mère qui se tourne vers sa fille allongée et lui tend des fleurs rouges.

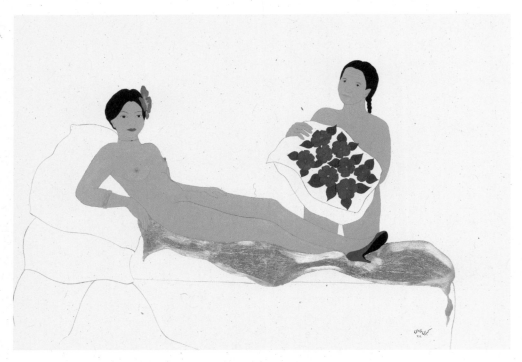

6 *Portrait of my mother and mine 1*, 2020 (Cat. | Kat. 64)

WHERE DO I COME FROM, WHERE AM I HEADED?

For Kubra Khademi, her works are created "deep in the story of [her] life,"[10] from exploring what she has experienced herself, and her own identity, which she feels is indivisibly linked to her mother. The mother gives birth to a person, and influences that person, who in turn must break free of the mother. Khademi relives this process as an adult in her gouache painting *Decision of Destination* (2020, fig. 7, cat. 68). At approximately thirty years of age, she emerges from the maternal body and severs the red umbilical cord with a pair of scissors held in her own hands. In her eyes, the self is not imaginable without the mother. This is especially apparent in her work *Passport Photo*—the photo that acts as the basis of one's certified identity—from the year 2019 (fig. 8, cat. 66). In this

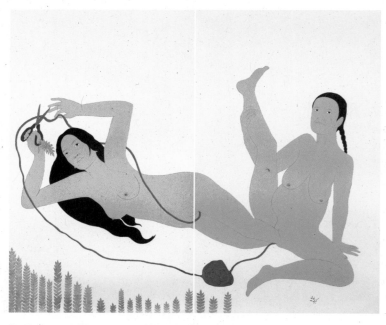

7 *Decision of Destination*, 2020 (Cat. | Kat. 68)

Haar ein. Hinter ihrem angedeuteten Bett steht die Mutter, die sich der liegenden Tochter zuwendet und ihr rote Blüten reicht.

29

WOHER KOMME ICH, WOHIN GEHE ICH?

Für Kubra Khademi entstehen ihre Werke „[…] tief in [ihrer] Lebensgeschichte […]",[10] aus der Beschäftigung mit dem eigenen Erleben und der eigenen Identität. Diese hängt für die Künstlerin untrennbar mit der Mutter zusammen. Von ihr wird man geboren, von ihr wird man geprägt und von ihr muss man sich abnabeln. Khademi lebt diesen Prozess in ihrer Gouachemalerei *Decision of Destination* (2020, Abb. 7, Kat. 68) als Erwachsene nach. Als etwa 30-Jährige geht sie aus dem mütterlichen Körper hervor und trennt eigenhändig mit einer Schere die rote Nabelschnur durch. Für sie ist ihr Selbst nicht ohne die Mutter denkbar: Besonders verdeutlicht dies ihr Werk *Passport Photo* – das Passbild als Grundlage für die beglaubigte Identität – aus dem Jahr 2019 (Abb. 8, Kat. 66). In dieser Malerei stellt sich Khademi in Passbildmanier auf weißem, einfarbigem Hintergrund dar und blickt mit gerade ausgerichtetem Kopf und neutralem Gesichtsausdruck in die „Kamera" – rechts vor ihr befindet sich ihre Mutter. In der Darstellung der eigenen Mutter setzt die Künstlerin (neben den sonst eher anonymisierten, jung wirkenden Frauen) auch deren gealterten, gerundeten Körper und die Zeichen des Lebens ins Bild.[11]

Auf eine Wortschöpfung ihrer Mutter geht außerdem der Serientitel *Paraqcha Ha* zurück. Damit beschreibt sie die kleinen und schönen, aber gefährlich explosiven Flugfunken eines Feuers. Diesen Ausdruck verwendet sie zugleich als poetischen wie kraftvollen Kosenamen für ihre Töchter. Khademis Serie greift einerseits das Element des Spiels in der Erziehung auf, andererseits aber auch das Bestrafen oder Beschützen von Kindern. In einem unbetitelten Bild der Serie (Abb. 9, Kat. 31) steht exemplarisch eine

D'OÙ VIENS-JE, OÙ VAIS-JE ?

Pour Kubra Khademi, ses œuvres naissent « […] dans les profondeurs de l'histoire de [sa] vie […][10] », de l'étude de son propre vécu et de sa propre identité, laquelle est indissociable de la mère. C'est d'elle que l'on naît, c'est d'elle que l'on s'imprègne, c'est d'elle que l'on doit se détacher. Khademi revisite ce processus à l'âge adulte dans sa peinture à la gouache *Decision of Destination* (2020, ill. 7, cat. 68). Âgée d'une trentaine d'années, elle sort du corps maternel et coupe elle-même le cordon ombilical rouge à l'aide de ciseaux. Pour elle, son être n'est pas concevable sans la mère : l'œuvre *Passport Photo* de 2019 – la photo d'identité comme fondement de l'identité certifiée – l'illustre tout particulièrement (ill. 8, cat. 66). Dans cette peinture, Khademi se représente sur un fond blanc monochrome et fixe l'« objectif », la tête droite et l'expression neutre – sa mère est à droite devant elle. Dans la représentation de sa propre mère, l'artiste met en scène (en plus de femmes d'allure et jeune et rendues anonymes) son corps vieilli et arrondi marqué par la vie[11].

Le titre de la série *Paraqcha Ha* reprend lui aussi un néologisme de sa mère, par lequel elle décrit les étincelles d'un feu, petites et belles, mais dangereusement explosives. Cette expression est le surnom poétique et fort qu'elle donne à ses filles. La série de Khademi reprend d'une part un élément ludique de l'éducation, mais d'autre part aussi la punition ou la protection des enfants. Dans une image sans titre de la série (ill. 9, cat. 31), une figure maternelle – toujours reconnaissable aux tresses que Khademi lui associe – se tient de manière édifiante au-dessus d'un feu. Elle a les bras largement étendus sur les côtés et tient dans chaque main un enfant par les cheveux, qu'elle protège de l'incandescence. Sans se soucier de se faire elle-même mal, sa pose toute en symétrie, jambes écartées, a quelque chose d'héroïque. On peut lire dans ces œuvres de la gratitude et de la déférence envers la mère. C'est le cas dans *Dowry* (2019, cat. 35), où Khademi la représente, tel un ange, sous la forme d'une femme ailée et lui offre symboliquement la dot de quatre bovins, autrefois promise par son futur beau-père et dont elle a été privée.

painting, Khademi portrays herself against a monochromatic white background in the style of a passport photo and looks straight ahead, with a neutral expression, into the "camera"—her mother is standing before her on the right. In the depiction of her own mother, the artist also illustrates (alongside the—usually anonymized—seemingly young women) aged, rounded female bodies, and the traces life has left on them.[11]

The title of the *Paraqcha Ha* series can also be traced back to one of her mother's neologisms she used to describe the small and beautiful—but dangerously explosive—flying sparks of a fire. At the same time, she used this term as a poetic, but forceful, pet name for her daughters. On the one hand, Khademi's series deals with the element of play in one's upbringing and, on the other, punishing or protecting children. A mother figure—always recognizable by the plaits Khademi associates with her—stands, exemplarily, above a fire in an untitled picture of the series (fig. 9, cat. 31). Her hands are stretched out far from her sides, and she has grabbed a child by the hair in each hand to protect them from the scorching heat. Without paying any heed to possibly harming herself, something heroic emanates from her symmetric stance with her legs placed wide apart. It is also possible to read thankfulness and respect toward the mother into the works. This is true of *Dowry* (2019, cat. 35), in which Khademi shows her as a winged woman, similar to an angel, and symbolically presents her with the four head of cattle that had been promised by her future father-in-law, but which she had never received. The animals and wings are formed out of gold leaf to give the picture a sense of solemnity and exceptional value. The artist recognizes the injuries that have been inflicted, makes them visible, and invests them with the missing recognition.

In addition to the thematic study of the mother and her roots in the family, the relationship to her home country plays a central role in Khademi's work. One example of this is when the artist devotes herself to the conquest of the mythical dragon and its seven children: According to the legend, this beast eats a (virginal) woman every

Mutterfigur – stets erkennbar an den geflochtenen Zöpfen, die Khademi mit ihr assoziiert – über einem Feuer. Sie hat die Arme weit zu den Seiten von sich gestreckt und hält mit beiden Händen je ein Kind am Schopf gepackt, um es vor der sengenden Hitze zu bewahren. Ohne jede Rücksicht darauf, selbst Schaden zu nehmen, birgt ihre breitbeinige und symmetrisch angelegte Pose etwas Heroisches. Weiter lässt sich aus den Werken Dankbarkeit und Ehrerbietung gegenüber der Mutter lesen. So in *Dowry* (2019, Kat. 35), wenn Khademi sie gleich einem Engel als geflügelte Frau zeigt und ihr symbolisch die ehemals von ihrem künftigen Schwiegervater versprochene und vorenthaltene Mitgift von vier Rindern schenkt. Tiere und Flügel sind aus Blattgold gestaltet, was dem Bild eine feierliche Stimmung und einen besonderen Wert verleiht. Die Künstlerin erkennt zugefügte Verletzungen, macht sie sichtbar und lässt ihnen die fehlende Anerkennung zuteilwerden.

Neben der thematischen Auseinandersetzung mit der Mutter als familiärem Ursprung spielt auch das Verhältnis zu ihrem Heimatland eine zentrale Rolle in Khademis Werk. Beispielsweise, indem sich die Künstlerin der Bezwingung des mythischen Drachens und seiner sieben Kinder verschreibt: Im Drachental (Darre-ye Azhdaha) in der afghanischen Provinz Bamiyan frisst dieser einer Legende zufolge täglich eine (Jung-)Frau (Kat. 5–7). Oder wenn sie in einer Zusammenarbeit mit dem US-amerikanischen Künstler Daniel Pettrow vor allem in Foto- und Videoarbeiten die Beziehung zwischen Afghanistan und den USA in den Blick nimmt (Abb. 10–11 u. Kat. 73–86). Und jüngst fertigte sie eine großformatige Malerei an, in der sie provokant die Mitglieder des afghanischen Parlaments durch unbekleidete Frauen auswechselt (Kat. 3) – während im realen Afghanistan die Taliban Frauen verhüllen, verstecken und unterdrücken, sie ihrer Grundrechte berauben und aus dem Arbeitsleben oder politischen Ämtern vertreiben.

Bereits in Khademis Kindheit migrierte ihre Familie zwischen Afghanistan, dem Iran und Pakistan. Nach der Aufführung ihrer öffentlichen Performance *Armor* (Kat. 2) im

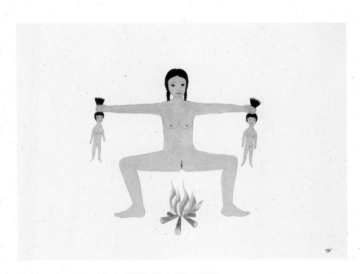

9 بدون عنوان, *Untitled*, 2019 (Cat. | Kat. 31)

Les animaux et les ailes sont réalisés à la feuille d'or, ce qui confère au tableau un caractère solennel et une valeur particulière. L'artiste reconnaît les blessures infligées, elle les rend visibles et leur donne la reconnaissance qui leur fait défaut.

Outre la réflexion thématique sur la mère en tant qu'origine de la famille, la relation avec son pays d'origine joue également un rôle crucial dans l'œuvre de Khademi. Ainsi quand elle part à la conquête du dragon mythique et de ses sept enfants : la légende raconte qu'à Darre-ye Azhdaha, dans la province afghane de Bamiyan, celui-ci dévore une femme (vierge) chaque jour (cat. 5-7). Mais l'artiste s'intéresse aussi à la relation entre l'Afghanistan et les États-Unis, notamment avec des œuvres photos et vidéos réalisées dans le cadre d'une collaboration avec l'artiste américain Daniel Pettrow (fig. 10-11 et cat. 73-86). Et récemment, elle a réalisé une peinture grand format dans laquelle elle remplace de manière provocante les membres du Parlement afghan par des femmes dévêtues (cat. 3) – alors que dans la réalité afghane, les talibans voilent, cachent et oppriment les femmes, les privent de leurs droits fondamentaux et les excluent de la vie professionnelle ou des fonctions politiques.

Dès l'enfance, Khademi a dû migrer avec sa famille entre l'Afghanistan, l'Iran et le Pakistan. Après la présentation de sa performance publique *Armor* (cat. 2) à Kaboul en 2015, elle a été contrainte de quitter à nouveau son pays. *Like a wave in this slope*

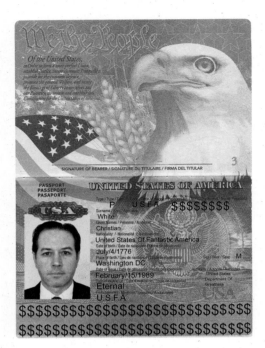

10 Kubra Khademi and | und | et Daniel Pettrow, کریستین وایت, *Christian White*, 2021, ایمان بیاوریم به آغاز فصل داغ, Let us believe in the beginning of the hot season, Photo collage print on | Fotocollage gedruckt auf | photomontage sur Hahnemühle Brillant baryta 325g, 100 × 67 cm, property of the artists | Eigentum der Künstlerinnen | propriété des artistes, Galerie Eric Mouchet, Paris, France | Frankreich

11 Kubra Khademi and | und | et Daniel Pettrow, مولانا خیرالله برادر, *Mowlana Kahir ulla Baradar*, 2021, ایمان بیاوریم به آغاز فصل داغ, Let us believe in the beginning of the hot season, Photo collage print on | Fotocollage gedruckt auf | photomontage sur Hahnemühle Brillant baryta 325g, 100 × 67 cm, property of the artists | Eigentum der Künstlerinnen | propriété des artistes, Galerie Eric Mouchet, Paris, France | Frankreich

day in the Valley of the Dragon (Darre-ye Azhdaha) in the Afghan province of Bamiyan (cat. 5–7). Or when she focuses on the relationship between Afghanistan and the United States in the photo and video works she creates in collaboration with the American artist Daniel Pettrow (figs. 10 and 11 and cat. 73–86).

And she recently created a large-scale painting in which she provocatively substituted bare women for the members of the Afghan parliament (cat. 3)—this, at a time when, in real Afghanistan, the Taliban are veiling, hiding, and suppressing women, taking away their fundamental rights, and driving them out of working life and political offices.

During Khademi's childhood, her family migrated between Afghanistan, Iran, and Pakistan. After her public performance of *Armor* (cat. 2) in Kabul in 2015, Khademi was once again forced to leave her country. *Like a wave in this slope* (fig. 12, cat. 71), a preliminary study for a performance in which the artist rolls a large, colorful ball of personal and everyday objects in front of her, raises questions about home and migration: What do I need to feel at home? What do I want to take with me? But also: What is it even possible to take? And: How can I transport it? This is one way for Khademi, who is now a French citizen, to deal with her personal experience of being forced to flee. She has this in common with many other citizens of the war-torn country. The artist also sees a personal responsibility in this: Together with Maria-Carmela Mini, her performance agent, she has helped evacuate especially endangered (female) artists out of Afghanistan, bringing them to France since the summer of 2021.[12] With the creation of a new group of

Jahr 2015 in Kabul war Khademi schließlich erneut gezwungen, ihr Land zu verlassen. *Like a wave in this slope* (Abb. 12, Kat. 71), eine Vorstudie für eine Performance, bei der die Künstlerin eine große bunte Kugel aus persönlichen und Gebrauchsgegenständen vor sich her rollt, wirft Fragen zu Heimat und Migration auf: Was brauche ich, um mich heimisch zu fühlen? Was möchte ich mitnehmen? Aber auch: Was kann ich überhaupt mitnehmen? Und: Wie kann ich es transportieren? So setzt sich Khademi, die heute auch französische Staatsbürgerin ist, mit der eigenen Fluchterfahrung auseinander. Sie teilt sie mit vielen Bürgerinnen des seit Jahrzehnten kriegsgebeutelten Landes. Die Künstlerin zieht daraus auch eine persönliche Verantwortung: Gemeinsam mit ihrer Performance-Agentin Maria-Carmela Mini half sie seit dem Sommer 2021, besonders gefährdete Künstlerinnen aus Afghanistan nach Frankreich zu evakuieren.[12] Mit einer neu entstehenden Werkgruppe aus für das Publikum interaktiv nutzbaren Jacken im Militärstil verarbeitet und erzählt Khademi die Geschichte(n) dieser afghanischen Frauen (Kat. 72). Sie fügt den secondhand erworbenen und umgearbeiteten Textilien Briefe, Fotografien oder Kleinodien – Objekte von persönlicher Bedeutung – bei. Ausstellungsbesucherinnen sind dazu angehalten, die Jacken anzuprobieren und die vielen für die Kleidungsstücke typischen Taschen beziehungsweise deren individuelle Inhalte zu erkunden. Welcher Person mögen sie gehört haben? Mit welchen Emotionen und Ereignissen stehen sie in Verbindung? Militärjacken respektive schusssichere Westen stehen bei Khademi symbolisch für Momente zwischen Leben und Tod. Solche Jacken sollen in Momenten größter Gefahr beschützen, ohne zu gewährleisten, wer überlebt und wer nicht. Auch der Künstlerin wurde bei ihrer Flucht aus Kabul in der französischen Botschaft für den Weg zum Flugzeug eine solche angelegt. Ihr blieb besonders die Schwere des Kleidungsstücks in Erinnerung.[13]

(ill. 12, cat. 71) est l'étude préliminaire pour une performance dans laquelle l'artiste fait rouler devant elle une grande boule colorée avec des objets personnels et usuels. Ce travail soulève des questions sur la patrie et la migration : de quoi ai-je besoin pour me sentir chez moi ? Qu'est-ce que je veux emporter avec moi ? Mais aussi : qu'est-ce que je *peux* emporter ? Et comment puis-je le transporter ? Khademi, qui a aujourd'hui la citoyenneté française, se penche ainsi sur l'expérience de son propre exil et la partage avec de nombreuses citoyennes de ce pays ravagé par la guerre depuis des décennies. L'artiste assume aussi personnellement : depuis l'été 2021, avec son agente Maria-Carmela Mini, elle aide à évacuer d'Afghanistan vers la France des femmes artistes particulièrement menacées[12]. Khademi crée actuellement un groupe d'œuvres, composé de vestes militaires utilisables de manière interactive par le public, pour traiter et raconter la ou les histoires de ces femmes afghanes (cat. 72). Aux textiles achetés en seconde main puis transformés, elle ajoute des lettres, photographies ou bibelots – des objets qui ont une importance individuelle. Les visiteuses de l'exposition sont invitées à essayer les vestes, à fouiller dans les nombreuses poches, à sonder ce qu'elles contiennent. À quelle personne ont-elles pu appartenir ? À quelles émotions et à quels événements sont-elles associées ? Chez Khademi, les vestes militaires et les gilets de sécurité symbolisent des moments entre la vie et la mort. Ces vestes sont censées protéger dans les moments de grand danger, mais sans qu'on sache qui survivra et qui ne survivra pas. Lors de sa fuite de Kaboul, l'artiste en a elle aussi reçu une à l'ambassade de France, pour se rendre à l'avion. De la lourdeur de ce vêtement, elle a gardé le souvenir[13].

L'IMAGE DU CORPS COMME SURFACE DE PROJECTION COLLECTIVE

Même sans connaître les détails de la biographie de Khademi, ni les récits spécifiques ou les perspectives propres à la société afghane, de nombreuses personnes sont touchées par l'art de Kubra Khademi dans le monde entier. Quantité d'articles de presse et expositions témoignent de l'intérêt pour ce qu'elle crée. Or c'est peut-être

12 همچون موج در این نشیب, *Like a wave in this slope*, 2020 (Cat. | Kat. 71)

works made of military-style jackets that can be used interactively by the public, Khademi processes and tells the story, or stories, of these Afghan women (cat. 72). She adds letters, photographs, and trinkets—objects with a personal significance—to the second-hand textiles she has purchased and reworked. Visitors to the exhibition are required to try on the jackets and explore the many pockets, which are so typical of the pieces of clothing, and their contents. Who could they have belonged to? What are the emotions and events connected to them? For Khademi, military jackets and bulletproof vests are symbolic of the moment between life and death. Such jackets are intended to protect in times of the utmost danger without being able to guarantee who will survive and who will not. When she fled from Kabul, the artist also had to put on a jacket of this kind as she made her way from the French Embassy to the aircraft. She particularly remembers just how heavy the piece of clothing was.[13]

BODY IMAGES AS PROJECTION SURFACES

Even without being aware of the details of Kubra Khademi's biography, the specific narratives, and the inner perspective of Afghan society, many people throughout the world have been moved by her art; numerous articles in the press and exhibitions bear witness to the interest in her work. However, it is likely that precisely the story of her life and her experiences enable her to create transferable images. Starting from the subjective, she sensitively invests contents with a universal validity that make it possible for the viewer to find intuitive gateways to her work and to comprehend her body images as collective projection surfaces: "They are all me, and they are all other, there is no difference," the artist states.[14] In its number with illustrations by Khademi, the culture journal *Lettre International* fittingly described her work as "An artistic act of courage, liberty, and subversion. A humanization of the view."[15]

KÖRPERBILDER ALS KOLLEKTIVE PROJEKTIONSFLÄCHE

Auch ohne die Details von Khademis Biografie, die spezifischen Erzählungen oder die Innenperspektive der afghanischen Gesellschaft zu kennen, sind weltweit viele Menschen von Kubra Khademis Kunst bewegt; zahlreiche Presseartikel und Ausstellungen belegen das Interesse an ihrer Kunst. Doch vielleicht gerade aufgrund ihrer Lebensgeschichte und Erlebnisse vermag sie übertragbare Bilder zu schaffen. Vom Subjektiven ausgehend verleiht sie Inhalten sensibel eine Allgemeingültigkeit, sodass es möglich ist, intuitiv Zugänge zu ihrer Arbeit zu finden und ihre Körperbilder als kollektive Projektionsfläche zu verstehen: „Sie sind alle ich, und sie sind alle anderen, es gibt keinen Unterschied",[14] sagt die Künstlerin. Die Kulturzeitschrift *Lettre International* beschreibt in ihrer von Khademi bebilderten Ausgabe deren künstlerische Arbeit treffend mit: „Ein artistischer Akt des Mutes, der Freiheit und der Subversion. Eine Humanisierung des Blicks."[15]

Als Feministin und als Teil einer afghanischen Exil-Opposition nutzt Kubra Khademi ihre Werke auch als politisches Sprachrohr; vor allem, indem sie anhand souveräner Frauenkörper eine visuelle Gegenwelt zu vorherrschenden Darstellungskonventionen und Bildsprachen bietet: indem sie alles offenlegt, was schlichtweg zu einem (weiblichen) Leben dazugehört. Künstlerische Arbeit hat das Potenzial, in die Gesellschaft hineinzuwirken und Änderungsprozesse anzustoßen. Es geht nicht allein darum, dass Khademi es als Selbstverständlichkeit sieht, die Geschichten von Frauen aufzuzeichnen und mit ihren Werken Freiraum für sie einzufordern. Es geht auch um die Wirkung ihrer Arbeiten auf das Publikum: Gelegentlich kommt ihre Bildsprache fast lieblich daher, gleichwohl rüttelt sie mit einer enormen Kraft an Tabus. Mit Kubra Khademi, die in ihren Bildern unübersehbar zeigt, was oft verborgen bleibt, soll diese Ausstellung auch ein sichtbares Zeichen für das Streben nach gleichberechtigten Gesellschaftssystemen und nach einem diskriminierungssensiblen Miteinander sein. Sie soll einladen, zu hinterfragen und aufeinander zu-

justement en raison de son histoire et de son vécu qu'elle parvient à concevoir des images qui se transmettent. À partir du subjectif, elle confère avec sensibilité une universalité aux contenus, de sorte qu'il est possible de trouver intuitivement l'accès à son travail et de percevoir ses images de corps comme une surface de projection collective : « Ils sont tous moi, et ils sont tous les autres, il n'y a pas de différence », confie l'artiste[14]. Dans son numéro illustré par Khademi, le magazine culturel *Lettre International* décrit avec justesse le travail de celle-ci : « C'est un acte artistique de courage, de liberté et de subversion. Une humanisation du regard[15]. »

En tant que féministe et membre d'une opposition afghane en exil, Kubra Khademi utilise également ses œuvres comme porte-voix politique ; surtout en offrant, à travers des corps de femmes assurés, un monde visuel qui va à l'encontre des conventions de représentation et des langages visuels dominants : elle montre tout simplement ce qui fait la vie (des femmes). Le travail artistique peut potentiellement influencer la société et amorcer des processus de changement. Car non seulement Khademi considère comme évident de consigner les histoires des femmes et de revendiquer leur espace de liberté à travers ses œuvres. Mais ce qui compte aussi c'est l'impact de son art sur le public : son langage visuel a beau être plutôt doux, il remue les tabous avec une force énorme. Les œuvres de Kubra Khademi mettent en plein jour ce qui reste bien souvent dissimulé, et ainsi même cette exposition doit être un signal visible : celui d'une aspiration à des sociétés égalitaires et à un vivre-ensemble sensible aux discriminations. Il s'agit donc ici d'une incitation à se remettre en question, à aller à la rencontre de l'autre. Et il s'agit aussi de contribuer à ce que la situation précaire des filles et des femmes, en particulier en Afghanistan, reste dans les consciences publiques.

Par son travail artistique, Khademi défie la société patriarcale et les structures misogynes de son pays, elle remet en cause le système sociopolitique, elle dénonce ouvertement les inégalités entre femmes et hommes. Dans un but d'émancipation et avec un vocabulaire artistique révolutionnaire, même en dehors du contexte afghan, elle rompt

As a feminist and part of the Afghan opposition in exile, Kubra Khademi also uses her work as a political mouthpiece; above all, by having sovereign female bodies offer a visual counterworld to the predominant conventions of representation and visual languages; by revealing everything that—quite simply—is part of (female) life. Artistic work has the potential to influence society and trigger processes of change. It is not merely that Khademi sees it as a matter of course to record the stories of women and, through her work, demand an area of freedom for them. It is also a matter of the effect her work has on the public: Occasionally, her visual language appears to be almost charming but, at the same time, she challenges taboos with enormous force. With Kubra Khademi, who conspicuously shows what is often concealed in her pictures, this exhibition also aims at offering a visual sign for the efforts for equal social systems and a discrimination-sensitive togetherness. Its aim is to encourage questioning and getting closer to each other. And it should also help to make sure that the current precarious situation of girls and women—especially in Afghanistan—does not disappear from the public sphere.

With her artistic work, Khademi defies the patriarchal society and the partly misogynist system of her homeland and questions sociopolitical orders. She openly denounces the dominant inequality of men and women. With her emancipatory intention and a visual language that is revolutionary—not only in the Afghan context—Kubra Khademi breaks with established perceptions and, in doing so, also irritates the Western view. In this way, she provides recognition for the woman per se that goes beyond mere visibility. She ties in with universal feminist demands, takes a stance with her art, and is currently fighting especially for the fundamental rights of women in Afghanistan that have, once again, been challenged.

1 See the contribution by Salima Hashmi in the present volume, pp. 52-63. **2** See the contribution by Philippe Dagen in the present volume, pp. 38-51. **3** Kubra Khademi in conversation with the author, January 2022. **4** In the languages concerned, in this text—as in the entire catalogue—the generic feminine is used. The feminine terms include male persons and those who do not consider themselves in binary gender models to the same extent; all readers can therefore feel equally addressed. The decision to use the generic feminine in place of a gender-neutral or masculine syntax (mainly in the French and German languages) for this project was made by the artist and curator. It is to be understood as a linguistic (reading) experiment, as providing food for thought, and as a statement against masculine-dominated language. See also the preface by Britta E. Buhlmann in the present volume, pp. 6-11, here 8-10. **5** Kubra Khademi in conversation with the author, January 2022; see also Philomena Epps, "The Unbearable Artist: In Conversation with Kubra Khademi" (October 9, 2021), from: *V/A - Various Artists*, https://various-artists.com/the-unbearable-artist/ (accessed January 31, 2022). **6** See Atiq Rahimi, "Kubra," text for the exhibition *Kubra Khademi: From the Two Page Book* (January 30-March 16, 2021), Galerie Eric Mouchet, http://www.ericmouchet.com/wp-content/uploads/2021/01/English_PR_KubraKhademi.pdf (accessed January 31, 2022); as well as Kubra Khademi in conversation with the author, January 2022. **7** In this way, Khademi also shows or "celebrates" drawing paper as a material that was a scarce commodity in her childhood, and that has remained a great treasure for her to the present day. Kubra Khademi in conversation with the author, January 2022; see also Epps, "The Unbearable Artist." **8** Epps, "The Unbearable Artist." **9** See Rahimi, "Kubra." **10** Kubra Khademi in conversation with Bettina Wohlfarth in the present volume, pp. 64-65, here 64. **11** In addition, she dealt extensively with the history of female relatives, such as her grandmother, in the previous paintings. She presented them impressively in a lecture performance, *Kubra Khademi: I Will Greet the Sun Again*, in the Bozar Centre for Fine Arts in Brussels. See: Palais des beaux-arts de Bruxelles, Kubra Khademi / Live Performance / BOZAR (October 22, 2020), https://www.youtube.com/watch?v=Hvz98mH3bkE (accessed January 31, 2022). **12** See the interview between Kubra Khademi and Bettina Wohlfarth in the present volume, pp. 64-65. **13** Kubra Khademi in conversation with the author, January 2022. **14** Kubra Khademi cited in: Ana Bordenane, "The Political Poetics of Kubra Khademi," https://galeriejoseph.com/en/2021/12/02/the-political-poetics-of-kubra-khademi/ (accessed January 31, 2022). **15** Kubra Khademi, "Truth of the Body," *Lettre International* 134 (2021): 5.

zugehen. Und sie soll helfen, die derzeit prekäre Situation von Mädchen und Frauen insbesondere in Afghanistan nicht aus dem Fokus der Öffentlichkeit verschwinden zu lassen.

Khademi bietet mit ihrer künstlerischen Arbeit der patriarchalen Gesellschaft und dem teils misogynen System ihrer Heimat die Stirn und stellt gesellschaftspolitische Ordnungen infrage. Sie prangert die vorherrschende Ungleichbehandlung von Frauen und Männern offen an. In emanzipatorischer Absicht und einer Bildsprache, die nicht allein für den afghanischen Kontext revolutionär ist, bricht sie mit etablierten Sichtweisen – und irritiert damit auch den sogenannten westlichen Blick. So verschafft sie der Frau an sich über die Sichtbarkeit hinaus auch Anerkennung. Sie knüpft an universell feministische Forderungen an, bezieht mit ihrer Kunst Stellung und kämpft derzeit besonders für die aufs Neue infrage gestellten Grundrechte von Frauen in Afghanistan.

1 Siehe dazu den Beitrag von Salima Hashmi in diesem Band, S. 52–63. 2 Siehe dazu den Beitrag von Philippe Dagen in diesem Band, S. 38–51. 3 Kubra Khademi im Gespräch mit der Autorin, Januar 2022. 4 In diesem Text wie dem gesamten Katalog wird verallgemeinernd das generische Femininum verwendet. Die weiblichen Bezeichnungen umfassen gleichermaßen auch männliche Personen und Menschen, die sich nicht im binären Geschlechtsmodell wiederfinden; alle Lesenden dürfen sich damit gleichberechtigt angesprochen fühlen. Die Verwendung des generischen Femininums entgegen jener einer geschlechtsneutralen Schreibweise oder des generischen Maskulinums wurde projektspezifisch gemeinsam von Künstlerin und Kuratorin entschieden. Sie ist als sprachliches (Lese-)Experiment, Gedankenanstoß und Statement gegen eine maskulin geprägte Sprache zu verstehen. Siehe dazu das Geleitwort von Britta E. Buhlmann in diesem Band, S. 6–11, hier S. 11. 5 Kubra Khademi im Gespräch mit der Autorin, Januar 2022; vgl. hierzu auch Philomena Epps, The Unbearable Artist: In Conversation with Kubra Khademi (9.10.2021), aus: V/A – Various Artists, URL: https://various-artists.com/the-unbearable-artist/ [gelesen am 31.1.2022]. 6 Vgl. Atiq Rahimi, Kubra, Text zur Ausstellung Kubra Khademi. From the Two Page Book (30.1.–16.3.2021), Galerie Eric Mouchet, aus: URL: http://www.ericmouchet.com/wp-content/uploads/2021/01/English_PR_KubraKhademi.pdf [gelesen am 31.1.2022]; sowie Kubra Khademi im Gespräch mit der Autorin, Januar 2022. 7 Khademi zeigt bzw. „feiert" damit aber auch das Zeichenpapier als Material, das in ihrer Kindheit Mangelware war und für sie bis heute eine große Kostbarkeit ist. Kubra Khademi im Gespräch mit der Autorin, Januar 2022; vgl. hierzu auch Epps 2021 (wie Anm. 5). 8 Ebd. 9 Vgl. Rahimi 2021 (wie Anm. 6). 10 Kubra Khademi im Gespräch mit Bettina Wohlfarth in diesem Band, S. 66–67, hier S. 66. 11 Darüber hinaus setzt sie sich in vorhergehenden Malereien ausführlich mit der Geschichte weiblicher Verwandter, etwa ihrer Großmutter, auseinander. In einer Vortragsperformance, Kubra Khademi – I will Greet the Sun Again, im Bozar Centre for Fine Arts in Brüssel stellte sie diese eindrücklich vor. Siehe hierzu Palais des beaux-arts de Bruxelles, Kubra Khademi / Live Performance / BOZAR (22.10.2020), aus: URL: https://www.youtube.com/watch?v=Hvz98mH3bkE [gesehen am 31.2.2022]. 12 Siehe dazu das Interview von Kubra Khademi mit Bettina Wohlfarth in diesem Band, S. 66–67. 13 Kubra Khademi im Gespräch mit der Autorin, Januar 2022. 14 Kubra Khademi zit. in: Ana Bordenane, The Political Poetics of Kubra Khademi (o. D.), aus: URL: https://galeriejoseph.com/en/2021/12/02/the-political-poetics-of-kubra-khademi/ [gelesen am 31.1.2022]. 15 Kubra Khademi. Wahrheit des Körpers, in: Lettre International 134, 2021, S. 5.

avec les opinions toutes faites — et, par là, trouble aussi le regard dit occidental. Au-delà de la visibilité qu'elle donne aux femmes, elle leur procure de la reconnaissance. En s'inscrivant dans le cours des revendications féministes universelles, son art prend position et lutte pour les droits fondamentaux des femmes en Afghanistan.

1 Voir l'article de Salima Hashmi dans la présente publication, p. 52-63. 2 Voir l'article de Philippe Dagen dans la présente publication, p. 38-51. 3 Kubra Khademi dans un entretien avec l'autrice, janvier 2022. 4 Ce texte comme l'ensemble du catalogue utilise le féminin générique. Les désignations féminines englobent également les individus de sexe masculin et non-binaires ; toutes les personnes qui lisent peuvent ainsi se sentir pareillement interpellées. L'utilisation du féminin générique, contrairement à celle d'une orthographe neutre ou du masculin générique, a été décidée conjointement par l'artiste et la commissaire d'exposition en fonction de la nature du projet. Cet usage se conçoit comme une expérience linguistique (de lecture), une incitation à la réflexion et un énoncé contre l'emploi par trop marquant du masculin. Voir à ce sujet l'avant-propos de Britta E. Buhlmann dans la présente publication, p. 6-11, p. 11. 5 Kubra Khademi dans un entretien avec l'autrice, janvier 2022; cf. aussi Philomena Epps, « The Unbearable Artist : In Conversation with Kubra Khademi » (9 octobre 2021), extrait de V/A – Various Artists, https://various-artists.com/the-unbearable-artist/ [consulté le 31 janvier 2022]. 6 Cf. Atiq Rahimi, « Kubra », texte pour l'exposition Kubra Khademi. From the Two Page Book (30 janvier-16 mars 2021), Galerie Eric Mouchet, http://www.ericmouchet.com/wp-content/uploads/2021/01/English_PR_KubraKhademi.pdf [consulté le 31 janvier 2022] ; Kubra Khademi dans un entretien avec l'autrice, janvier 2022. 7 Khademi montre voire « célèbre » aussi le papier à dessin comme un matériau ayant manqué dans son enfance et aujourd'hui encore précieux à ses yeux. Kubra Khademi dans un entretien avec l'autrice, janvier 2022 ; cf. Epps 2021 (op. cit. note 5). 8 Ibid. 9 Cf. Rahimi 2021 (op. cit. note 6). 10 Kubra Khademi dans un entretien avec Bettina Wohlfarth, p. 68–69 de la présente publication, p. 68. 11 Dans des peintures précédentes, elle a ailleurs largement abordé l'histoire des femmes de sa famille, comme sa grand-mère par exemple. Elle a présenté celle-ci de manière saisissante dans la performance Kubra Khademi – I will Greet the Sun Again au Bozar Centre for Fine Arts de Bruxelles. Voir à ce sujet : Palais des beaux-arts de Bruxelles, Kubra Khademi / Live Performance / BOZAR (22 octobre 2020), https://www.youtube.com/watch?v=Hvz98mH3bkE [consulté le 31 janvier 2022]. 12 Kubra Khademi dans un entretien avec Bettina Wohlfarth, p. 68–69 de la présente publication. 13 Kubra Khademi dans un entretien avec l'autrice, janvier 2022. 14 Kubra Khademi, citée in : Ana Bordenane, The Political Poetics of Kubra Khademi (s. d.), https://galeriejoseph.com/en/2021/12/02/the-political-poetics-of-kubra-khademi/ [consulté le 31 janvier 2022]. 15 « Kubra Khademi. Wahrheit des Körpers », in Lettre International 134, 2021, p. 5.

PERFORMANCEKUNST UND KAMPF
PERFORMANCE AND COMBAT
PERFORMANCES ET COMBAT

For a long time to come, Kubra Khademi will remain that young artist who, on February 26, 2015, embodied the resistance of women to religious fanaticism and to the political regimes that tyrannize them. For eight minutes, she walked down a crowded street in the Kote Sangi district of Kabul, dressed in black. Over her clothes, she wore metal armor; according to her narrative, "I made the armor using a gas cooker and a hammer. I worked on it for an hour every day over a month." This armor both protected and exaggerated her breasts, her stomach, and her buttocks. She gave her performance the title of *Armor* (fig. 1, cat. 2). The video images and photographs show the mocking or violent actions of the men as they walked by or passed on their motorbikes. They crowd together, they jostle to see her, they shout insults. The performance was intended to last ten minutes, but it lasted only eight, when Khademi was forced to cut her walk short to get into a car and leave the scene.

Looking at these images today, three things jump out at you. First of all, the most obvious: The meaning of *Armor* and its provocative power were immediately understood by the crowd. Second: The overwhelming unanimity of the hostile reactions. And finally: These were launched by men of all ages, with adolescents among them. There can be no doubt that not all of them are Taliban or Taliban supporters, but they nevertheless all agree that it is scandalous for a woman to wear this armor to denounce the groping and harassment that Afghan women have to endure so frequently, and that Khademi herself experienced while she was still a child and never forgot.[1] If she had not escaped, she would have been at serious physical risk. Only a few hours later, she could see that these eight minutes had turned her into a public enemy. In 2020, she stated: "When I saw, on the same evening in all the Afghan social media that my performance had been an insult to Islam, I knew that I was in danger of death."[2] She escaped from Afghanistan and reached France.

Für lange Zeit wird Kubra Khademi als die junge Künstlerin im Gedächtnis bleiben, die am 26. Februar 2015 zum Symbol weiblichen Widerstands gegen religiösen Fanatismus und ein die Rechte der Frauen missachtendes politisches Regime wurde. Acht Minuten lang spazierte sie durch eine bevölkerte Straße im Kote-Sangi-Viertel in Kabul und trug dabei über ihrer schwarzen Kleidung einen mit Gasbrenner und Hammer selbst gefertigten Metallharnisch. Ihre Brüste, ihr Bauch und ihr Gesäß wurden durch diese Rüstung zugleich geschützt und herausgestellt. Der Titel dieser Performance lautete *Armor* (Abb. 1, Kat. 2). Auf Videoaufnahmen und Fotografien sind die verhöhnenden, obszönen, bis zur Gewaltandrohung reichenden Reaktionen der Männer zu sehen, die ihr zu Fuß oder auf Motorrädern begegnen. Sie brüllen Beleidigungen, bedrängen sie gaffend. Khademi muss die auf zehn Minuten angelegte Performance bereits nach acht Minuten abbrechen, sich in ein Auto flüchten und den Schauplatz verlassen.

Betrachtet man die Bilder heute, so springen einem drei Dinge besonders ins Auge. Zunächst einmal, dass der Inhalt von *Armor* und die provozierende Stoßrichtung der Performance von der Menge sofort verstanden werden. Zweitens fällt die Einhelligkeit der feindseligen Reaktionen auf. Und schließlich belegen die Bilddokumente, dass die Schmähungen und Beleidigungen von Männern allen Alters vorgebracht werden, darunter auch Heranwachsende. Es scheint sich dabei keineswegs nur um Taliban oder Anhänger der Taliban zu handeln, doch alle eint die Empörung darüber, dass eine Frau durch das Tragen eines solchen Harnischs auf die sexuellen Belästigungen und Übergriffe hinweist, die afghanische Frauen häufig erleiden müssen und die auch Khademi bereits als Kind widerfahren sind.[1] Wäre sie den Männern auf der Straße nicht entkommen, hätte sie mit schwerer körperlicher Gewalt rechnen müssen. Wenige Stunden später war klar, dass diese acht Minuten aus ihr eine Staatsfeindin gemacht hatten. „Noch am selben Abend konnte ich auf allen afghanischen Social-Media-Kanälen lesen, dass

Pour longtemps, Kubra Khademi demeurera cette jeune artiste qui, le 27 février 2015, a incarné la résistance des femmes aux fanatismes religieux et aux régimes politiques qui les tyrannisent. Pendant huit minutes, elle marche dans une rue bondée du quartier de Kote Sangi, à Kaboul, vêtue de noir. Sur ses vêtements elle porte une armure de métal qu'elle a confectionnée chez elle avec une gazinière et un marteau. Cette armure protège et exagère ses seins, son ventre et ses fesses. Elle donne son titre à la performance, *Armor* (ill. 1, cat. 2). Les images vidéo et photographiques montrent les réactions railleuses ou violentes d'hommes qui passent à moto ou marchent. Ils s'attroupent, ils se bousculent pour voir, ils crient des insultes. La performance devait durer dix minutes, mais n'en dure que huit, Khademi étant contrainte d'abréger sa marche pour se réfugier dans une voiture et quitter les lieux.

À qui regarde ces images aujourd'hui, trois faits sautent aux yeux. D'abord, cette évidence : le sens d'*Armor* et sa puissance provocatrice sont immédiatement compris par la foule. Puis cette deuxième : l'accablante unanimité des réactions hostiles. Et enfin : elles sont lancées par des hommes de tous âges, parmi lesquels des adolescents. Sans doute ne sont-ils pas alors tous des talibans ni des partisans de ceux-ci, mais ils n'en sont pas moins d'accord pour juger scandaleux qu'une femme dénonce par le port de cette cuirasse les attouchements et harcèlements que les Afghanes endurent si fréquemment et dont Khademi a fait elle-même enfant l'expérience indélébile[1]. Si elle ne s'était échappée, elle aurait couru des risques physiques graves. Quelques heures suffisent pour qu'elle puisse mesurer que ces huit minutes ont fait d'elle une ennemie publique. « *Quand j'ai vu le soir même, sur tous les réseaux sociaux afghans, que ma performance était une insulte à l'islam, j'ai su que j'étais en danger de mort* », disait-elle en 2020[2]. Exfiltrée d'Afghanistan, elle rejoint la France.

Ces faits sont aujourd'hui si largement connus qu'*Armor* est devenu une légende. Les évènements ultérieurs n'ont fait que conférer à la performance une très forte valeur

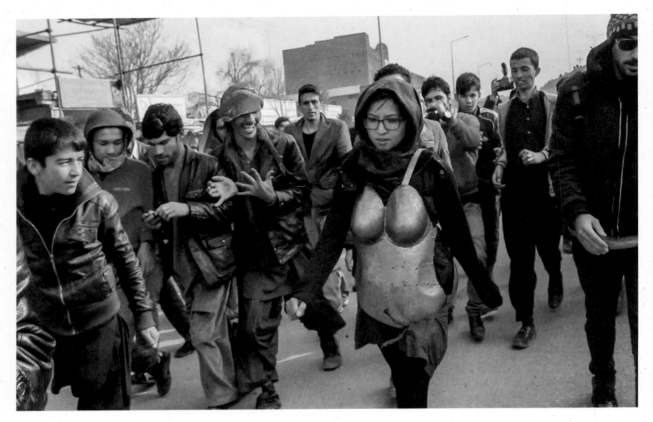

1 ەرز, *Armor*, 2015 (Cat. | Kat. 2)

Today, these facts are so widely known that *Armor* has become a legend. Subsequent events have invested the performance with an extraordinarily strong symbolic value that is both specific and universal. Specific, because since then Afghanistan has fallen back into the hands of the Taliban and prohibitions on all forms of freedom for women have become more systematic. What Khademi denounced in July 2021 and fought against by ardently taking part in operations that made it possible for men and women, who would otherwise have been doomed to face the worst, to take off from Kabul Airport is now happening for all the world to see: being born female in Afghanistan is, once again, a curse. But the meaning of *Armor* is also universal because is it possible to name any country where harassment and sexism are unknown?

The power of this charge lies in the fact that in *Armor* the visible expression and the moral and political significance are in complete agreement. This agreement explains its repercussion and rapid inscription in the history of performance, as much as in that of feminist struggles. It is important to remember that these two histories are inseparable and have been so since the early days of performance art around 1960 when these actions were more often referred to as *happenings*. It would be no exaggeration to state that performance art is partly born of feminist demands.

To make this clear, we have to distinguish between actions that take place in the presence of a few people, in a studio or other enclosed space, and those that are carried out in front of what is more than an audience, since it is suggested that they intervene as the performance unfolds. This simple typology, which will also apply to Khademi, corresponds to different situations and varying degrees of danger. The category of actions performed without the presence or participation of outsiders includes pieces that have become milestones in the critical work on the female nude, sexuality, fantasies, and

mein Auftritt eine Beleidigung des Islam gewesen sei – und da wusste ich, dass ich in Lebensgefahr war", erzählte sie 2020 in einem Gespräch.[2] Heimlich wurde sie außer Landes gebracht und gelangte schließlich nach Frankreich.

Diese Geschehnisse sind heute so bekannt, dass *Armor* nachgerade legendär geworden ist. Im Licht der jüngsten Ereignisse kommt Khademis Performance eine nochmals verstärkte Symbolkraft zu, ganz konkret und allgemein. Ganz konkret, weil Afghanistan erneut unter der Herrschaft der Taliban steht und die Freiheiten für Frauen dort wieder systematisch eingeschränkt werden – eine sich unter den Augen der Weltöffentlichkeit vollziehende Entwicklung, auf die Khademi im Juli 2021 klar und deutlich hingewiesen hat. Im August 2021 beteiligte sie sich maßgeblich an einer Rettungsaktion aus Kabul, bei der Frauen und Männer, die ohne diese Hilfe das Schlimmste zu befürchten hatten, gerade noch rechtzeitig ausgeflogen werden konnten. In Afghanistan als Frau geboren zu sein, kommt seither wieder einem Fluch des Schicksals gleich. Doch ist *Armor* auch von allgemeiner symbolischer Bedeutung, denn welches Land der Welt könnte von sich behaupten, keinen Sexismus und keine sexuelle Belästigung von Frauen zu kennen?

Die Macht der Anklage in *Armor* resultiert aus der vollständigen, augenblicklich vollzogenen Gleichsetzung von visuellem Ausdruck und moralisch-politischer Aussage. Diese Deckungsgleichheit erklärt die breite Rezeption des Werks, das schnell Eingang in die Geschichte der Performance wie auch des Feminismus fand. Dabei gilt es sich in Erinnerung zu rufen, dass Performance und Feminismus voneinander untrennbar sind, nicht erst heute, sondern bereits seit den Anfängen der Performancekunst – damals häufig noch mit dem Begriff *Happening* bezeichnet – in den 1960er-Jahren. Ohne Übertreibung lässt sich behaupten, dass die Gattung der Performance zumindest in Teilen aus dem Feminismus entstanden ist.

Um der größeren Klarheit willen soll hier zwischen Performances unterschieden werden, die sich in Anwesenheit weniger Menschen in einem Atelier oder einem anderen geschlossenen Ort abspielen, und solchen, die ihre endgültige Form erst in

symbolique, à la fois particulière et universelle. Particulière, parce que depuis lors, l'Afghanistan est retombé sous le pouvoir taliban et que les interdictions de toute forme de liberté imposées aux femmes n'ont fait que s'aggraver systématiquement. Ce que Khademi a dénoncé en juillet 2020, et qu'elle a combattu en participant ardemment aux opérations qui ont permis au mois d'août de faire décoller de l'aéroport de Kaboul des femmes et des hommes voués sans cela au pire, est en train de se produire à la vue du monde entier : naître de sexe féminin en Afghanistan est à nouveau une malédiction. Mais le sens d'*Armor* est aussi universel, car de quel pays pourrait-on affirmer que le harcèlement et le sexisme y sont inconnus ?

La puissance de la charge tient donc à ce que, dans *Armor*, l'adéquation est totale et instantanée entre l'expression visible et la signification morale et politique. Cette adéquation explique son retentissement et sa rapide inscription dans l'histoire de la performance autant que dans celle des luttes féministes. Or il importe de le rappeler : ces deux histoires sont inséparables et le sont depuis l'apparition de la performance – alors plus souvent désignée par le terme *happening* – autour de 1960. Il ne serait pas excessif d'affirmer que la performance naît pour partie de la revendication féministe.

Pour l'établir clairement, on doit distinguer entre les actions qui se déroulent en présence de peu de personnes, dans un atelier ou tout autre lieu fermé, et celles qui s'accomplissent devant ce qui est plus qu'un public puisqu'il lui est proposé d'intervenir dans le déroulement de la performance. À cette typologie simple, qui s'appliquera aussi à Khademi, correspondent des situations différentes et des degrés de danger inégaux. De la catégorie des actions réalisées sans présence ni participation extérieure relèvent des œuvres qui ont fait date dans le travail critique sur le nu féminin, la sexualité, les fantasmes et les interdits : en 1963, *Eyebody* de Carolee Schneemann, répertoire photographique de stéréotypes joués sur un mode délibérément outrancier ; en 1964, de la

2 حوا, *Eve is a seller*, 2018, Performance at the Molenbeek market | auf dem Markt in |
au marché de Molenbeek, Brussels | Brüssel | Bruxelles

the forbidden: In 1963 Carolee Schneemann's *Eye Body*, a photographic repertoire
of stereotypes played in a deliberately outrageous manner; in 1964 the same artist's
Meat Joy, a ballet of food and sexuality between burlesque and disgust; and in 1969
Aktionshose: Genitalpanik (*Action Pants: Genital Panic*) by VALIE EXPORT, a performed
photograph of the terror of the female sex organ.

The best-known performance in the second category, which involves exposing the
performer's body to unpredictable reactions and gestures, is Yoko Ono's *Cut Piece*, which
she tried out in 1964 and repeated in the following year. Its principle is not unrelated to
that of *Armor*. For *Cut Piece*, Ono, who was dressed in a sober suit, asked members of the
audience to come and cut off pieces of her clothing with scissors, a symbolic gesture
of the body's being laid bare. Ono seemed to be offering her nudity to anybody who
would go as far as destroying the garment, while Khademi, symmetrically, sets a breast-
plate against the impulse to see and touch the undressed woman. She enraged passers-
by and had to flee, just as Ono in 1964 aroused increasingly uncontrollable excitement
and had to interrupt the performance when a man tried to expose her breasts. Violence
was aroused just as quickly in both cases. *Cut Piece* was followed by other female per-
formances that appeared unexpectedly in the city: Starting in 1967, the sudden burst

Gegenwart eines Publikums finden, dessen Mitwirken für den Ablauf der Performance unabdingbar ist. Diese einfache Typologie, die auch auf Khademi anwendbar ist, lässt sich je nach spezifischer Situation und Gefährlichkeitsgrad weiter auffächern. Zur Kategorie der ohne Anwesenheit oder Mitwirkung eines Publikums verwirklichten Aktionen zählen Werke, die als wegweisend für die Auseinandersetzung mit den Themen des weiblichen Körpers, der Sexualität, erotischer Fantasien und Tabus angesehen werden, wie etwa Carolee Schneemanns *Eye Body*, eine fotografische Abfolge von ins Extreme übersteigerten Stereotypen aus dem Jahr 1963, oder ihre Performance *Meat Joy* von 1964, ein Tanz der Nahrungsaufnahme und Sexualität, angesiedelt zwischen Burleske und Ekel. Auch VALIE EXPORTs fotografische Serie *Aktionshose: Genitalpanik* von 1969, in der sie die Furcht vor weiblicher Sexualität zum Thema macht, ist dem ersten Typus zuzurechnen. Die bekannteste Performance der zweiten Kategorie, in der eine Künstlerin ihren Körper den unvorhersehbaren Reaktionen des Publikums aussetzt, ist *Cut Piece* von Yoko Ono, uraufgeführt 1964 und im folgenden Jahr wiederholt. Ähnlichkeiten zu *Armor* lassen sich dabei durchaus feststellen. In *Cut Piece* lädt die Künstlerin im schwarzen Kostüm das Publikum dazu ein, mit einer Schere Stofffetzen aus ihrer Kleidung herauszuschneiden – eine symbolische Geste der Entblößung des Körpers. Während Yoko Ono sich dem Publikum, das an diesem Prozess mitwirkt, mehr und mehr in ihrer Nacktheit darzubieten scheint, widersetzt sich Khademi mit ihrem Harnisch all jenen, die nur zu gerne eine nackte Frau sehen und berühren wollen. Sie muss daraufhin vor einer aufgebrachten Männerhorde fliehen, wie auch Yoko Ono 1964 bei zunehmend aufgeheizter Stimmung ihre Performance abbricht, als ein Mann tatsächlich ihre Brust entblößen will. In beiden Fällen kippt die Atmosphäre schnell in Gewalt um. Auf *Cut Piece* folgen weitere wegweisende Performances von Künstlerinnen als unangekündigte Auftritte im städtischen Raum, ab 1967 etwa die Interventionen auf New Yorker Straßen von Yayoi Kusama und ihrer Performancegruppe junger Frauen und Männer, deren nackte Körper mit Farbpunkten be-

même, *Meat Joy*, ballet de la nourriture et de la sexualité entre burlesque et dégoût ; en 1969, *Aktionshose: Genitalpanik (Action pantalon : panique génitale)* de VALIE EXPORT, photographie performée de la terreur du sexe féminin. De la deuxième catégorie, qui suppose l'exposition du corps de la performeuse à des réactions et des gestes imprévisibles, la performance la plus connue est la *Cut Piece* de Yoko Ono, expérimentée en 1964, recommencée l'année suivante. Son principe n'est pas sans rapport avec *Armor*. Pour la *Cut Piece*, Ono, vêtue d'un tailleur sobre, propose à l'assistance de venir découper avec des ciseaux des morceaux de son costume, geste symbolique de la mise à nu du corps. Ono semble ainsi offrir sa nudité à qui ira jusqu'au terme de la destruction du vêtement, et, symétriquement, Khademi oppose une cuirasse à la pulsion qui veut voir et toucher la femme déshabillée. Elle met en rage les passants et doit fuir, de même qu'en 1964, Ono suscite une excitation de moins en moins maîtrisable et doit interrompre la performance quand un homme prétend dénuder sa poitrine. La violence naît aussi vite dans l'un et l'autre cas. Après la *Cut Piece* viennent d'autres performances au féminin qui surgissent à l'improviste dans la ville : à partir de 1967 les irruptions de la nudité dans l'espace public new-yorkais de Yayoi Kusama et de son groupe de jeunes femmes et hommes aux corps ponctués de points de couleur, puis le *TAPP und TASTKINO (Cinéma du toucher)* de VALIE EXPORT en pleine rue viennoise en 1968 qui propose de caresser ses seins en passant les mains à travers un rideau. Plus tard viennent la *Rape Scene* d'Ana Mendieta en 1973 et, sur le principe de la *Cut Piece*, *Rythme II* de Marina Abramovic en 1974, qui livre son buste aux atteintes que peuvent lui infliger ceux qui se saisissent des objets placés sur une table devant elle. Cet inventaire, non exhaustif, suffit à vérifier combien la performance est, depuis ses débuts, associée au sujet non seulement de la femme en tant qu'artiste, mais encore de la femme en tant qu'être humain dont la liberté et la sécurité sont menacées. En son temps, dans la situation afghane dont elle

44

of nudity in the public space by Yayoi Kusama and her team of young men and women whose bodies were dotted with color, then VALIE EXPORT's *TAPP und TASTKINO* (*TOUCH and TAP CINEMA*) in the middle of a street in Vienna in 1968, when she offered people the opportunity to caress her breasts after they had passed their hands through a curtain. Ana Mendieta's *Rape Scene* came later in 1973, followed in 1974 by Marina Abramović's *Rhythm 0*, based on the principle of *Cut Piece*, in which Abramovic was subjected to the attacks of those people who picked up objects placed on a table in front of her.

This nonexhaustive inventory is sufficient to verify how much performance art—since its beginnings—has been linked to the subject of women not only as artists but also as human beings whose freedom and security are threatened. In her time in the situation in Afghanistan of which she was a victim, Khademi reactivated gestures of this kind, taking the greatest risk—that of intervention on the street. In this way, she renewed the original alliance of performance and the feminist struggle, while inventing situations that were her own.

Some of them took place in closed and protected spaces, others in open and potentially dangerous locations, in keeping with the typology in question. *The Moist Realities* (2013) is placed in the open category: She settles down to read on a rug with a few accessories around her; she is not in a park as might be expected but on the pavement of an access road to a motorway in Lahore, where she disrupts the traffic and asserts the incongruous image of a young woman at work between the cars and motorbikes brushing past her. She stays there for 45 minutes. Little needs to be said about the provocative force of this gesture. She continued in this genre between incongruity and challenge in Europe. Shortly after arriving in France, she walked through the city where she now lives for fifteen hours: *From Sunrise to Sunset in Paris*. What the title does not

malt sind. VALIE EXPORT tritt 1968 auf Wiener Straßen mit ihrem *TAPP und TASTKINO*
auf, bei dem sie Passanten auffordert, die Hände durch einen Vorhang zu stecken und
ihren Busen zu streicheln. Später kommen *Rape Scene* (1973) von Ana Mendieta und –
nach dem Prinzip von *Cut Piece* – die Performance *Rhythm 0* (1974) von Marina Abramo-
vic hinzu, die ihren Körper dabei für sämtliche Handlungen zur Verfügung stellt, die an
ihr mittels der auf einem Tisch ausgebreiteten Gegenstände vollführt werden können.

Diese keineswegs vollständige Auflistung mag genügen, um zu belegen, wie sehr
die Performance seit ihren Anfängen nicht nur mit dem Thema der Frau als Künstle-
rin, sondern auch mit der Forderung nach Freiheit und körperlicher Unversehrtheit von
Frauen verbunden ist. Khademi greift im Rahmen der gegenwärtigen politischen und
gesellschaftlichen Situation in Afghanistan, deren Opfer sie ist, auf solche Performance-
gesten zurück und geht mit der Entscheidung für eine Intervention auf der Straße das
höchste nur denkbare Risiko ein. Indem sie eigene Szenarien erfindet, erneuert sie die
ursprüngliche Verbindung zwischen Performance und feministischem Aktivismus.

Gemäß der eingeführten Typologie lassen sich Khademis Performances unter-
teilen in Aktionen, die in geschützten, geschlossenen Räumen durchgeführt werden,
und andere, die an öffentlichen Orten mit Gefahrenpotenzial stattfinden. Letzteres ist

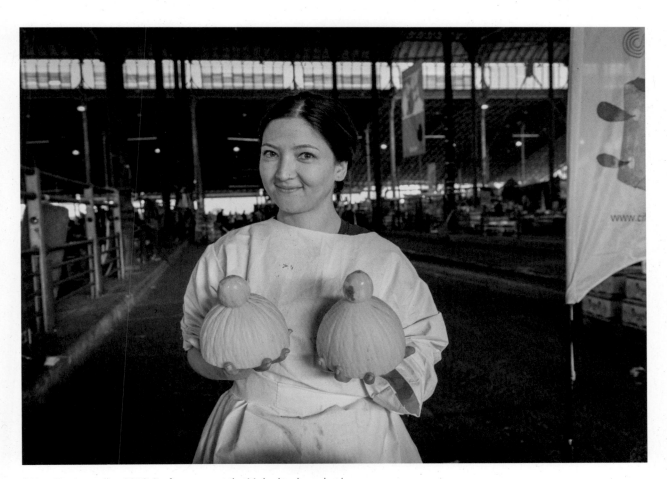

3 حوا, *Eve is a seller*, 2018, Performance at the Molenbeek market |
auf dem Markt in | au marché de Molenbeek, Brussels | Brüssel | Bruxelles

est la victime, Khademi réactive de tels gestes, en prenant le risque le plus élevé, celui
de l'intervention de rue. Ainsi renouvelle-t-elle l'alliance première de la performance et
du combat féministe tout en inventant des situations qui lui sont propres.

Les unes se situent dans des espaces clos et protégés, d'autres dans des lieux
ouverts et potentiellement dangereux, selon la typologie que l'on a proposée. Du
côté de l'ouvert, se place en 2013 *The Moist Realities* : elle s'installe pour lire sur un

reveal is that she was dressed in Afghan style with a bundle of folded clothes on her head. An image of this half-initiatory, half-allegorical journey was hung on the wall of the studio she occupied for a time in Romainville: the moment when she passes the Louvre Pyramid. The symbolic significance of the place is obvious. In 2018, in *Eve is a seller* (figs. 2, 3), she played a grocer in the market in Molenbeek, the district in Brussels where the attacks of November 13, 2015, in Paris and March 22, 2016, in Brussels were planned. At the stall, she arranges fruit and vegetables in a way that suggests female and male anatomies, and places two melons against her breasts. She says: "I was the only woman at the market; at first, it was a bit tense."[3]

The analogy between human anatomy and vegetables was repeated in *Transition through reproach valley* in 2020, but this performance, in which the bodies were almost naked, was carried out with art-school students in places devoted to artistic creation in Lyon and Paris. As disturbing as this reflection on the disasters plaguing our planet might be, it does not assume outside intervention. This other conception of a performance—in a location destined for it—was implemented in *18 kg* in 2018, *Quanchiq* in 2018, and *Reperformance* in the same year. The last mentioned has some relationship with a theatrical performance: In a basic but meaningful set—carpet, pedestal tables, coatrack—and simple props—crutches, bowls, shawl, black tunic—Khademi performs sketches from the childhood of a little girl who plays with a doll, dances by herself, imagines life "when I grow up," and draws. She was forbidden to carry out this last activity when she was young, and her mother punished her brutally when she discovered her drawings that were badly hidden in the house, because drawing was considered to be ungodly. Her fate was to be subjected to the ancestral order, which is crudely symbolized in *Quanchiq*: Khademi, with a dog collar around her neck, is put on a chain like a domestic animal, which is pretty much the traditional status given to women. She is doomed to serve and give birth, regardless of her own desires and will. *18 kg* (fig. 4)

2013 bei ihrer Performance *The Moist Realities* der Fall: Khademi lässt sich dafür mitsamt Zubehör zum Lesen und Arbeiten auf einem Teppich nieder, jedoch nicht wie zu erwarten wäre in einem Park, sondern mitten auf der Fahrbahn einer breiten Ausfallstraße in Lahore. Als Verkehrshindernis bietet sie den irritierenden Anblick einer jungen Frau, die zwischen Autos und Motorrädern unbeirrt ihrer Arbeit nachgeht. Khademi hält ihre Performance eine Dreiviertelstunde lang durch. Welch provokatorische Kraft in dieser Geste liegt, bedarf keiner weiteren Erläuterung. Auch in Europa fährt Khademi zwischen Irritation und Herausforderung mit ihren Aktionen fort. Kurz nach ihrer Ankunft in Paris spaziert sie 15 Stunden lang durch die Stadt, in der sie künftig leben wird, und nennt ihre Performance: *From Sunrise to Sunset in Paris*. Nicht zu entnehmen ist dem Titel, dass sie dabei afghanisch gekleidet ist und auf dem Kopf ein Bündel mit Kleidungsstücken trägt. An der Wand des Ateliers, das ihr eine Zeit lang in Romainville zur Verfügung stand, hing damals ein Foto dieses initiatorischen und allegorischen Gangs durch Paris: Darauf ist der Moment zu sehen, in dem sie an der Glaspyramide des Louvre vorbeigeht. Die symbolische Aussagekraft des Ortes ist offensichtlich. 2018 spielt sie in *Eve is a seller* (Abb. 2, 3) eine Marktfrau in Molenbeek, dem Brüsseler Viertel, in dem die terroristischen Attentate vom 13. November 2015 in Paris und vom 22. März 2016 in Brüssel geplant wurden. Obst und Gemüse hat sie an ihrem Stand so angeordnet, dass es an weibliche und männliche Geschlechtsorgane erinnert, und sie hält sich zwei Melonenhälften vor die Brust. „Ich war dort die einzige Marktfrau", erzählt sie. „Anfangs war es etwas angespannt."[3]

Die Analogie zwischen menschlicher Anatomie und Früchten bzw. Gemüse findet sich auch in *Transition through reproach valley* von 2020, doch wird die Performance – mit diesmal beinahe nackten Körpern – von Kunststudierenden in Lyon und Paris aufgeführt und an Stätten, die dem Kunstschaffen gewidmet sind. Khademis verstörende Reflexion über die Verheerung unseres Planeten ist außerdem nicht darauf angelegt, dass von außen eingegriffen werden könnte. Das Prinzip einer für einen dafür vorge-

tapis avec quelques accessoires, non dans un parc comme on pourrait s'y attendre, mais sur la chaussée d'une bretelle autoroutière de Lahore, perturbe la circulation et impose l'image incongrue d'une jeune femme travaillant entre les automobiles et les motos qui la frôlent. Elle s'y maintient 45 minutes. Il est inutile d'insister sur la force provocatrice de ce geste. Elle continue dans ce genre, entre incongruité et défi, en Europe. Peu après son arrivée en France, elle marche 15 heures dans la ville où elle vit désormais : *From Sunrise to Sunset in Paris*. Ce que le titre ne précise pas c'est qu'elle est habillée à l'afghane et porte sur la tête un ballot de vêtements pliés. Au mur de l'atelier qu'elle a occupé un temps à Romainville était fixée une image de ce trajet mi initiatique, mi allégorique : le moment où elle passe près de la pyramide du Louvre. La portée symbolique de l'endroit est flagrante. En 2018, dans *Eve is a seller* (ill. 2, 3), elle joue l'épicière au marché de Molenbeek, quartier de Bruxelles où furent préparés les attentats du 13 novembre 2015 à Paris et du 22 mars 2016 à Bruxelles. Sur l'étal, elle dispose fruits et légumes de manière à suggérer anatomies féminines et masculines et plaque contre ses seins deux melons. « J'étais la seule femme du marché, raconte-t-elle. Au début, c'était un peu tendu[3]. »

L'analogie entre anatomie humaine et légumes se retrouve dans *Transition through reproach valley* en 2020, mais cette performance où les corps sont presque nus est exécutée avec des élèves d'écoles d'art dans des lieux dévolus à la création artistique, à Lyon et à Paris. Si perturbante soit cette réflexion sur les désastres qui accablent la planète, elle ne suppose pas d'interventions extérieures. Cette autre conception de la performance, dans un endroit destiné à la recevoir, est mise en œuvre dans *18 kg* en 2018, *Quanchiq* en 2018 et, la même année, dans *Reperformance*. Cette dernière a quelque parenté avec un spectacle théâtral : dans un décor sommaire mais explicite – tapis, guéridons, porte-manteaux – et des accessoires simples – béquilles, bols, châle,

48

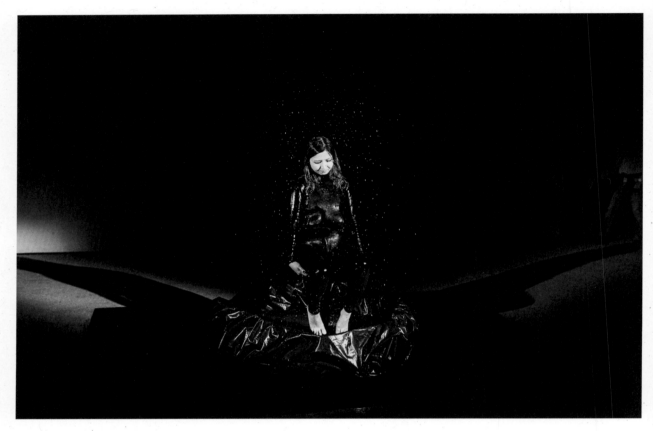

4 *18 kg*, 2018, Performance at | im | au Palais de Tokyo, Paris, Festival DoDisturb

alludes to this by showing the artist slowly emptying herself of a mass of water weighing her down.

Khademi continues to deconstruct the discourses that reduce women to obedience, to ancillary tasks, and repeated motherhood through the conception and execution of performances charged with her autobiography and collective symbols. She has experienced the danger inherent in these gestures when they are risked on the street. She has found concentrated forms between performance and theater which sometimes push the expression to the point of the unbearable and sometimes to the kind of tragicomic that gives rise to unease. Since 2020 and *Let us believe in the beginning of the hot season* (fig. 5), which she realized together with the American artist Daniel Pettrow, she has added a third mode of creation—performed photography—with ultra-touristy landscapes, typical costumes, and unambiguous postures. As the images unfold, she portrays a prominent Afghan with Pettrow as a North American politician; from the parody of televised discussions to sexual postures, it is tempting to decipher them as satires on the relationship between the two countries. There can be no doubt that she is not yet finished with the resources offered by these practices or that she knows how to take them to the highest level like Ono, Schneemann, VALIE EXPORT, and Mendieta did before her.

sehenen, geschlossenen Raum konzipierten Performance verwirklicht Khademi auch in *18 kg* von 2018 sowie in *Quanchiq* und *Reperformance* von 2018, wobei Letztere Ähnlichkeit mit einem Bühnenstück aufweist: Inmitten eines sparsamen, jedoch aussagekräftigen Dekors – Teppich, Tischchen, Garderobenständer – und mithilfe einfacher Requisiten wie Krücken, Schüsseln, Schultertuch und schwarzer Tunika stellt Khademi Kinderszenen nach: Ein Mädchen spielt mit seiner Puppe, tanzt, malt sich sein Leben aus, „wenn es einmal groß ist", und zeichnet. Khademi selbst war Zeichnen als kleines Mädchen verboten. Ihre Mutter verprügelte sie, als sie ihre ungeschickt versteckten Zeichnungen entdeckte, denn Zeichnen galt als Gotteslästerung. Ihr Schicksal sollte darin bestehen, sich der althergebrachten Ordnung zu unterwerfen. In aller Deutlichkeit kommt dies in der Performance *Quanchiq* zum Ausdruck, in der die Künstlerin mit einem Hundehalsband wie ein Haustier angeleint ist – der Rolle entsprechend, die Frauen in Afghanistan traditionellerweise zukommt. Sie sollen dienen und Kinder gebären, ohne Rücksicht auf ihren eigenen Willen oder ihr eigenes sexuelles Begehren. Auch *18 kg* (Abb. 4) spielt darauf an und zeigt die Künstlerin, wie sie sich allmählich von der schweren Wassermasse befreit, die sie niederdrückt.

In Konzeption und Ausführung ihrer Performances, die voller kollektiver Symbole, aber auch Anspielungen auf ihre eigene Biografie sind, verfolgt Khademi die Dekonstruktion der Diskurse, welche die Frauen auf Gehorsam gegenüber den Männern, auf Haushaltspflichten und vielfache Mutterschaft reduzieren. Die Gefährlichkeit dieser Aktionen auf offener Straße hat sie am eigenen Leib erlebt. Die verdichteten Formen zwischen Performance und Theater, die sie für sich gefunden hat, steigern den Gefühlsausdruck ins Unerträgliche oder führen eine Tragikomik vor, die ebenfalls Unwohlsein hervorruft. Seit dem Projekt *Let us believe in the beginning of the hot season* (Abb. 5), das sie gemeinsam mit dem amerikanischen Künstler Daniel Pettrow 2020 verwirklicht hat, kommt bei ihr ein dritter Typus hinzu, nämlich die performative Fotografie – mit Selbstinszenierungen inmitten touristischer Hochglanzlandschaften, in landestypischer

tunique noire –, Khademi interprète des saynètes de l'enfance d'une petite fille qui joue avec un poupon, danse seule, imagine sa vie « quand elle sera grande » et dessine. Cette dernière activité lui était interdite quand elle était cette fillette, que sa mère punit brutalement quand elle découvrit ses dessins mal cachés dans la maison parce que dessiner aurait été impie. Son destin était d'être soumise à l'ordre ancestral, ce que symbolise avec crudité *Quanchiq* : Khademi, un collier de chien au cou, attachée à une chaîne tel un animal domestique, ce qui est à peu près le statut accordé à la femme selon la tradition – elle est vouée à servir et à enfanter, sans considération de son désir et de sa volonté. *18 kg* (ill. 4) y fait allusion en montrant l'artiste se vider lentement de la masse d'eau qui l'alourdit.

Ainsi Khademi poursuit-elle, par la conception et l'exécution de performances chargées d'autobiographie et de symboles collectifs, la déconstruction des discours qui réduisent la femme à l'obéissance, aux tâches ancillaires et à des maternités à répétition. Elle a fait l'expérience du danger inhérent à ces gestes quand ils sont aventurés dans la rue. Elle a trouvé des formes concentrées, entre performance et théâtre, qui poussent l'expression tantôt jusqu'à l'insupportable, tantôt jusque vers une sorte de tragi-comique qui suscite le malaise. Depuis 2020 et *Let us believe in the beginning of the hot season* (ill. 5), qu'elle réalise avec l'artiste américain Daniel Pettrow, elle ajoute un troisième mode de création, la photographie performée, avec paysages ultra touristiques, costumes typiques et postures sans équivoques. Au fil des images, elle joue un notable afghan et Pettrow un politicien nord-américain, de la parodie des discours télévisés à des postures sexuelles qu'il est tentant de décrypter comme autant de figures satiriques des relations entre les deux pays. Il ne fait aucun doute qu'elle n'en a pas fini avec les ressources de ces pratiques, qu'elle sait porter à leur paroxysme, comme l'ont fait Ono, Schneemann, VALIE EXPORT ou Mendieta.

50

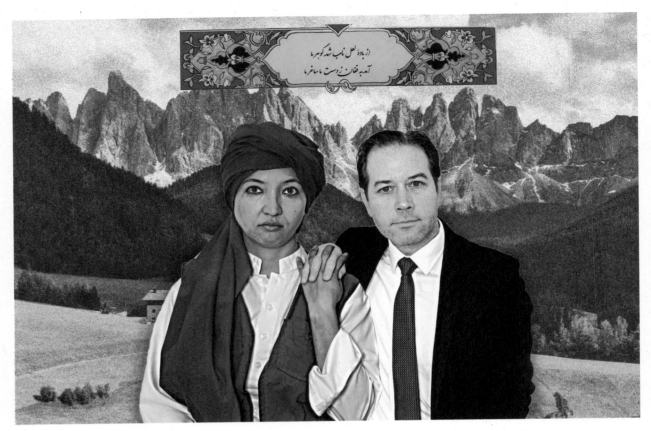

5 Kubra Khademi and | und | et Daniel Pettrow, ایمان بیاوریم به آغاز فصل داغ 2021, از باده لعل ناب شد گوهر شد گوهر ما,
Let us believe in the beginning of the hot season, Photo collage on | Fotocollage gedruckt auf | photomontage sur
Hahnemühle Brillant baryta 325g, 100 × 67 cm, property of the artists | Eigentum der Künstlerinnen | propriété des artistes,
Galerie Eric Mouchet, Paris, France | Frankreich

I would like to close with one final observation. It is rightly said that, in the 1960s and 1970s, female performers used their bodies as means of expression all the more intensely because the art world of that period was almost exclusively that of male artists who practiced painting and sculpture in one form or other. With rare exceptions, such as Louise Bourgeois, Joan Mitchell, Germaine Richier, and Niki de Saint Phalle—some of whom did not receive recognition until later—women painters were almost completely absent from exhibitions, museums, and the art market. Under these conditions, performance art seemed to be more accessible to female artists and freed them from the male tutelage that bore down on painting and sculpture. Being a performer and feminist made sense as the two notions went hand in hand and reinforced each other. Today, this is no longer the case for Khademi. In a quite different artistic situation than in the past, drawing and painting are no longer tacitly reserved for male artists. She is therefore simultaneously, and in a complementary and coherent manner, the performer we have presented and the person who executes gouaches on paper in which she continues her liberating work with such resoluteness.

1 "I was raped at the age of five. Unfortunately, that is more common than you think. I regret not having iron knickers." In *Kharmohra: L'Afghanistan au risque de l'art | Art under Fire in Afghanistan*, ed. Guilda Chahverdi and Angès Devictor, exh. cat. Mucem (Arles: Actes Sud, 2019), 70. 2 Interview with the artist, December 20, 2020. 3 Interview with the artist, July 5, 2021.

Kostümierung und in eindeutiger Gestik. Im Verlauf der Bilderfolge spielt Khademi einen afghanischen Würdenträger und Pettrow einen nordamerikanischen Politiker, von der Parodie auf Fernsehdiskussionen bis hin zu sexuellen Posen, die möglicherweise als satirische Darstellung der Beziehungen zwischen den beiden Ländern aufzufassen sind. Es besteht kein Zweifel, dass die Künstlerin die Möglichkeiten der Performance noch bei Weitem nicht ausgeschöpft hat. Wie Yoko Ono, Carolee Schneemann, VALIE EXPORT und Ana Mendieta versteht es Khademi, das Genre perfekt zu nutzen.

Abschließend eine letzte Beobachtung. Von den Performancekünstlerinnen der 1960er- und 1970er-Jahre wird zu Recht gesagt, dass sie ihre Körper und Gesten zu ihren Ausdrucksmitteln gemacht haben – und dies mit umso größerer Eindrücklichkeit, als die Kunstwelt in jenen Jahren beinahe ausschließlich von Künstlern beherrscht wurde, die sich auf unterschiedliche Weise in der Malerei oder Skulptur betätigten. Bis auf wenige Ausnahmen, die teils erst sehr spät Anerkennung fanden – wie Louise Bourgeois, Joan Mitchell, Germaine Richier oder Niki de Saint-Phalle –, waren Malerinnen und Bildhauerinnen in Ausstellungen, in Museen und auf dem Kunstmarkt so gut wie nicht vertreten. Das Medium der Performance war für die Künstlerinnen weitaus leichter zugänglich und befreite sie von der in Malerei und Skulptur gängigen Bevormundung durch die Männer. Zugleich Performancekünstlerin und Feministin zu sein, lag deshalb in der Logik der Sache, beides ging miteinander konform und verstärkte sich wechselseitig. Bei Khademi verhält es sich heute anders. In einer vollkommen gewandelten künstlerischen Situation sind Zeichnung und Malerei nicht mehr stillschweigend den Männern vorbehaltene Gattungen. Daher ist Khademi in einer zusammenhängenden und sich ergänzenden Kunstpraxis nicht nur die Performancekünstlerin, als die wir sie bisher kennengelernt haben, sondern sie setzt ihr emanzipatorisches künstlerisches Schaffen genauso entschieden mit ihren Gouachen auf Papier fort.

1 „Mit fünf Jahren bin ich vergewaltigt worden. Das ist leider üblicher, als man denkt. Ich habe es bedauert, keine Rüstung getragen zu haben", in: Kharmohra, l'Afghanistan au risque de l'art (Ausst.-Kat. Mucem, Marseille), Arles 2019, S. 70. 2 Gespräch des Autors mit der Künstlerin, 20.12.2020. 3 Gespräch des Autors mit der Künstlerin, 5.7.2021.

Une dernière observation pour finir. Des performeuses des décennies 1960 et 1970, il est dit, à juste titre, qu'elles ont fait de leurs corps et de leurs gestes leurs moyens d'expression avec d'autant plus d'intensité que le monde de l'art, dans ces années, était presque exclusivement celui d'artistes masculins qui pratiquaient d'une manière ou d'une autre la peinture et la sculpture. À de rares exceptions près, qui pour certaines n'ont été reconnues que plus tard – Louise Bourgeois, Joan Mitchell, Germaine Richier, Niki de Saint Phalle –, femmes peintres et sculptrices étaient presque absentes des expositions, des musées et du marché. Dans ces conditions, la performance apparaissait comme plus accessible aux femmes artistes et les délivrait de la tutelle masculine qui pesait sur la peinture et la sculpture. Être performeuse et féministe n'en était que plus logique, les deux notions allant de pair et se renforçant mutuellement. Aujourd'hui, pour Khademi, il n'en est plus de même. Dans une situation artistique très différente de celle d'autrefois, le dessin et la peinture ne sont plus des arts tacitement réservés aux artistes masculins. De façon complémentaire et cohérente, elle est simultanément la performeuse que l'on a présentée et celle qui exécute les gouaches sur papier dans lesquelles elle continue avec autant de fermeté son œuvre libératrice.

1 « J'ai été violée à l'âge de cinq ans. C'est hélas plus commun qu'on ne le pense. J'ai regretté de ne pas avoir une culotte en fer. » In Kharmohra, l'Afghanistan au risque de l'art, Mucem/Actes Sud, 2019, p. 70. 2 Entretien avec l'artiste, 20 décembre 2020. 3 Entretien avec l'artiste, 5 juillet 2021.

SALIMA HASHMI

A VOICE IN EXILE STIMME IM EXIL UNE VOIX EN EXIL

A survey of the past two decades of South Asian contemporary art reveals the critical role played by women as pioneering art educators, practitioners, and activists. The tumultuous times this region has lived through in terms of military dictatorships, civil wars, and ethnic and communal strife has instigated a fertile, ebullient, and exciting shift in art making. The chronologies differ—as do the circumstances, idioms, and narratives—but the context across the region has resulted in a wellspring of ideas and unusual practices, gaining national and international attention. The discourse involving women artists in particular deserves to be examined with the intent of placing them on the map of the transnational art world.

It is almost a cliché to interpret the art practice of South Asian women artists against the backdrop of the patriarchal societies they inhabit. Their struggles are taken for granted. Nevertheless, Kubra Khademi stands out as an exceptional actor against this familiar backdrop. This is only partly due to the nature of her multidisciplinary practice; it is more to do with the unusual set of circumstances which led to her development as a significant artist from South Asia, and Afghanistan in particular.

Khademi belongs to the Hazara tribe, which has a long and harrowing history of displacement and persecution. Originating in Central Asia, they invaded Afghanistan in the thirteenth century and came to occupy Central Afghanistan, where they settled in the so-called Hazarajat in the Bamiyan Valley. Persian-speaking and belonging to the Islamic Shia sect, they have been reviled by other tribes and were conquered and massacred by Emir Abdur Rahman Khan in the nineteenth century. The genocide destroyed 65 percent of the population, many fleeing to what is today West Pakistan, a pattern that was to be repeated.

A century later, at the beginning of the Soviet-Afghan War, Khademi's father fled Afghanistan to Iran, and in 1999 moved his family to Pakistan during the Taliban advance into Hazara territory. The destruction of the Bamiyan Buddhas in 2001 was a

Ein Blick auf die beiden zurückliegenden Jahrzehnte zeitgenössischer südasiatischer Kunst zeigt, welch wichtige Rolle Frauen darin als Kunstvermittlerinnen, Künstlerinnen und Aktivistinnen gespielt haben. Die aufwühlenden Zeiten, die die Region in diesem Zeitraum mit Militärdiktaturen, Bürgerkriegen und ethnischen Auseinandersetzungen durchlebt hat, führten zu einem tiefgreifenden, lebhaft diskutierten, fruchtbaren Wandel in Verständnis und Ausübung von Kunst. Die zeitliche Abfolge der Ereignisse mag unterschiedlich sein – wie auch die Umstände, Idiome und Narrative –, doch haben sich in der gesamten Region neue, ungewöhnliche künstlerische Ideen und Praktiken ausgebildet, die in ihren jeweiligen Ländern, aber auch international Aufmerksamkeit auf sich ziehen. Insbesondere der Kunstdiskurs der Frauen verdient eine genauere Betrachtung, in der Absicht, ihre Praktiken innerhalb der transnationalen zeitgenössischen Kunstwelt zu verorten.

Die Kunstpraxis südasiatischer Frauen vor dem Hintergrund der patriarchalischen Gesellschaften zu deuten, in denen sie leben, ist fast schon zum Klischee geworden. Der Kampf um Emanzipation gilt als selbstverständlich. Dennoch nimmt Kubra Khademi hier eine außergewöhnliche Stellung ein, was nur zum Teil auf ihre multidisziplinäre Praxis zurückzuführen ist. Vielmehr ist es die Verflechtung besonderer Umstände, die sie zu einer bedeutenden Künstlerin aus Südasien, genauer aus Afghanistan, werden ließ.

Khademi gehört der Ethnie der Hazara an, die eine lange und erschütternde Geschichte von Flucht und Verfolgung hinter sich hat. Aus Zentralasien stammend drangen die Hazara im 13. Jahrhundert ins Gebiet des heutigen Afghanistans vor, wo sie sich im sogenannten Hazaradschat im Bamyian-Tal niederließen. Als persischsprachige schiitische Minderheit wurden sie von anderen Stämmen bekämpft und das Hazaradschat Ende des 19. Jahrhunderts von Emir Abdur Rahman Khan besetzt. Der damals

Lorsque l'on observe les deux dernières décennies de l'art contemporain en Asie du Sud, il s'avère que les femmes y ont joué un rôle essentiel de praticiennes, d'activistes et de pionnières dans l'éducation artistique. Les périodes tumultueuses que cette région a traversées – dictatures militaires, guerres civiles, conflits ethniques et communautaires – ont donné lieu, dans le domaine de la création et de l'art, à une évolution fertile, bouillonnante, passionnante. Les chronologies diffèrent, tout comme les circonstances, les idiomes et les récits, mais le contexte régional a fait jaillir des idées et pratiques inhabituelles, qui ont suscité l'attention bien au-delà des frontières et dans le monde entier. Notamment le discours sur les femmes artistes gagne à être étudié et inscrit dans l'univers de l'art contemporain transnational.

Interpréter la pratique des femmes artistes d'Asie du Sud sur fond de sociétés patriarcales, celles dans lesquelles elles vivent, relève presque du cliché. Leurs luttes sont considérées comme acquises. Pourtant, dans ce contexte a priori familier, Kubra Khademi se démarque de manière exceptionnelle. Non seulement en raison de la nature même de sa pratique multidisciplinaire, mais aussi et surtout compte tenu de toutes les circonstances inhabituelles qui ont marqué l'évolution de cette artiste majeure, dans cette région du globe et en Afghanistan en particulier.

Khademi est issue de la tribu des Hazaras dont la longue et douloureuse histoire est ponctuée de déplacements et de persécutions. Originaires d'Asie centrale, les Hazaras ont envahi au XIIIe siècle le territoire correspondant aujourd'hui à l'Afghanistan et se sont établis dans le Hazarajat, dans la vallée de Bamyian. En tant que minorité chiite de langue persane, ils ont été combattus par d'autres tribus et le Hazarajat a été occupé par l'émir Abdul Rahman Khan à la fin du XIXe siècle. Ce génocide a détruit deux tiers de la population, dont une grande partie a fui vers l'actuel Pakistan occidental. Par la suite, le schéma allait se répéter.

1 حقايق نمناک, *The Moist Realities*, 2013, Performance on the street in | auf der Straße in | dans la rue à Lahore, Pakistan, property of the artist | Eigentum der Künstlerin | propriété de l'artiste, Latitudes Contemporaines, Lille, France | Frankreich

stattfindende Völkermord kostete zwei Drittel der Hazara das Leben, ein weiterer Teil der Bevölkerung floh ins heutige Westpakistan. Ein Muster, das sich wiederholen sollte.

Zu Beginn des sowjetisch-afghanischen Kriegs rund ein Jahrhundert später floh Khademis Vater mit seiner Familie in den Iran und zog 1999 nach Pakistan, als die Taliban auf das Territorium der Hazara vorrückten. Die Zerstörung der Buddha-Statuen von Bamiyan wurde zum traumatischen Symbol der Vernichtung und Auslöschung von Kultur und Menschenleben. Es folgte die Enthauptung von tausenden Hazara durch die Taliban und Al-Qaida. Es heißt, dass Frauen ihren Enkelkindern später erzählten, wie rot die Tulpen in jenem Jahr waren, wegen des vielen Bluts, das die Erde getränkt hatte.

Zwar sind die Hazara sowohl in Afghanistan als auch in Pakistan eine marginalisierte Bevölkerungsgruppe, doch zeichnen sie sich durch Resilienz und kulturelle Geschlossenheit aus. Ihre überlieferten Erzählungen preisen Heldenmut und Tapferkeit, das Alltagsleben ist durch besondere Traditionen in Musik, Dichtung und Handwerkskunst geprägt. Frauen spielen im Rahmen der patriarchalischen Sozialstruktur eine wichtige Rolle bei Entscheidungen innerhalb der Familie. Will man einige wesentliche Faktoren von Khademis künstlerischem Werdegang sowie ihrer künstlerischen Praxis verstehen, ist es unabdingbar, die anthropologischen und psychologischen Charakteristika der Gemeinschaft der Hazara einzubeziehen – oder um Virginia Whiles zu zitieren: „Kunst und Anthropologie teilen im Feld der Kultur einander überlappende Diskurse."[1]

„Die Frauen der Hazara waren lange Zeit weniger in ihren Rechten beschnitten als die Frauen anderer ethnischer Gruppen in Afghanistan", führt Atika Hussain aus. Sie gibt dafür historische Gründe an. „Aufgrund des Massakers mussten sie jederzeit bereit sein, ihr Leben und ihren Besitz an der Seite ihrer Männer zu verteidigen."[2]

Denn davon erzählt Khademi auch: vom Einfluss der Frauen in ihrer Familie. Von der Großmutter, die schon früh für ihre Brüder sorgen musste. Von ihrer strengen Mutter, die sie als kleines Mädchen häufig verprügelt hat, weil sie „ein böses Kind" war: „In jeder Familie gibt es einen Dämon, sagt man bei uns. Ich war der Dämon!"[3]

Au début de la guerre soviéto-afghane, environ un siècle plus tard, le père de Khademi a fui en Iran avec sa famille et s'est installé au Pakistan en 1999, lorsque les talibans ont envahi le territoire des Hazaras. La destruction des statues de Bouddha de Bamiyan est devenue le symbole douloureux de la décimation des cultures et des vies humaines. Par la suite, de milliers de Hazaras ont été décapités par les talibans et Al-Qaida. Les femmes, plus tard, auraient raconté à leurs petits-enfants combien les tulipes étaient rouges cette année-là, à cause de tout le sang dont la terre était emplie.

Si les Hazaras sont marginalisés, tant en Afghanistan qu'au Pakistan, ils sont résistants aussi, et homogènes dans leur culture. Les légendes chantant la bravoure et la force de l'âme, la musique, la poésie et l'artisanat sont intimement mêlés à la vie quotidienne. L'organisation sociale patriarcale a permis ainsi aux femmes de jouer un rôle clé dans les prises de décisions au sein de la structure familiale. Le rôle anthropologique et le profil psychologique de la communauté hazara sont intrinsèques à la compréhension des facteurs qui ont façonné la trajectoire de Khademi et ses choix artistiques. Pour citer Virginia Whiles, « l'art et l'anthropologie partagent des discours qui se superposent dans le champ de la culture[1] ».

Atika Hussain, à propos des femmes hazaras, déclare : « Longtemps, les femmes hazaras ont été moins restreintes que d'autres groupes ethniques en Afghanistan[2]. » Pour elle, cela est dû à l'histoire de l'extermination des Hazaras. « En raison de ce massacre, leurs femmes ont toujours été prêtes à défendre la vie et les biens aux côtés des hommes de la société[3]. »

Khademi évoque également l'influence de femmes fortes dans sa famille. Une grand-mère courageuse qui s'est occupée de la progéniture masculine. Une mère dure, qui la battait souvent : « J'étais une mauvaise enfant ! Dans chaque famille, on dit qu'il y a un démon. J'étais ce démon ![4] »

traumatic symbol of the decimation of lives and culture in Afghanistan. It was followed by the beheading of thousands Hazara by the Taliban and Al Qaeda. It is said that women narrated to their grandchildren how red the tulips were that year, because of all the blood that flowed into the earth.

While the Hazara are a marginalized people in both Afghanistan and Pakistan, they are also resilient and culturally cohesive. Brought up on legends of bravery and forti- tude, music, poetry, and crafts are intertwined with daily life. Thus, the patriarchal social structure has allowed the presence of women to play a key role in decision-making in the family structure. The anthropological role and psychological profile of the Hazara community is intrinsic to understanding some of the factors shaping the trajectory of Khademi's development and choices made in her art practice—to quote Virginia Whiles, "art and anthropology share overlapping discourses in the field of culture."[1]

Atika Hussain, commenting on Hazara women, states "Hazara women have long been less restricted than other ethnic groups in Afghanistan." She argues that this is because of the history of Hazara carnage. "Because of this massacre, their women have always been ready to defend their lives and properties alongside their men of society."[2]

Khademi also narrates the influence of strong women in her family. A courageous grandmother who looked after her male siblings. A mother who was harsh, beating her frequently because "I was a bad child! In every family there is an animal we say; I was that animal!"[3]

As with most Hazara refugees who had fled to Quetta in the Pakistani province of Balochistan, Khademi's radius of life was limited to the Hazara-inhabited district of Quetta ("Hazara Town"). As a child she went to the Afghan school, until her father died and they could no longer afford the fees. She turned to embroidery to contribute to the household but also to save for her future as an artist. Embroidery has long been a conduit for economic independence. Khademi was determined to use her earnings to

Wie bei den meisten Hazara-Flüchtlingen, die nach Quetta in der pakistanischen Provinz Belutschistan geflohen waren, beschränkte sich Khademis Lebensradius auf das von Hazara bewohnte Stadtviertel („Hazara Town"). Als Kind besuchte sie dort die afghanische Schule, bis ihr Vater starb und die Familie nicht länger die Schulgebühren aufbringen konnte. Um zum Lebensunterhalt beizutragen, aber auch um für ihre Zukunft als Künstlerin zu sparen, widmete sie sich der Stickerei. Die Stickkunst stellte für Frauen der Hazara seit jeher ein Mittel ökonomischer Unabhängigkeit dar. Khademi war nach eigenen Angaben fest entschlossen, durch ihre Einkünfte einer Ehe zu entkommen, der festgeschriebenen weiblichen Rolle, die sie erwartete. „In meiner Kultur muss ein Mädchen heiraten", so die Künstlerin.

Doch die Hazara waren in Pakistan nicht sicher, nicht einmal in ihrer Schutzzone in Hazara Town. Denn auch dort wurden sie zum Ziel von Bombardierungen und tödlichen Angriffen der Taliban. Nach den Terroranschlägen am 11. September 2001, die in Afghanistan veränderte Machtverhältnisse zur Folge hatten, gab es für Khademi neue Hoffnung auf eine Rückkehr in ihre Heimat und auf ein normales Leben als Frau in Afghanistan – auch wenn ihr bewusst war, dass sie immer als Angehörige der Hazara zu erkennen sein würde, denn „mein Gesicht ist das einer Hazara". Nach der Absetzung der Taliban konnte Khademi nach Kabul zurückkehren, wobei sie die Ersparnisse aus ihrer Stickereiarbeit nutzte, um ihre weitere Ausbildung zu finanzieren und ihr Ziel zu verfolgen, Künstlerin zu werden. Ein unerhörter, rebellischer Akt.

Ein Stipendium der South Asia Foundation des UN-Sonderbotschafters Madanjeet Singh ermöglichte Khademi ab 2009 ein Kunststudium an der Beaconhouse National University in Lahore. Dort traf sie mit anderen angehenden jungen Künstlerinnen aus Bhutan, Bangladesch, Indien, Sri Lanka, Nepal, von den Malediven und aus Pakistan zusammen, was ihr die Möglichkeit grenzüberschreitender multikultureller Erfahrungen

Comme pour la plupart des personnes réfugiées qui ont fui à Quetta, dans la province du Baloutchistan au Pakistan, le rayon d'action de Khademi se limitait au quartier de « Hazara Town ». Enfant, elle allait à l'école afghane, jusqu'à ce que son père décède et que les frais de scolarité ne puissent plus être payés. Elle se tourne alors vers la broderie pour apporter sa contribution au foyer, mais aussi pour économiser en vue de devenir artiste. La broderie constitue depuis longtemps un moyen d'accéder à l'indépendance économique. Khademi était déterminée à utiliser ce qu'elle gagnait pour échapper au mariage, obligatoire pour les filles. « Ma culture exigeait que je me marie », dit l'artiste.

Or les Hazaras n'étaient pas en sécurité au Pakistan, pas même dans leur repli. Les talibans les ont pris pour cible, perpétrant meurtres horribles et bombardements. Le 11 septembre a fait naître l'espoir. L'espoir de reconquérir l'Afghanistan, où Khademi aspirait à être simplement une femme afghane, même si elle était consciente que ses traits physiques la trahissaient – « mon visage est hazara ». Avec la défaite des talibans, elle a pu s'enfuir à Kaboul en utilisant les économies réalisées grâce à sa broderie et poursuivre sa formation ainsi que son objectif de devenir une artiste. C'était là un acte de rébellion inouï.

La bourse d'études artistiques de la South Asia Foundation, qu'elle a la chance d'obtenir et financée par l'ambassadeur de bonne volonté de l'UNESCO Madanjeet Singh, la conduit à l'université nationale Beaconhouse de Lahore en 2009. Elle se retrouve parmi d'autres jeunes artistes en devenir, originaires du Bhoutan, du Bangladesh, de l'Inde, du Sri Lanka, du Népal, des Maldives et, bien sûr, du Pakistan. L'expérience culturelle dépasse les frontières et permet d'élargir considérablement ses horizons. Le corps enseignant est aussi varié que les étudiant.es. Khademi se souvient combien il a fallu se battre pour passer d'un ordre social difficile à un environnement universitaire tout aussi exigeant. Grâce à sa camarade de classe afghane et amie proche

evade marriage, the ordained role for the girl child. "My culture demanded marriage," she says.

The Hazaras were not safe in Pakistan, not even in their cocoon in Hazara Town. The Taliban targeted them and there were horrific bombings and killings. After the terror attacks on September 11, 2001, which resulted in changed power relations in Afghanistan, there was new hope for Khademi to return to her homeland and live a normal life as a woman in Afghanistan—even though she was aware that she would always be recognizable as a member of the Hazara, because "my face is that of a Hazara." With the defeat of the Taliban, she was able to get away to Kabul, using the savings from her embroidery for further education and to pursue her goal to be an artist. It was an unheard-of rebellious act.

A scholarship from the South Asia Foundation of the UN Ambassador Madanjeet Singh enabled Khademi to study art at the Beaconhouse National University in Lahore from 2009. Here she was among other young would-be artists from Bhutan, Bangladesh, India, Sri Lanka, Nepal, the Maldives, and, of course, Pakistan. The cultural experience reached beyond borders and was a critical expansion of her horizons. The faculty was as diverse as the students. Khademi recalls the struggle to move from a challenging social order to an equally demanding academic environment.

A fellow student from Afghanistan, Masooma Reza, was her close and constant companion, which helped to minimize their isolation. They constantly worked together "collaborating until they developed confidence," according to the Pakistani artist Huma Mulji, a teacher who was a decisive influence. Mulji remembers her as a person "who always had a clarity, a strong will and a rage within her."[4] A progression toward performance might have evolved after a workshop with Stefanie Oberhoff, a German performance artist who introduced them to the genre.

und eine Erweiterung ihres Horizonts eröffnete. Von derselben Diversität wie die Studentinnen war auch das Lehrangebot. Im Gespräch schildert Khademi, welche Herausforderung es für sie bedeutete, aus einem schwierigen sozialen Umfeld in die anspruchsvolle akademische Welt zu wechseln.

Masooma Reza, eine ebenfalls aus Afghanistan stammende Mitstudentin, war in dieser Zeit Khademis enge Weggefährtin. Sie halfen sich über ihre Einsamkeit hinweg, stützten einander und entwickelten gemeinsame Projekte, „bis jede von ihnen genug Vertrauen in die eigene künstlerische Kraft entwickelt hatte", so die pakistanische Künstlerin Huma Mulji. Als Lehrerin übte sie auf Khademi entscheidenden Einfluss aus und erinnert sich an sie als eine Studentin, bei der „Klarheit stets mit starkem Willen und Wut gepaart war".[4] Die Entwicklung hin zur Performance wurde möglicherweise durch einen Workshop der deutschen Künstlerin Stefanie Oberhoff in Lahore angestoßen.

Im letzten Studienjahr verlangte Mulji von den Freundinnen, eigenständige Kunst-projekte zu verfolgen, was für die jungen Künstlerinnen einen entscheidenden Einschnitt markierte, denn von da an entwickelte jede ihre eigene visuelle Sprache und schlug ihren eigenen künstlerischen Weg ein. Khademi führte mehrere aufsehenerregende Performances durch. So ließ sie sich etwa mitten auf einer Ausfallstraße nieder und vollführte Alltagstätigkeiten, las und rauchte, während der Verkehr an ihr vorbeirausch-te (Abb. 1). Eine zweite Performance im öffentlichen Raum, mit der sie kurzfristig ein Durcheinander an Lahores belebtem Bahnhof verursachte, bestand darin, dass sie um die Erlaubnis bat, dort die Lautsprecheranlage für Durchsagen benutzen zu dürfen. Nach mehreren vergeblichen Anläufen hielt sie auf einmal das Mikrofon in der Hand. Dreißig Sekunden lang hielt sie der Menge eine Ansprache mit banalen Äußerungen. Masooma Reza begleitete die Aktion mit der Videokamera und zeichnete die konster-nierten Reaktionen der Menschen auf, die in alle Richtungen auseinanderliefen – ein

Masooma Reza, elle se sent moins isolée. Les deux travaillent constamment ensemble, « collaborant jusqu'à ce qu'elles prennent confiance en elles », selon Huma Mulji, une enseignante qui a exercé une influence décisive. Mulji se souvient de Khademi comme d'une personne « ayant toujours en elle une clarté, une rage et une volonté forte[5] ». Le cheminement vers la performance se fait à la suite d'un atelier d'initiation avec une performeuse allemande, Stefanie Oberhoff.

Au cours de la dernière année, les deux amies sont mises au défi par Mulji de travailler séparément, ce qui marque profondément les deux jeunes artistes : à partir de là, leurs modes d'expression divergent et prennent des directions différentes. Khademi entreprend plusieurs performances étonnantes. L'une d'elles consiste à s'asseoir au milieu d'une grande artère, tandis que la circulation passe devant elle et qu'elle-même accomplit de simples tâches quotidiennes (ill. 1), comme fumer ou lire. Une deuxième performance éminemment publique fait sensation dans la gare ferroviaire de Lahore : là, elle fait tout pour être autorisée à utiliser le système d'annonce. Après de nombreuses sollicitations, les autorités cèdent et on lui tend soudain le micro. Elle s'adresse alors à la foule pendant trente secondes avec les propos les plus banals qui soient. Masooma, témoin de la scène, a filmé la consternation des gens se précipitant dans tous les sens — un élément étonnant et inattendu de la performance. Elle évoque d'ailleurs « une performance absurde ».

Le travail final de Khademi, qui lui a valu la distinction des examinateurs, est le résultat de trois mois d'entraînement physique dans une salle de sport, afin de préparer son corps à une épreuve de grande envergure. Elle s'est exercée en effet à porter des valises lourdes, de huit kilos chacune. Elle intensifie aussi l'exploration de son propre corps. Vêtue de noir, Khademi se suspend dans les airs à deux piliers de l'atelier, à une hauteur de trois mètres, les bras tendus (ill. 2). Le spectacle est stupéfiant, douloureux

In the final year the two friends were challenged by Mulji into working separately, which had a profound influence on both young artists, and from that point their visual expression diverged and went in their own directions. Khademi undertook several startling performances. One involved sitting in the middle of a thoroughfare, with traffic zooming past her as she performed innocuous mundane daily tasks, smoking and reading (fig. 1). A second hugely public performance which caused a stir at Lahore's busy railway station was accomplished by her pleading to be allowed to use the public address system. After many visits the authorities relented and she was suddenly handed the microphone. She addressed the multitude with the most banal of statements for thirty seconds! Masooma witnessed and videoed the consternation of people who started to react and rush in all directions—an amazing and unexpected component of the performance. She calls it "an absurdist performance."

Khademi's final work, which earned her a distinction from the examiners, was the result of three months of physical training in a gym to prepare her body for an ordeal of grave proportions. She practiced carrying heavy suitcases, each weighing eight kilos. The exploration of her own body became intense. Dressed in black, Khademi suspended herself midair from two pillars in the studio at a height of nine feet, arms outstretched (fig. 2). It was a stunning, breathtakingly painful and poignant sight. Kubra muses on these times as being processes leading toward clarity of thought, learning the persistence required for the realization of an idea.

After completing her art studies, Khademi was offered a teaching position at the university, but she decided to return to Kabul. She was now an artist. It was 2013.

On February 26, 2015, *Armor* (cat. 2), her walk through the busy Kabul bazaar wearing a harness that replicated the female breasts and bottom, challenged social religious norms and provoked extreme, life-threatening reactions. The artist had to go into hiding while everyone associated with her had to change their abodes for their own safety.

überraschendes, unerwartetes Element der Performance. Kadhemi nennt dieses Werk eine „absurde Performance".

Für ihre Abschlussarbeit an der Beaconhouse National University, die ihr eine Auszeichnung einbrachte, trainierte sie drei Monate lang in einem Fitnessstudio, um für die immensen körperlichen Anforderungen ihrer Aktion gewappnet zu sein. Und sie übte, acht Kilogramm schwere Koffer zu schleppen. Die Erforschung ihres Körpers intensivierte sich. Mit ausgestreckten Armen hing sie schwarz gekleidet in einer Höhe von beinahe drei Metern zwischen zwei Pfeilern (Abb. 2). Es war ein eindrucksvoller, atemberaubender und schmerzhafter Anblick. Die Künstlerin bezeichnet diese Zeit als Klärungsprozess, in dem sie viel über die zur Umsetzung einer Idee erforderliche Hartnäckigkeit lernte.

Nach dem Abschluss ihres Kunststudiums erhielt Khademi ein Angebot für eine Lehrtätigkeit an der Universität, doch sie entschied sich zur Rückkehr nach Kabul. Sie war jetzt Künstlerin. Das war im Jahr 2013.

Am 26. Februar 2015 hinterfragte Khademi in ihrer Performance *Armor* (Kat. 2) – bei einem Gang durch den Bazar von Kabul trug sie einen Harnisch, der die weiblichen Formen von Brüsten und Gesäß nachbildete – die sozialen und religiösen Normen der afghanischen Gesellschaft. Die Situation eskalierte, die Reaktionen der Menge wurden lebensbedrohlich. Die Künstlerin musste untertauchen und Menschen, die mit ihr in engerer Beziehung standen, sicherheitshalber den Wohnsitz wechseln. Die komplizierten Bemühungen zu Khademis Rettung und ihrer Übersiedelung nach Paris wären eine eigene Erzählung wert. Khademi stand vor der schmerzhaften Aufgabe, endgültig den Verlust ihrer Heimat zu verarbeiten.

Denn natürlich handelt es sich bei ihrem Exil um viel mehr als einen bloßen Ortswechsel. Auf vielfältigste Weise bedeutet das gewaltsame Herausgerissenwerden aus

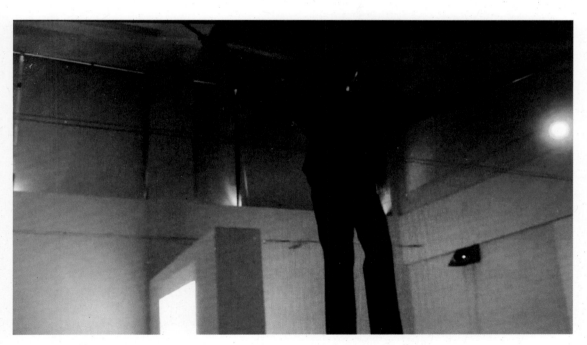

2 بدون عنوان, *Untitled*, 2013, Performance, Lahore, Pakistan, property of the artist | Eigentum der Künstlerin | propriété de l'artiste, Latitudes Contemporaines, Lille, France | Frankreich

et poignant, à couper le souffle. Kubra considère ces moments comme autant de processus menant à la clarté de la pensée et à l'apprentissage de l'endurance nécessaire à la réalisation d'une idée.

Le vice-recteur lui propose un poste d'enseignante à l'université, mais elle est déterminée à retourner à Kaboul, en Afghanistan. Elle est désormais artiste. Nous sommes en 2013.

The complicated efforts for her rescue and relocation to Paris is a separate saga, but the artist had to painstakingly come to terms with the loss of home.

It has been infinitely more problematic than mere displacement. In a myriad of ways, the gut-wrenching snatching away of context resulted in a painful remaneuvering, dismantling, and reconstruction of a fresh context which could nurture the artist, the woman, the Hazara Afghan. The cost has been profound.

Khademi confesses how difficult it is to overcome the trauma of danger, of no longer having the safety and reassurance of the collective social order. She evades interviews, "wanting to get them over quickly," and still needs therapy, even as the allegiance to her art practice moves to center stage in her life. The many portals unfold. Embroidery of her girlhood reappears and merges with photo and digital techniques of her art training. The fractures begin to heal but are resurrected after recent events in Afghanistan. Khademi is never severed from these references to home that flow in the capillaries of her art making. Her defiance of stereotypes and labels allow conjectural innovations and a fresh framing of context and her selfhood.

1 Virginia Whiles, *Art and Polemic in Pakistan: Cultural Politics and Tradition in Contemporary Miniature Painting* (London: I.B. Taurus, 2010), 203. 2 Atika Hussain, researcher and scholar in an email to this author dated January 21, 2022. 3 Kubra Khademi, conversation on Zoom with the author, January 13, 2022. All quotations of the artist are from this conversation. 4 Huma Mulji, in WhatsApp conversation with the author, January 20, 2022.

ihrem sozialen und kulturellen Kontext eine quälende, mühsame Umorientierung, eine Arbeit der De- und Rekonstruktion. Khademi war gezwungen, sich ein neues Umfeld zu erschaffen, das sie als Künstlerin, als Frau und als Angehörige der Hazara tragen und nähren konnte. Der Preis war gewaltig.

Die Künstlerin gesteht unumwunden, wie schwierig es für sie immer noch ist, die traumatische Erfahrung der Lebensgefahr zu überwinden, den Verlust der Sicherheit und Geborgenheit des Kollektivs, dem sie entstammt. Sie gibt nicht gerne Interviews, will sie schnell hinter sich bringen, ist nach wie vor in Therapie. Zugleich ist bei ihr die Kunst noch deutlicher als vorher in den Lebensmittelpunkt gerückt. Viele neue Wege eröffnen sich. Die Stickereien ihrer Kindheit tauchen wieder auf und verschmelzen mit Fotografie und digitalen Techniken, die sie während ihres Studiums kennengelernt hat. Die Wunden beginnen zu heilen, werden durch die jüngsten Ereignisse in Afghanistan aber wieder aufgerissen. Die Verbindung zu ihrer Heimat ist in Khademis Kunst immer spürbar, ja macht den Kern ihres Schaffens aus. Das Aufbrechen von Stereotypen und Etikettierungen ermöglicht neue Assoziationen und Bezüge – und erlaubt ihr selbst eine neue Interpretation ihres Herkunftskontextes und ihrer Identität.

1 Virginia Whiles, Art and Polemic in Pakistan: Cultural Politics and Tradition in Contemporary Miniature Painting, London 2010, S. 203. 2 E-Mail von Atika Hussain an die Autorin, 21.1.2022. 3 Gespräch der Autorin mit Kubra Khademi über Zoom, 13.1.2022. Alle Zitate der Künstlerin im vorliegenden Text stammen aus diesem Gespräch. 4 Gespräch der Autorin mit Huma Mulji über WhatsApp, 20.1.2022.

Le 26 février 2015, sa performance *Armor* (cat. 2) – la traversée du bazar animé de Kaboul avec une « armure » soulignant les formes féminines – a défié toutes les normes sociales et religieuses et provoqué des réactions extrêmes. La vie de l'artiste est en danger ; elle doit se cacher et toutes les personnes en lien avec elle doivent elles aussi changer de domicile pour se protéger. Les nombreux efforts déployés pour la secourir et la transférer à Paris sont une autre histoire. L'artiste perd son foyer et doit s'y résoudre. C'est là un événement infiniment plus problématique qu'un simple déplacement. À bien des égards, l'arrachement brutal à son environnement a entraîné un démantèlement douloureux et la reconstruction aussi douloureuse d'un contexte nouveau, susceptible de nourrir l'artiste, la femme, l'Afghane hazara. Le coût en a été très élevé.

Khademi avoue combien il est difficile de surmonter le traumatisme du danger, de ne plus avoir la sécurité et le réconfort de l'ordre social collectif. Elle fuit les interviews, qu'elle donne le plus vite possible, et poursuit sa thérapie, même si la pratique artistique, à laquelle est pleinement consacrée, occupe une place cruciale dans sa vie. De nombreuses voies s'ouvrent. La broderie de son enfance réapparaît et se mêle aux techniques photographiques et numériques de sa formation artistique. Les fractures ont commencé à se consolider, mais voilà qu'elles ressurgissent après les événements récents en Afghanistan. Khademi ne se départit jamais des références à la « maison », elles innervent toute sa création artistique. En défiant les stéréotypes et les étiquettes, elle peut oser des innovations visionnaires et, ce faisant, donner un nouveau cadrage à son environnement et son identité.

1 Virginia Whiles, *Art and Polemic in Pakistan : Cultural Politics and Tradition in Contemporary Miniature Painting*, Londres, 2010, p. 203. 2 Atika Hussain dans un courriel à l'autrice daté du 21 janvier 2022. 3 *Ibid.* 4 Kubra Khademi, conversation sur Zoom avec l'autrice, le 13 janvier 2022. Toutes les citations de l'artiste contenues dans cet essai proviennent de ce même échange. 5 Entretien de l'autrice avec Huma Mulji par WhatsApp le 20 janvier 2022.

WEAPONS INSTEAD OF EDUCATION

THE AFGHAN ARTIST KUBRA KHADEMI ON THE TALIBAN, CULTURE, AND EROTICISM

With her performances and large-format gouache drawings, Kubra Khademi, who was born in the Ghor Province of Afghanistan in the year 1989, thematizes the violent patriarchal society of her homeland. She was threatened with death following an open-air performance on a street in Kabul and had to leave her country in 2015. The artist found exile in France and lives in Paris today. In summer 2021 she played a key role in evacuating endangered artists out of Afghanistan. In spring 2022 Khademi took part in the *Walk* show in the Schirn Museum in Frankfurt, and the Museum Pfalzgalerie in Kaiserslautern is now devoting a solo exhibition to the artist.

Did you ever have the hope that Afghanistan could become a freer, maybe even more democratic, country? — The period of the Soviet occupation and the first Taliban regime was a very dark time. As a child, I experienced that there was no life for me in this country. I was twelve years old when the American forces drove out the Taliban and, as with many other Afghans, it was a celebration for me. All of a sudden, immense hope was awakened in us. At the time, we were refugees with my family in Pakistan because we belong to the Hazara minority that is persecuted by the Taliban. After 2001, there were incredibly momentous changes—at least in Kabul and other large cities—and we achieved a great deal for women and education. I was the first girl in my family who went to school. I was even able to study at the art colleges in Kabul and Lahore.

What thoughts went through your mind when it became clear that the Taliban would reconquer the country? — The first thing I thought about was the women, and the terrible fate that now awaited them. It made me unbelievably angry; and it still does. The Taliban now gave young girls to Pakistani soldiers to produce the next generation of Taliban. Afghanistan will remain a breeding ground for terrorism in the future. Under this regime, women are being degraded to sex slaves more than ever before; a Burka is hung over them, and they are supposed to produce children. If it's a boy, it's a triumph; if it's a girl, a disgrace. Afghanistan is dominated by a culture of sexual violence. This patriarchate has eradicated any form of morality; it is paralyzing our society.

Is that one of the reasons that the female body stands at the core of your work; both in the performances and in your drawings? — My work develops deep in the story of my life. My body is the most personal thing I bear with me. Everything comes from this existence that should not exist; that was mishandled because it was female. As a girl, I had to fight for every step I took to prove that it was possible to think and make decisions, to exist without having to be ashamed of it. My art has a great deal to do with that. When I look back, I see: Actually, everything was against me. I work with my body and paint female bodies, which are usually naked, because I want to insist on their female identity to the maximum extent possible. They are triumphant and absolutely present.

In your extremely narrative drawings, you process mythical tales and legends that often have direct sexual allusions. What inspires you? — The stories all come from where I come from; from the origin. The origin: that is my mother, that is my country, that is the way I grew up. In my pictures, I process stories that Afghan women tell each other when they talk about men, about sex, and about their phantasms. The suppression they live in has made them unbelievably active verbally because they are unable to experience anything pragmatically. We have a long tradition of erotic poetry in the Persian language. Some of my drawings were inspired by Rumi's verses.

You immediately recognized the danger facing artists and intellectuals as the Taliban approached and initiated an evacuation program. How did you go about that? — At the beginning of July 2021, I began drawing up a list of endangered artists. Maria-Carmela Mini, the director of the "Latitudes Contemporaines" theater and dance festival, whom I work with for my performances, was immediately ready to help. We had to find institutions here in France that could take them in. Some artists had already been killed at the time I was preparing the list; you see, the danger was very real. For example, we contacted an actress from Jowzjan, a province in the north of the country. She succeeded in getting to Kabul and we wanted to bring her to France from there. When I called her in Kabul, she told me that the Taliban had gone to her family to look for her. We started working on the visas immediately in July 2021 and told the people to have their passports ready. At the time, we had no idea that Kabul would fall so quickly. Maria-Carmela Mini and Joris Mathieu from the Centre Dramatique National Lyon worked together with a section of the Foreign Office, while I remained in contact with the artists on the spot. We evacuated almost eighty people. Theaters in many French cities opened their doors to the artists and provided them with accommodation. Galleries also integrated artists. However, it has now become almost impossible to bring anybody out of the country.

What is the situation for those who see themselves marginalized or threatened in the Taliban state: women, and artists and intellectuals? — Almost all of them no longer have anything to do. If women want to go out on the street, they have to be accompanied by a man. They are being forced out of their jobs. The latest is that they are no longer allowed to use smartphones in the street. You still see some women without a burka in Kabul; it is a sign of resistance. But that is no longer possible outside of Kabul. Artists and intellectuals are all in danger; they can't stay in their homes and have to repeatedly change where they live. They can't rely on anyone anymore because their artist friends have also fled. They all attempt to hide themselves. Many artists destroyed their works and all their documents before they fled because they could be used as evidence against them; they had to destroy them to protect themselves and their families. Others have hidden their works. The Taliban drew up lists long ago. Journalists and human rights activists started to be murdered last year.

Do you believe that the generation of young, connected people will be able to put up resistance? — After these twenty years, the majority of young women—in particular—are against the Taliban. Young Afghan men do not face the same problems and have much less to lose. The only people who currently stand on the streets with placards reading "We Need Education" are women, but they do that with a rifle under their noses. Support has to come from abroad, from politicians throughout the world. Afghanistan has become a trap, a cemetery. The people are hungry, and cultural and ethnic cleansing have already begun.

This interview appeared in the *Frankfurter Allgemeine Zeitung, October 14, 2021*, Feuilleton, p. 9, © All rights reserved, Frankfurter Allgemeine Zeitung GmbH, Frankfurt. Made available by the Frankfurter Allgemeine Archives. In agreement with the author Bettina Wohlfarth, the text was transferred with minor changes and at some points the use of the generic feminine in line with the chosen rule for this catalogue.

GEWEHRE STATT BILDUNG

DIE AFGHANISCHE KÜNSTLERIN KUBRA KHADEMI ZU TALIBAN, KULTUR UND EROTIK

Die 1989 in der Provinz Ghor geborene Kubra Khademi thematisiert mit ihren Performances und in ihren großformatigen Gouache-Zeichnungen die gewalttätige patriarchalische Gesellschaft ihres Heimatlandes. Nach einer Performance auf offener Straße in Kabul erhielt sie Todesdrohungen und musste im Jahr 2015 ihr Land verlassen. Sie fand in Frankreich Asyl und lebt heute in Paris. Im Sommer 2021 trug sie maßgeblich dazu bei, gefährdete Künstlerinnen aus Afghanistan zu evakuieren. Im Frühjahr 2022 nahm Khademi an der Schau *Walk* in der Frankfurter Schirn teil, das Museum Pfalzgalerie in Kaiserslautern widmet ihr nun eine Einzelausstellung.

Haben Sie je die Hoffnung gehabt, dass Afghanistan ein freierer, vielleicht sogar demokratischer Staat werden kann? — Die Zeit der sowjetischen Besatzung und des ersten Taliban-Regimes war eine sehr dunkle Zeit. Ich hatte als Kind die Erfahrung gemacht, dass es für mich in diesem Land kein Leben gibt. Als die Taliban von den amerikanischen Streitkräften vertrieben wurden, war ich zwölf Jahre alt, und es war für mich wie für viele Afghaninnen ein Fest. Plötzlich war eine immense Hoffnung in uns geweckt worden. Wir waren damals mit meiner Familie als Flüchtlinge in Pakistan, weil wir zu der von den Taliban verfolgten Hazara-Minderheit gehören. Seit 2001 hatte sich zumindest in Kabul und anderen großen Städten unglaublich viel verändert, wir haben für Frauen und Bildung viel erreicht. Ich bin in meiner Familie die Erste, die als Mädchen zur Schule ging. Ich habe gar an Kunsthochschulen in Kabul und Lahore studieren können.

Was ging in Ihnen vor, als klar wurde, dass die Taliban das Land zurückerobern würden? — Als Erstes dachte ich an die Frauen, an das furchtbare Los, das sie nun erwartet. Es machte und macht mich unglaublich wütend. Nun verschenken Taliban junge Mädchen an pakistanische Soldaten, um die nächste Generation von Taliban zu züchten. Afghanistan wird in Zukunft zu einer Brutstätte für den Terrorismus. Frauen werden unter diesem Regime mehr denn je zu sexuellen Sklavinnen degradiert, ihnen wird die Burka übergehängt und sie sollen Kinder zeugen. Wenn es ein Junge wird, ist es ein Triumph, wenn es ein Mädchen wird, eine Schande. In Afghanistan herrscht eine Kultur der sexuellen Gewalt. Dieses Patriarchat hat jede Moral liquidiert, es paralysiert unsere Gesellschaft.

Ist das einer der Gründe, warum der weibliche Körper im Mittelpunkt Ihrer Arbeit steht, sowohl in den Performances als auch in Ihren Zeichnungen? — Meine Arbeit entsteht tief in meiner Lebensgeschichte. Mein Körper ist das Persönlichste, das ich mit mir trage. Alles kommt von dieser Existenz, die nicht existieren sollte, die malträtiert wurde, weil sie weiblich war. Als Mädchen muss man bei jedem Schritt kämpfen, um zu beweisen, dass man nachdenken und entscheiden kann, dass man existieren darf, ohne sich dafür schämen zu müssen. Meine Kunst hat sehr viel damit zu tun. Wenn ich zurückschaue, sehe ich: Eigentlich stand alles gegen mich. Ich arbeite mit meinem Körper und male Frauenkörper, die meist nackt sind, weil ich maximal auf ihrer weiblichen Identität insistieren möchte. Sie sind triumphierend und sehr präsent.

Sie verarbeiten in Ihren sehr narrativen Zeichnungen mythische Geschichten und Legenden, oft mit direkten sexuellen Anspielungen. Was inspiriert sie? — Die Geschichten kommen alle von dort, wo ich herkomme, also vom Ursprung. Der Ursprung, das ist meine Mutter, das ist mein Land, das ist die Art, wie ich aufgewachsen bin. Ich verarbeite in meinen Bildern Geschichten, die sich afghanische Frauen untereinander erzählen, wenn sie über Männer, über Sex, über ihre Phantasmen sprechen. Durch die Unterdrückung, in der sie leben, werden sie im Mündlichen unglaublich aktiv, weil sie nichts auf eine pragmatische Weise leben dürfen. Wir haben in der persischen Sprache

auch eine lange Tradition erotischer Dichtung. Die Dichtungen von Rumi haben manche meiner Zeichnungen inspiriert.

Sie haben die Gefahr, die Künstlerinnen und Intellektuellen durch das Vorrücken der Taliban drohte, sofort erkannt und eine Evakuierungsaktion initiiert. Wie sind Sie vorgegangen? — Ich hatte schon Anfang Juli (2021) begonnen, eine Liste der gefährdeten Künstlerinnen aufzustellen. Maria-Carmela Mini, die Leiterin des Theater- und Tanzfestivals „Latitudes Contemporaines", mit der ich für meine Performances zusammenarbeite, war sofort bereit, mitzuhelfen. Wir mussten hier in Frankreich Einrichtungen finden, die sie aufnehmen können. Als ich diese Liste anlegte, waren schon einige Künstlerinnen umgebracht worden, die Gefahr war also reell. Wir haben zum Beispiel eine Schauspielerin aus Dschuzdschan kontaktiert, einer Provinz im Norden. Es gelang ihr, nach Kabul zu entkommen, von dort aus wollten wir sie weiter nach Frankreich bringen. Als ich sie in Kabul anrief, erzählte sie mir, dass kurz nachdem sie Dschuzdschan verlassen hatte, Taliban bei ihrer Familie nach ihr suchten. Sie wurde jetzt von einem französischen Theater aufgenommen. Wir haben im Juli (2021) sofort an den Visa gearbeitet und den Leuten gesagt, sie sollten sich mit ihren Pässen bereithalten. Zu diesem Zeitpunkt konnten wir uns noch nicht vorstellen, dass auch Kabul so schnell fallen würde. Maria-Carmela Mini und Joris Mathieu vom Centre Dramatique National Lyon arbeiteten mit einer Abteilung des Auswärtigen Amtes zusammen, während ich mit den Künstlerinnen vor Ort in Kontakt stand. Wir haben fast achtzig Leute evakuiert. Theater in vielen französischen Städten haben ihre Türen für die Künstlerinnen geöffnet und Wohnräume zur Verfügung gestellt. Auch Galerien haben Künstlerinnen integriert. Es ist nun aber nahezu unmöglich geworden, noch jemanden aus dem Land zu holen.

Wie ergeht es jenen, die im Taliban-Staat ausgegrenzt oder gefährdet sind: Frauen, Künstlerinnen und Intellektuellen? — Für sie alle gibt es jetzt nichts mehr zu tun. Wenn Frauen auf die Straße gehen wollen, müssen sie von einem Mann begleitet werden. Sie wurden aus ihren Arbeitsstellen gedrängt. Das Neueste ist, dass Frauen auf offener Straße kein Smartphone mehr benutzen dürfen. In Kabul sieht man noch einige Frauen ohne Burka, es ist ein Zeichen für Widerstand. Aber außerhalb von Kabul ist das nicht mehr möglich. Künstlerinnen und Intellektuelle sind alle gefährdet, sie können nicht in ihren Wohnungen bleiben und wechseln nun ständig den Aufenthaltsort. Sie können auf niemanden mehr zählen, denn auch ihre Künstlerfreunde sind auf der Flucht. Alle versuchen sich zu verstecken. Viele Künstlerinnen haben ihre Arbeit und alle Dokumente zerstört, bevor sie geflohen sind, denn das ist Beweismaterial, das sie zu ihrer Sicherheit und der ihrer Familien vernichten mussten. Andere haben ihre Werke versteckt. Die Taliban haben schon seit Langem Listen angelegt. Schon seit dem letzten Jahr sind Journalistinnen ermordet worden, auch Menschenrechtsaktivistinnen.

Glauben Sie, dass die junge, vernetzte Generation Widerstand leisten kann? — Gerade die jüngeren Frauen sind nach diesen zwanzig Jahren mehrheitlich gegen die Taliban. Für afghanische Männer stellt sich nicht dasselbe Problem, sie haben viel weniger zu verlieren. Die Einzigen, die derzeit mit Plakaten „Wir brauchen Erziehung" auf der Straße stehen, sind Frauen, aber man hält ihnen ein Gewehr unter die Nase. Es müsste Unterstützung von außen kommen, von Politikerinnen aus der ganzen Welt. Afghanistan ist zu einer Falle geworden, einem Friedhof. Die Menschen hungern, die kulturellen und ethnischen Säuberungen haben begonnen.

Dieses Interview erschien in: F.A.Z., 14.10.2021, Feuilleton, S. 9, © Alle Rechte vorbehalten, Frankfurter Allgemeine Zeitung GmbH, Frankfurt. Zur Verfügung gestellt vom Frankfurter Allgemeine Archiv. Im Einverständnis mit der Autorin Bettina Wohlfarth wurde der Text mit kleinen Änderungen und einer dem Katalog entsprechenden Anpassung ans generische Femininum übernommen.

QUAND LES ARMES REMPLACENT L'ÉDUCATION

L'ARTISTE AFGHANE KUBRA KHADEMI À PROPOS DES TALIBANS, DE CULTURE ET D'ÉROTISME

Née en 1989 dans la province de Ghor, Kubra Khademi aborde à travers ses performances et ses dessins à la gouache grand format les violences de la société patriarcale de son pays d'origine. Une performance en pleine rue à Kaboul lui a valu des menaces de mort et elle a dû quitter son pays en 2015. Réfugiée en France, elle vit aujourd'hui à Paris. L'été 2021, elle a largement contribué à l'évacuation d'artistes afghanes en danger. En printemps 2022, Khademi a participé à l'exposition *Walk* à la Schirn de Francfort, tandis que le Museum Pfalzgalerie de Kaiserslautern lui consacre une exposition personnelle.

Avez-vous jamais eu l'espoir que l'Afghanistan puisse devenir un État plus libre, voire démocratique? — La période de l'occupation soviétique et du premier régime taliban a été très sombre. Enfant, j'ai fait l'expérience qu'il n'y avait pas de vie pour moi dans ce pays. Lorsque les talibans ont été chassés par les forces américaines, j'avais douze ans, et pour moi, comme pour beaucoup d'Afghanes, c'était la fête. Soudain, un immense espoir est né en nous. Nous étions alors réfugiés au Pakistan avec ma famille, car nous appartenions à la minorité hazara persécutée par les talibans. Depuis 2001, les choses avaient incroyablement changé, du moins à Kaboul et dans d'autres grandes villes ; nous avons obtenu beaucoup pour les femmes et l'éducation. Dans ma famille, je suis la pre-mière fille à être allée à l'école. J'ai même pu étudier dans des écoles d'art à Kaboul et à Lahore.

Que s'est-il passé en vous lorsqu'il a été clair que les talibans allaient reprendre le pays? — En tout premier, j'ai pensé aux femmes, au terrible sort qui les attend désor-mais. Ça m'a mise et me met encore incroyablement en colère. Aujourd'hui, les talibans offrent des jeunes filles aux soldats pakistanais pour produire la prochaine génération de talibans. L'Afghanistan sera à l'avenir un vivier pour le terrorisme. Sous ce régime, les femmes sont plus que jamais réduites à l'état d'esclaves sexuelles, on leur met la burqa sur la tête et on leur demande de faire des enfants. Si c'est un garçon, c'est un triomphe, si c'est une fille, c'est une honte. En Afghanistan, il y a une culture de la violence sexuelle. Ce patriarcat a liquidé toute morale, il paralyse notre société.

Est-ce l'une des raisons pour lesquelles le corps féminin est au cœur de votre travail, que ce soit dans vos performances ou vos dessins ? — Mon travail prend naissance au plus profond de l'histoire de ma vie. Mon corps est pour moi ce qu'il y a de plus personnel. Tout vient de cette existence qui ne devrait pas exister, qui a été maltraitée parce qu'elle était féminine. En tant que fille, il faut se battre à tout moment pour prouver que l'on peut réfléchir et décider, que l'on peut exister sans avoir honte. Mon art a beaucoup à voir avec ça. Quand je regarde en arrière, je vois que tout était contre moi. Je travaille avec mon corps et je peins des corps de femmes, la plupart du temps nus, parce que je veux insister au maximum sur leur identité féminine. Elles sont triomphantes et très présentes.

Vos dessins sont très narratifs et traitent d'histoires et légendes mythiques, souvent avec des allusions sexuelles directes. Qu'est-ce qui les inspire ? — Les histoires viennent toutes de là d'où je viens, c'est-à-dire de l'origine. L'origine, c'est ma mère, c'est mon pays, c'est la façon dont j'ai grandi. Dans mes tableaux, j'intègre des histoires que les femmes afghanes se racontent entre elles lorsqu'elles parlent des hommes, du sexe, de leurs fantasmes. L'oppression dans laquelle elles vivent les rend incroyablement actives dans l'oralité, car elles ne peuvent rien vivre de manière pragmatique. Nous avons égale-ment une longue tradition de poésie érotique dans la langue persane. La poésie de Rûmî a ainsi inspiré certains de mes dessins

Vous avez immédiatement pris conscience du danger que représentait l'avancée des talibans pour les artistes et intellectuelles et vous avez lancé une opération d'évacuation. Comment avez-vous fait ? — J'avais déjà commencé début juillet (2021) à établir une liste des artistes en danger. Maria-Carmela Mini, la directrice du festival de théâtre et de danse « Latitudes Contemporaines », avec laquelle je collabore pour mes performances, a tout de suite accepté de nous aider. Il fallait trouver des structures à même de les accueillir, ici, en France. Lorsque j'ai fait cette liste, plusieurs artistes avaient déjà été tuées, le danger était donc réel. Nous avons par exemple contacté une comédienne de Djôzdjân, une province du nord. Elle a réussi à s'enfuir à Kaboul, d'où nous voulions la faire venir en France. Quand je l'ai appelée à Kaboul, elle m'a dit que peu après avoir quitté Djôzdjân, des talibans étaient venus la chercher dans sa famille. Maintenant, elle a été accueillie par un théâtre français. En juillet nous avons immédiatement travaillé sur les visas et dit aux gens de se tenir prêts avec leurs passeports. À ce moment-là, nous ne pouvions pas encore imaginer que Kaboul tomberait aussi rapidement. Maria-Carmela Mini et Joris Mathieu du Centre Dramatique National de Lyon ont travaillé avec un service du ministère des Affaires étrangères, tandis que j'étais en contact avec les artistes sur place. Nous avons évacué près de 80 personnes. Dans de nombreuses villes françaises, des théâtres ont ouvert leurs portes aux artistes et mis des espaces de vie à disposition. Des galeries, aussi, ont intégré des créatrices. Mais entre-temps il est quasiment impossible de faire sortir quiconque de là-bas.

Que se passe-t-il pour les personnes exclues ou menacées par l'État taliban – femmes, artistes, intellectuelles ? — Pour toutes et tous, il n'y a désormais plus rien à faire. Si les femmes veulent sortir dans la rue, elles doivent être accompagnées d'un homme. Elles ont été évincées de leurs postes. La dernière nouveauté est que les femmes n'ont plus le droit d'utiliser de téléphone mobile dans la rue. À Kaboul, on voit encore quelques femmes sans burqa, c'est un signe de résistance. Mais en dehors de Kaboul, ce n'est plus possible. Les artistes et les intellectuelles sont toutes en danger, elles ne peuvent plus rester chez elles et changent constamment de lieu de résidence. Elles ne peuvent plus compter sur personne, car leurs amies artistes sont elles aussi en fuite. Toutes essaient de se cacher. De nombreuses artistes ont détruit leur travail et tous leurs documents avant de s'enfuir, pour ne pas menacer leur sécurité ni celle de leur famille. D'autres ont caché leurs œuvres. Les talibans les ont listées depuis longtemps. Depuis l'année dernière déjà, des journalistes ont été assassinées, y compris des militantes des droits humains.

Pensez-vous que la jeune génération connectée puisse résister ? — Ce sont justement les jeunes femmes qui, après ces vingt années, sont majoritairement contre les talibans. Pour les hommes afghans, le problème n'est pas le même, ils ont beaucoup moins à perdre. Les seules actuellement dans la rue avec des pancartes « Nous avons besoin d'éducation » sont des femmes, mais on leur met un fusil sous le nez. Il faudrait que le soutien vienne de l'extérieur, de femmes politiques du monde entier. L'Afghanistan est devenu un piège, un cimetière. Les gens ont faim, le nettoyage culturel et ethnique a commencé.

Cette interview a paru dans les pages culture de la *Frankfurter Allgemeine Zeitung* du 14 octobre 2021, p. 9, © Tous droits réservés, Frankfurter Allgemeine Zeitung GmbH, Francfort. Mis à disposition par Frankfurter Allgemeine Archiv. En accord avec l'autrice Bettina Wohlfarth, le texte a été repris avec quelques modifications et adapté au féminin générique selon la règle choisie pour ce catalogue.

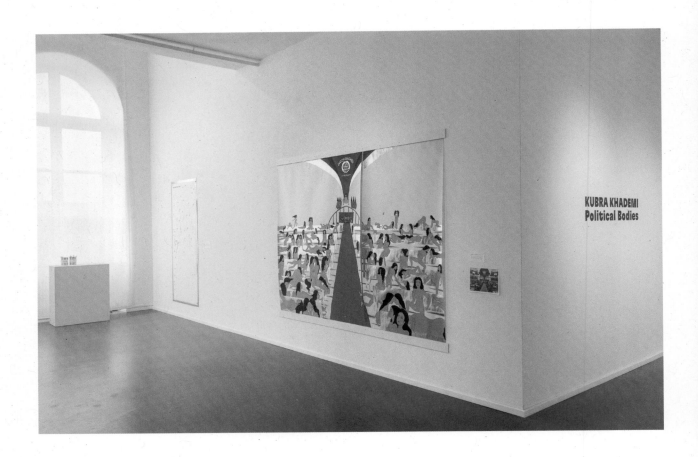

KUBRA KHADEMI
Political Bodies

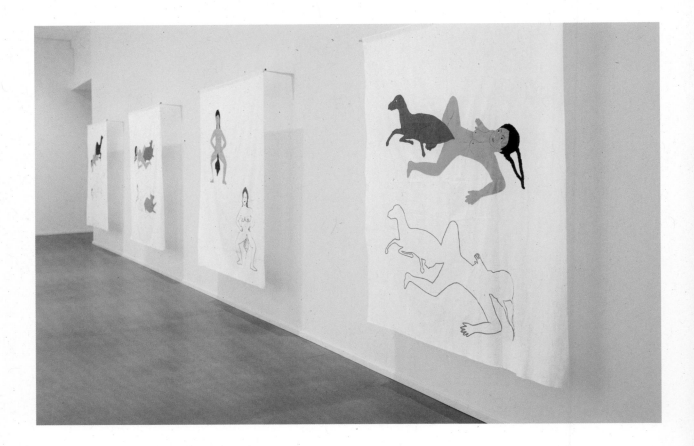

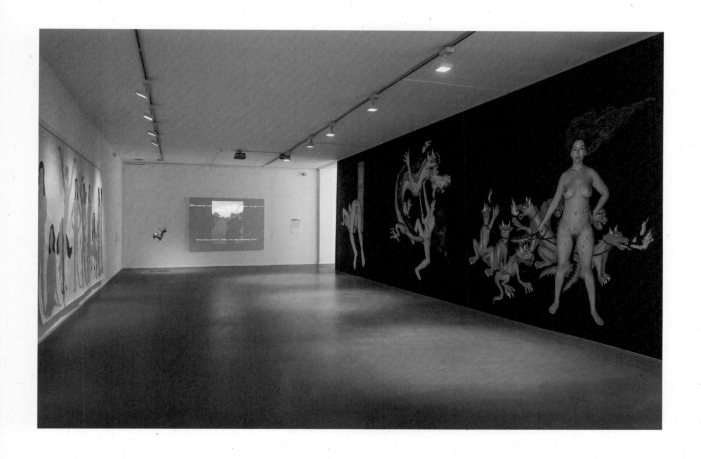

pp. | S. 70–77 Exhibition views | Ausstellungsansichten | vues de l'exposition *Kubra Khademi – Political Bodies*
at | im | au Museum Pfalzgalerie Kaiserslautern, 2022

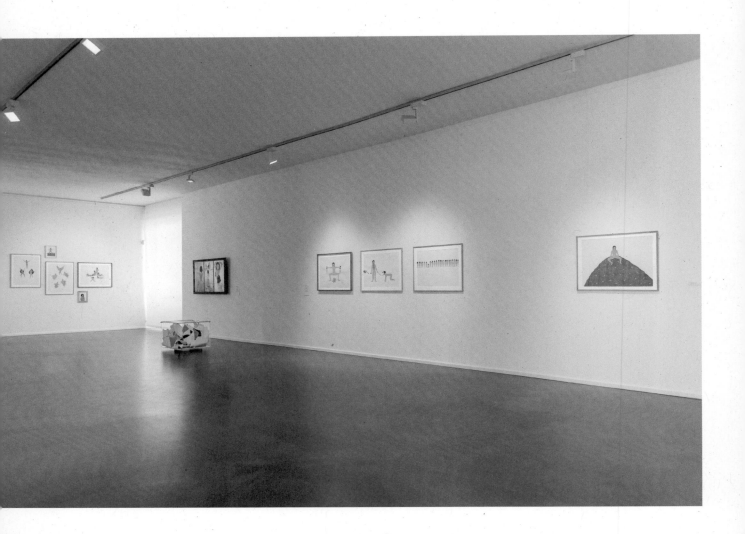

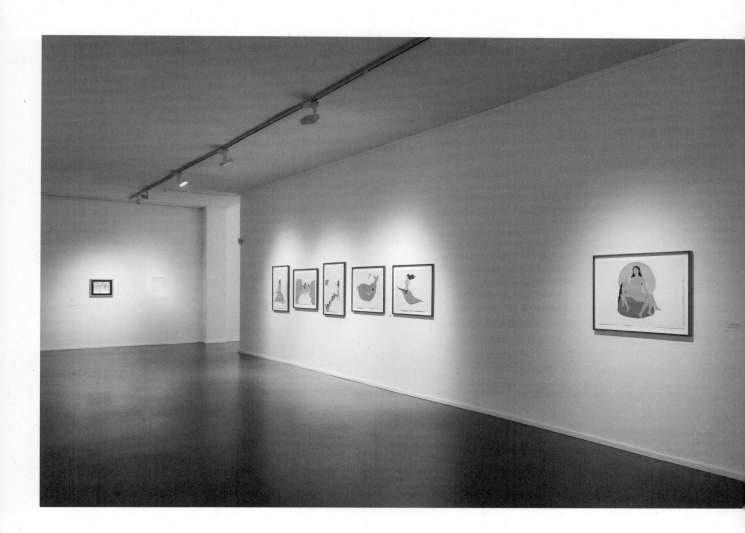

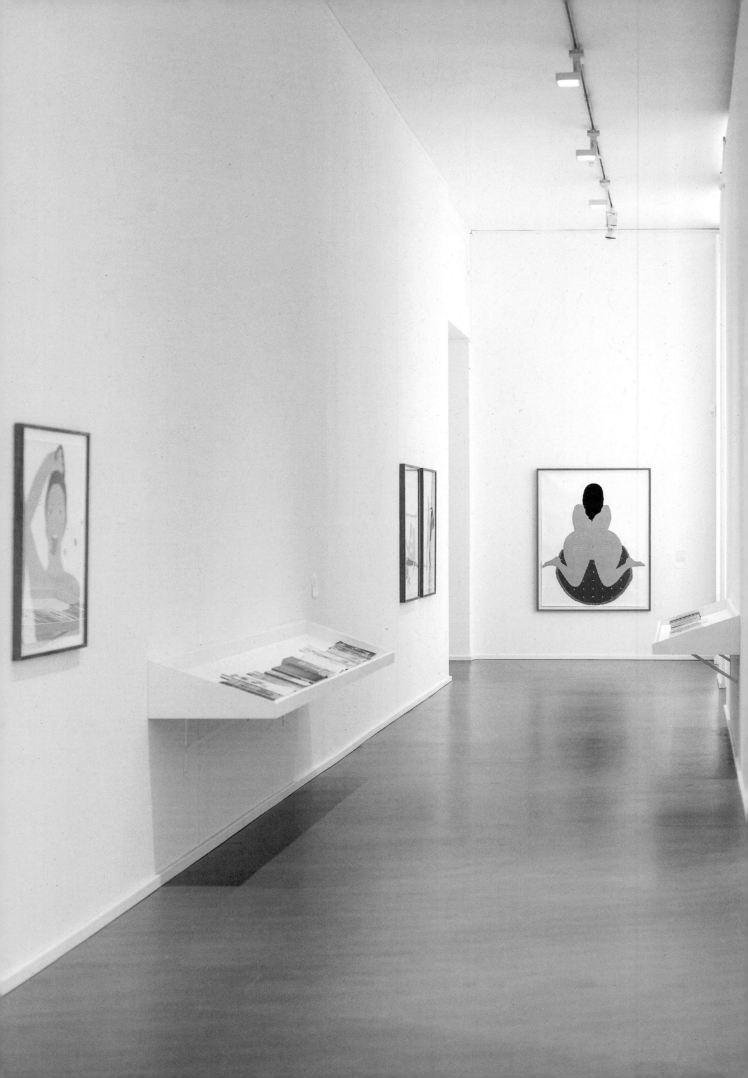

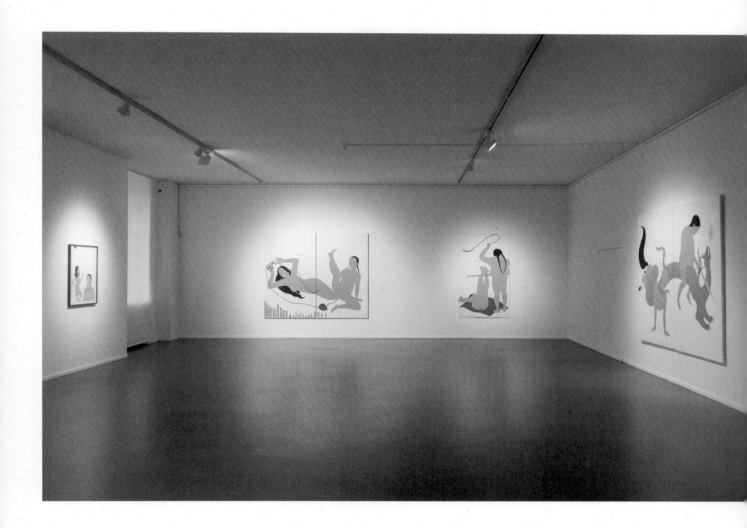

I am (not) a feminist, because...
Ich bin (K)ein*e Feminist*in, weil...
Je suis (pas) féministe parce que...

Weil die Welt
schön und noch
immer von Sexismus
geprägt ist.
Und Sexismus
bedeutet Hass
und Ungerechtigkeit.

For a more equal world, I want to see...
Für eine gleichberechtigtere Welt
wünsche ich mir...
Pour un monde plus égalitaire, je
souhaite...

... WENIGER
STEREOTYPEN...

!!!

I am (not) a feminist, be
Ich bin (k)ein*e Feminis
Je suis (pas) féministe

guns, fetuses and
corpses still have m
than a woman - no
how old she is - no
situations.

I am (not) a feminist, because...
Ich bin (k)ein*e Feminist*in, weil...
Je suis (pas) féministe parce que.

unser Frauenbild ein
Relikt des 19. Jhd. ist
Ohne Frauen wie kubra
keine Veränderung
stattfindet.

Danke Kubra
Danke mpk

I am (not) a feminist, because...
Ich bin (k)ein*e Feminist*in, weil...
Je suis (pas) féministe parce que

les femmes vont
avancer le
monde !

K

ania

I think that...
Ich denke, dass...
Je pense que...

LA LUMIÈRE
TRIOMPHERA DE
L'OMBRE -

PAIX
LUMIÈRE
SERENITE

KUBAH

G

I think that...
Ich denke, dass...
Je pense que...

Ich froh bin
in Europa
zu leben !

YES!
I am (not) a feminist, because...
Ich bin (k)ein*e Feminist*in, weil...
Je suis (pas) féministe parce que...

I am a woman!
but if I am a
man, I would
be a feminist, too

For a more equal world, I want to see...
Für eine gleichberechtigtere Welt
wünsche ich mir...
Pour un monde plus égalitaire, je
souhaite...

more
art
by
women
♡

I am (not) a feminist, because...
Ich bin (k)ein*e Feminist*in, weil...
Je suis (pas) féministe parce que...

I like being
a woman and
I want to fight
for our rights.

I think that...
Ich denke, dass... es
Je pense que...

notwendig
mutig
sein.
Sonst
sich

I am (not) a feminist, because...
Ich bin (k)ein*e Feminist*in, weil...
Je suis (pas) féministe parce que...

I HAVE TO

For a more equal world, I want to see...
Für eine gleichberechtigtere Welt
wünsche ich mir...

For a more equal world, I want to see...

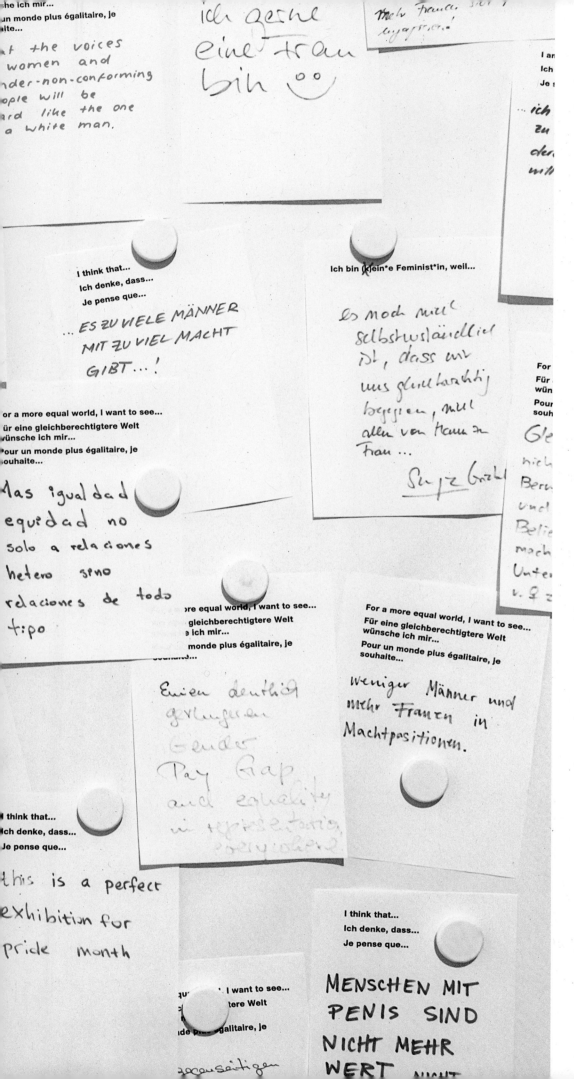

WORKS WERKE ŒUVRES

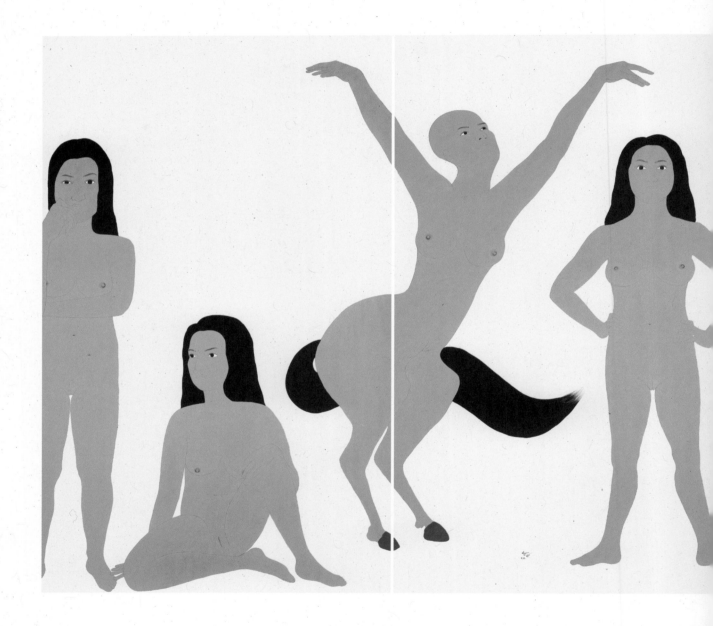

Cat. | Kat. **1** خط مقدم, *Front Line*, From the Two Page Book, 2020

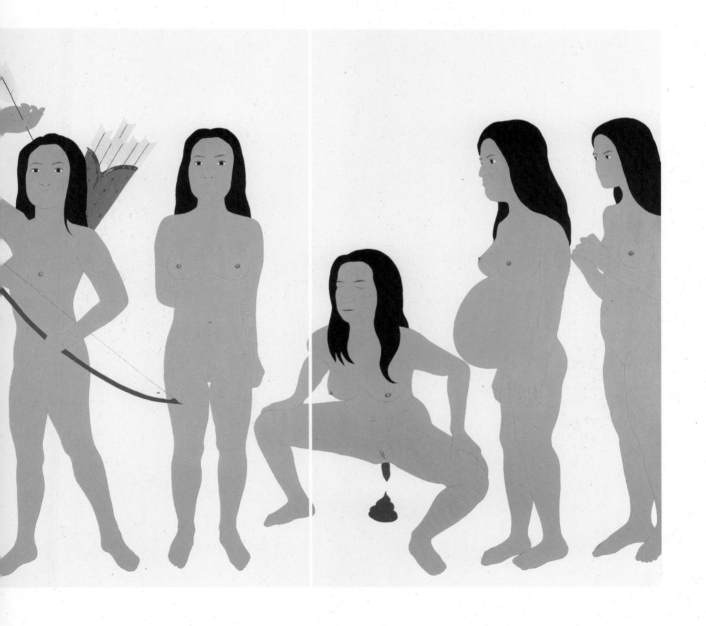

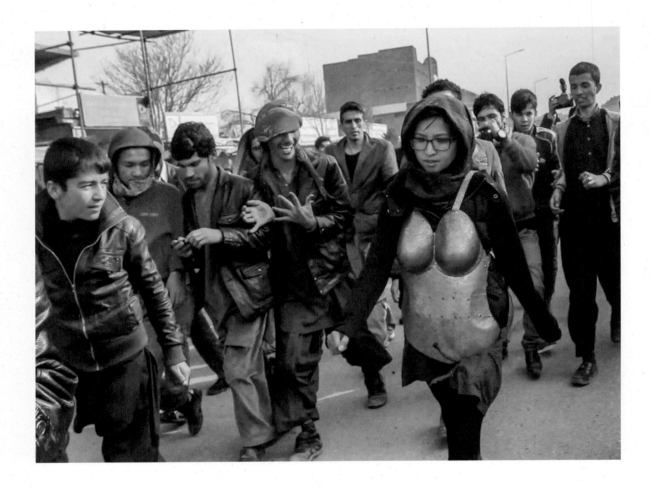

Cat. | Kat. 2 زره, *Armor*, 2015

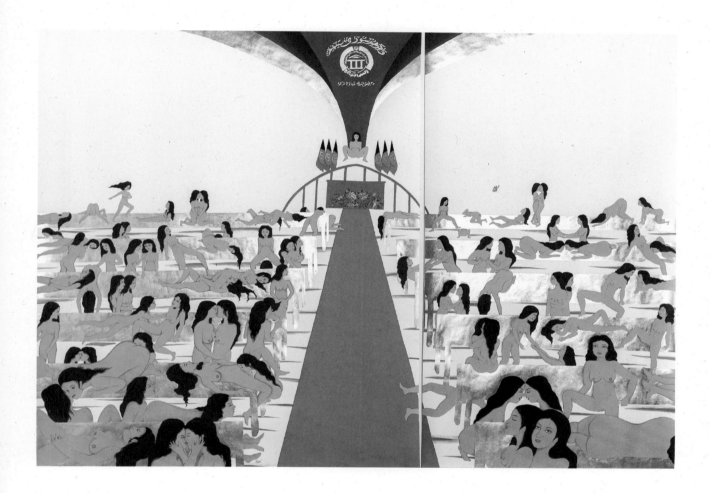

Cat. | Kat. **3** پارلمان افغانستان , *Parliament Scene*, 2021

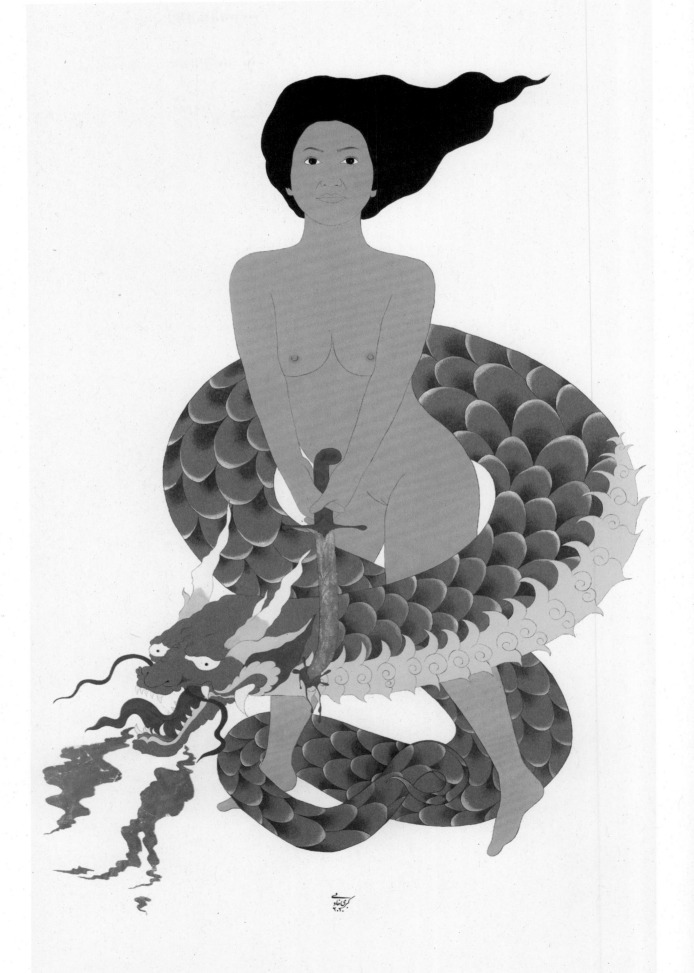

Cat. | Kat. **5** *The Thousands Pussy, La Mille Chattes,*
Thousands Pussies & the Dragon, Mille Chattes et le
Dragon, 2021

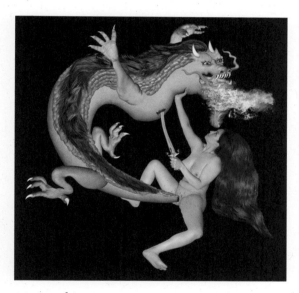

Cat. | Kat. **6** اژدها, *Dragon*, Thousands Pussies &
the Dragon, Mille Chattes et le Dragon, 2021

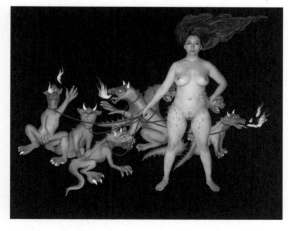

Cat. | Kat. **7** هفت اژدها, *The Seven Baby Dragons,*
Thousands Pussies & the Dragon, Mille Chattes et le
Dragon, 2021

Cat. | Kat. **4** بدون عنوان, *Untitled,*
From the Two Page Book, 2020

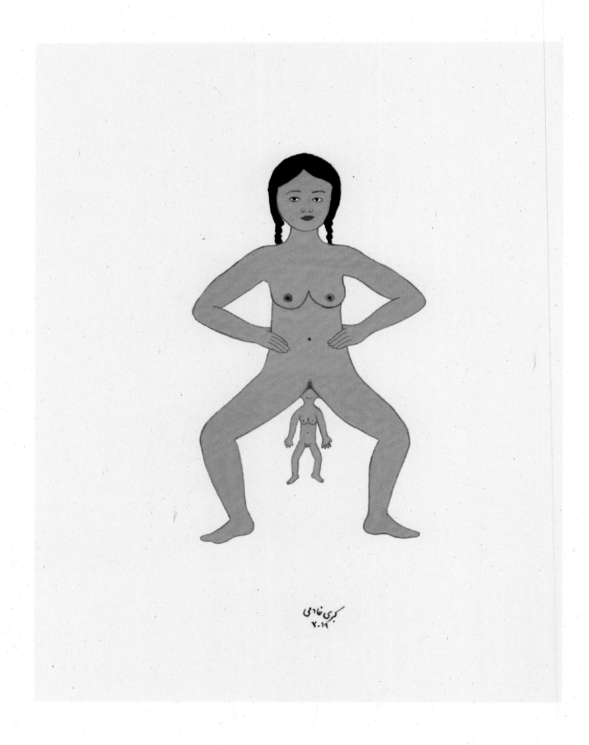

Cat. | Kat. **9** بدون عنوان, *Untitled*, Birth Giving, 2020

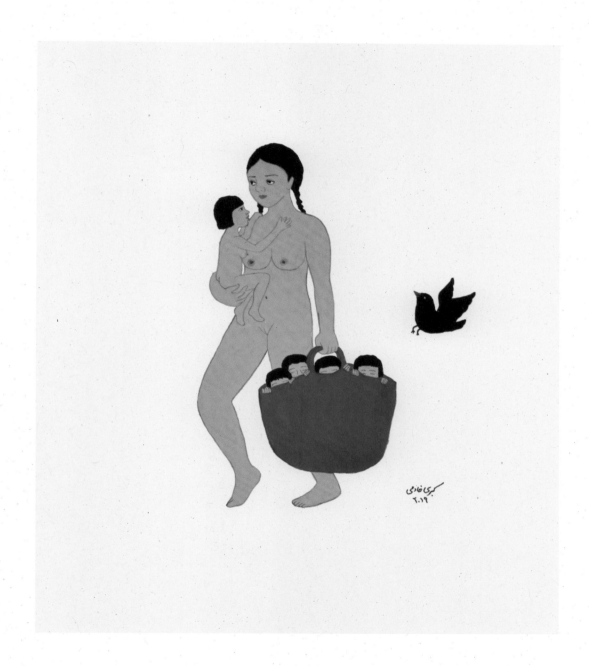

Cat. | Kat. **11** بدون عنوان, *Untitled*, Birth Giving, 2020

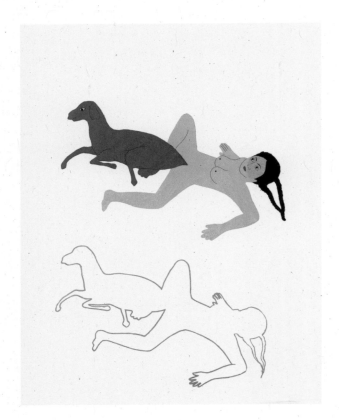

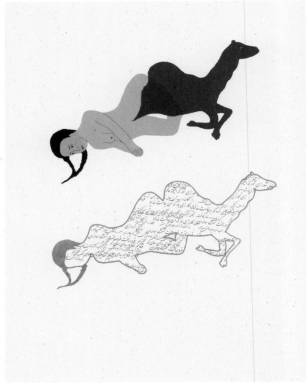

Cat. | Kat. **12** زاییدن, *The birth giving #01,*
Birth Giving, 2021

Cat. | Kat. **13** زاییدن, *The birth giving #04,*
Birth Giving, 2021

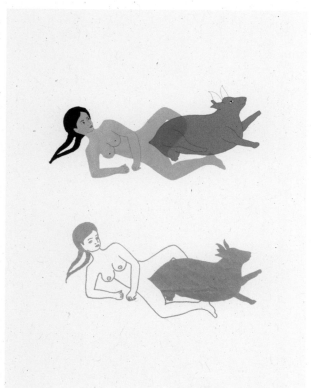

Cat. | Kat. **14** زاییدن, *The birth giving #03,*
Birth Giving, 2021

Cat. | Kat. **15** زاییدن, *The birth giving #08,*
Birth Giving, 2021

Cat. | Kat. **17** جرایم زنانه, *Untitled*, بدون عنوان,
Female Crimes, 2021

Cat. | Kat. **18** جرایم زنانه, *Untitled*, بدون عنوان,
Female Crimes, 2021

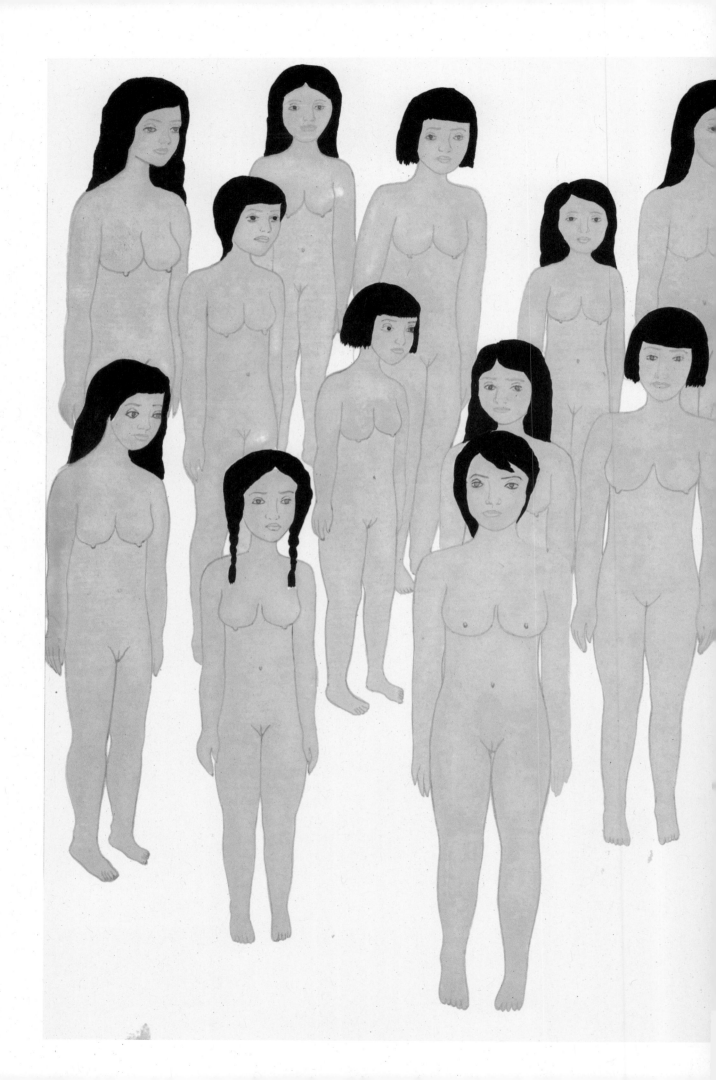

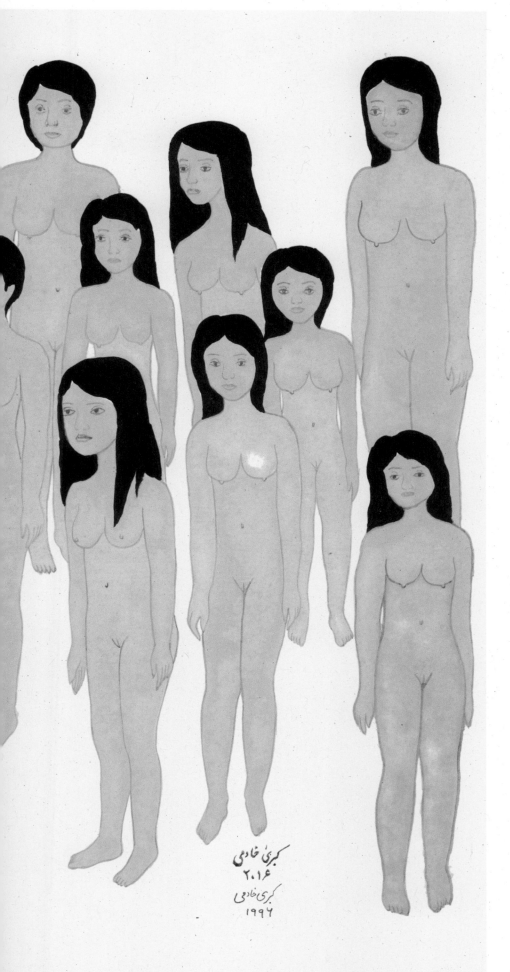

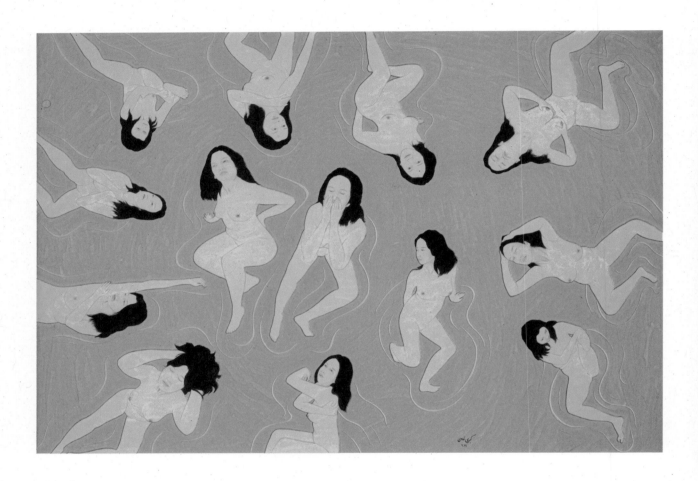

Cat. | Kat. **20** *Washing the Sins*, 2019

Cat. | Kat. **21** *Relaxed*, 2019

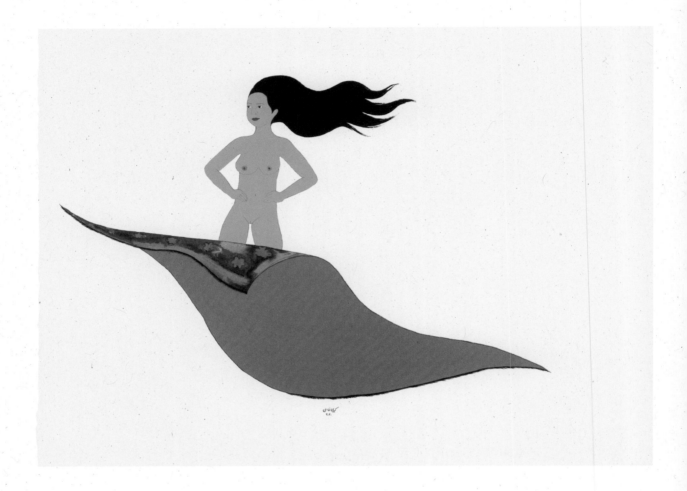

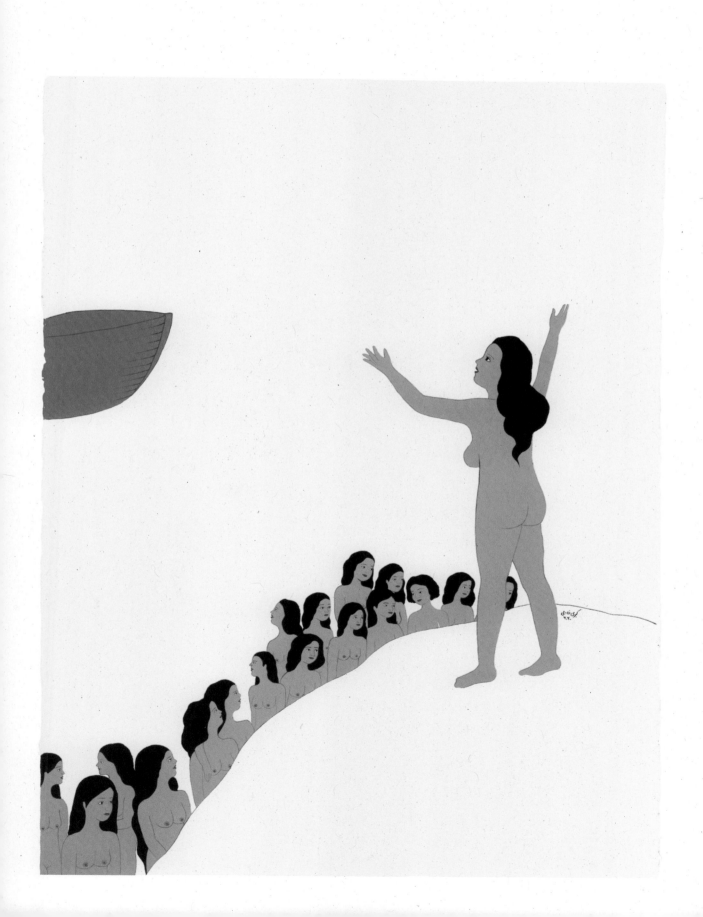

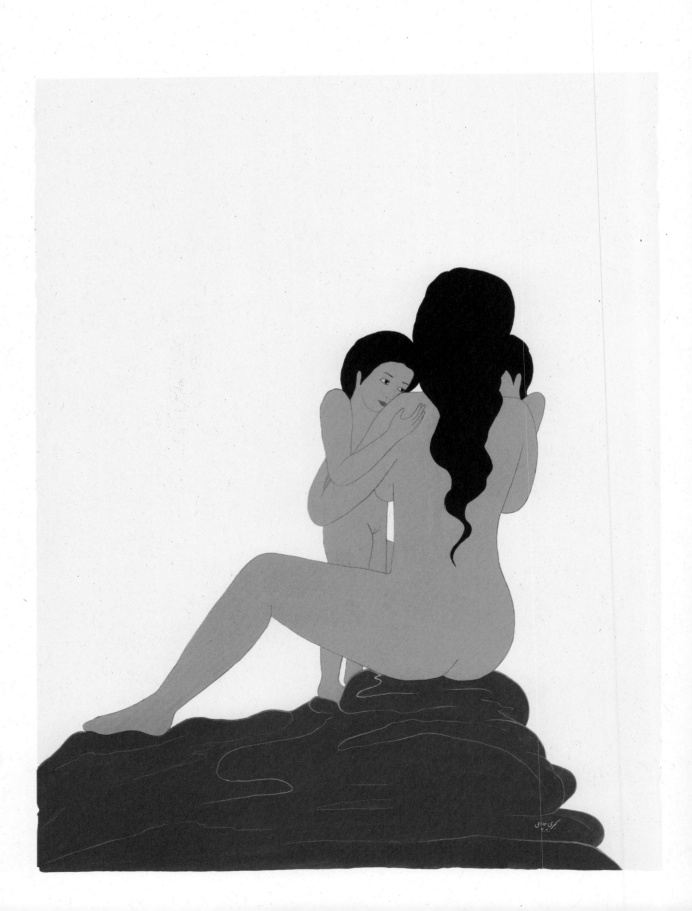

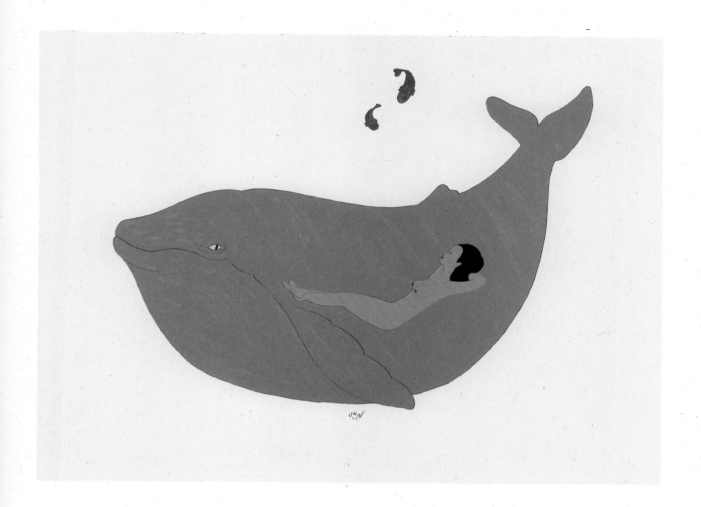

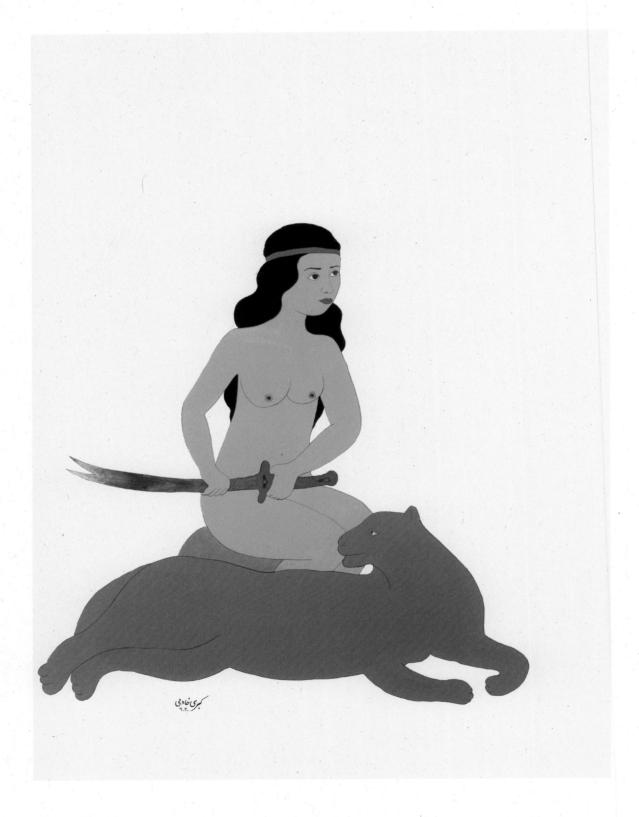

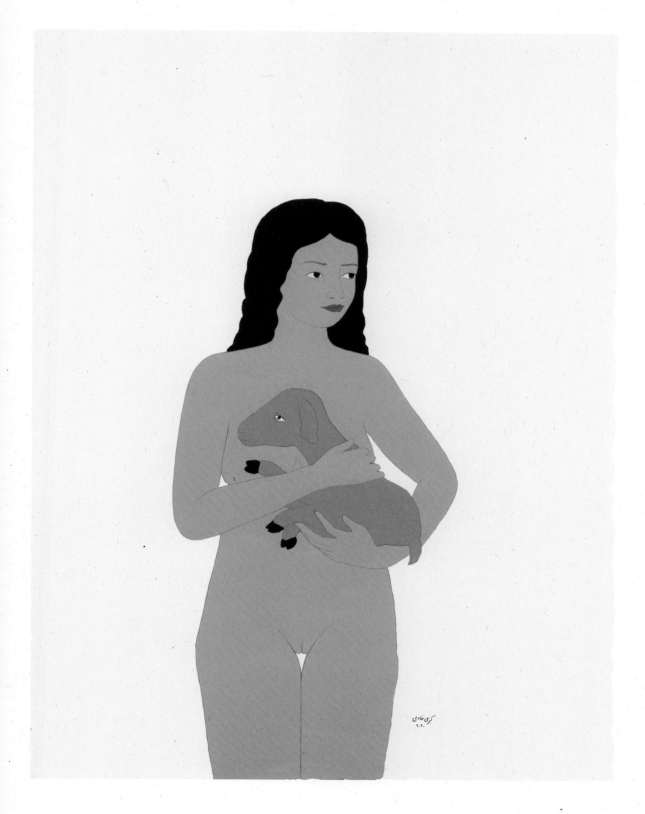

Cat. | Kat. 27 بدون عنوان, *Untitled #20*, Ordinary Women, 2020

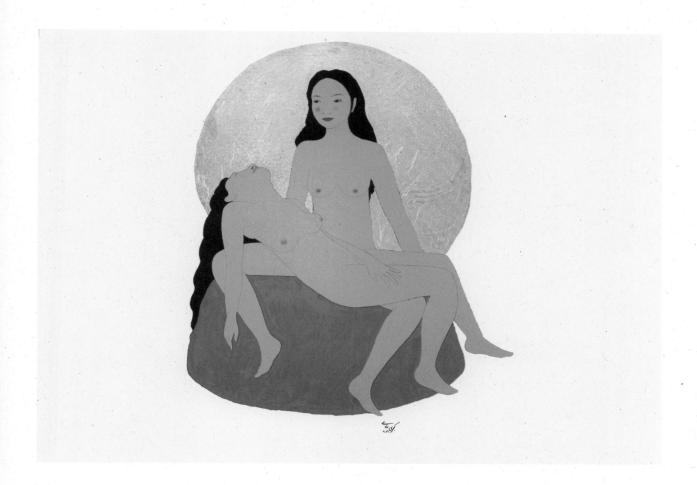

Cat. | Kat. **29** بدون عنوان , *Untitled (Pietà)*, 2019

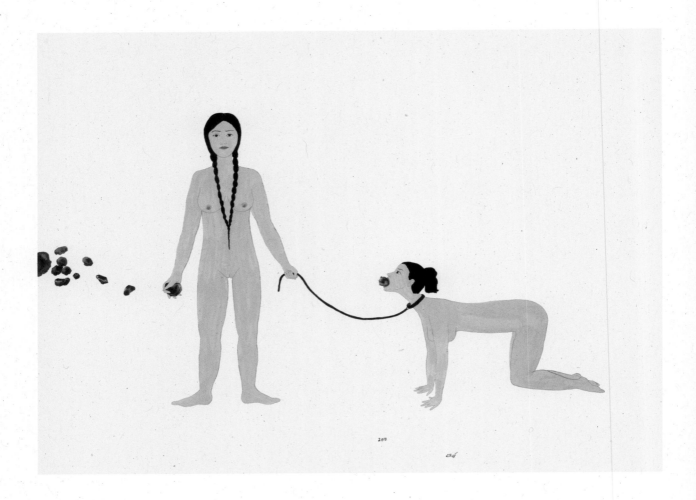

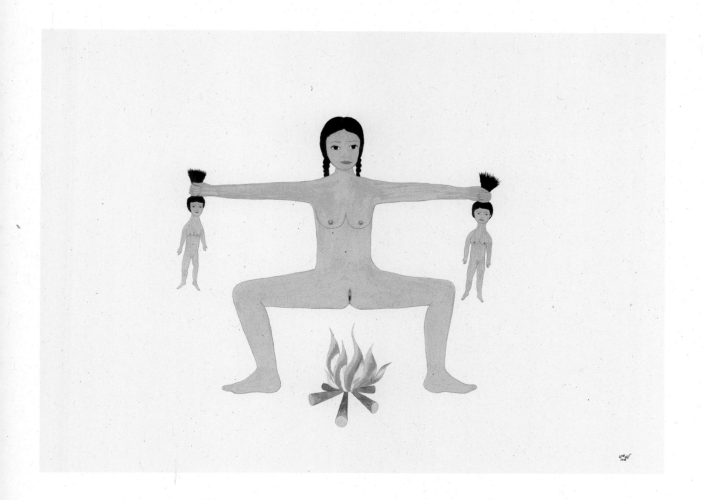

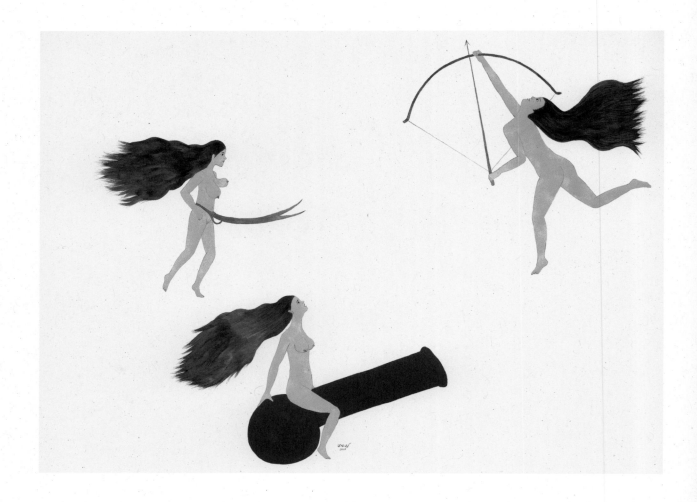

Cat. | Kat. **33** پرقچه ها ,*Untitled*, بدون عنوان, Paraqcha Ha, 2018

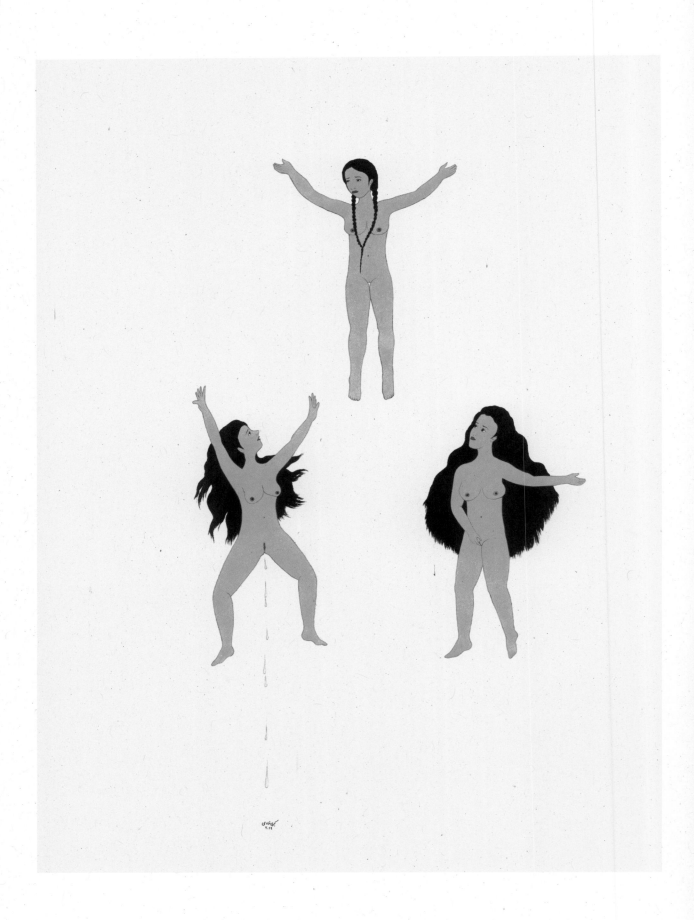

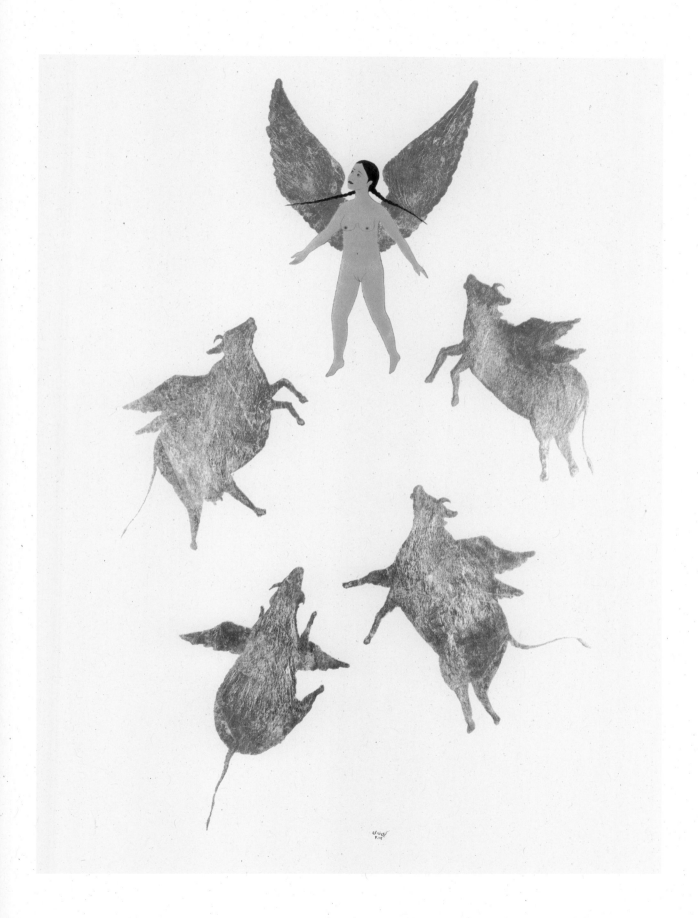

Cat. | Kat. **35** مهریه, *Dowry*, پرقچه ها, Paraqcha Ha, 2019

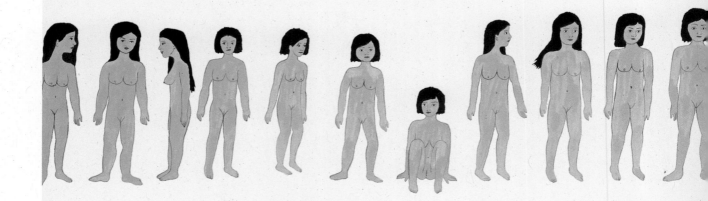

Cat. | Kat. **36** پرچه ها, *Untitled*, بدون عنوان, Paraqcha Ha, 2018

Cat. | Kat. 37 *Girl licking lollipop*, 2019

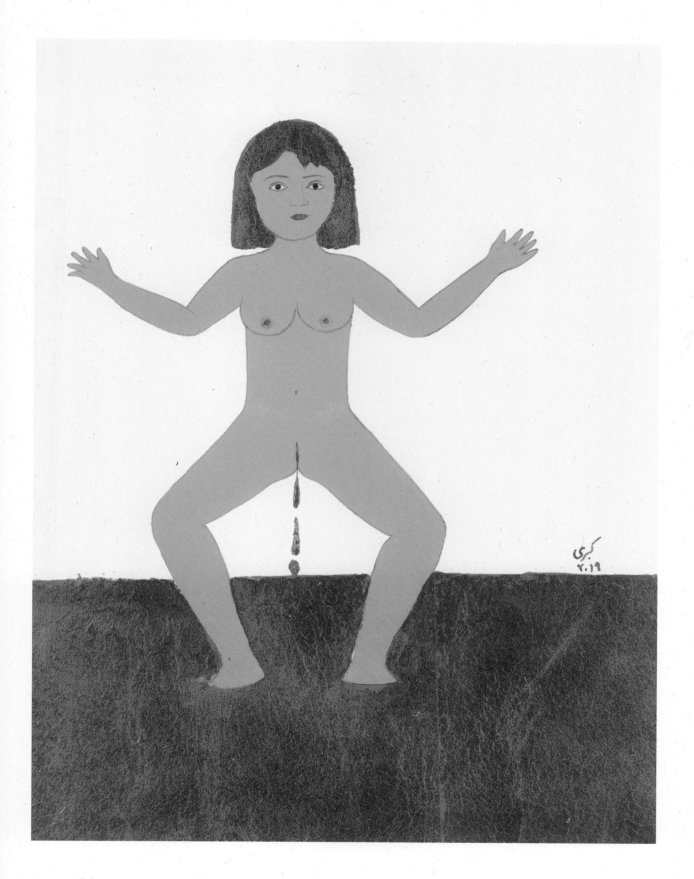

Cat. | Kat. **38** *Bloody girl*, 2019

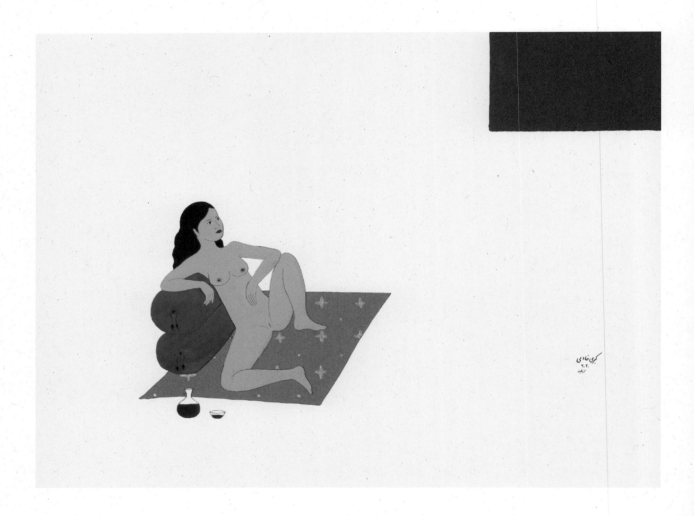

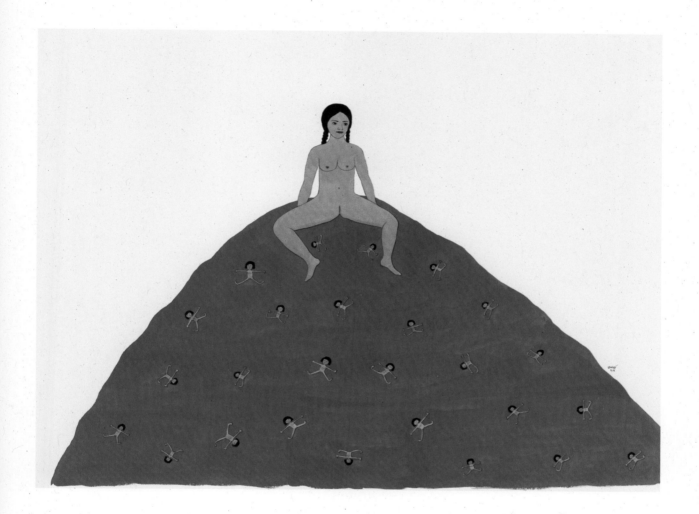

Cat. | Kat. **40** فرش قرمز, *Red carpet*, پرقچه ها, Paraqcha Ha, 2019

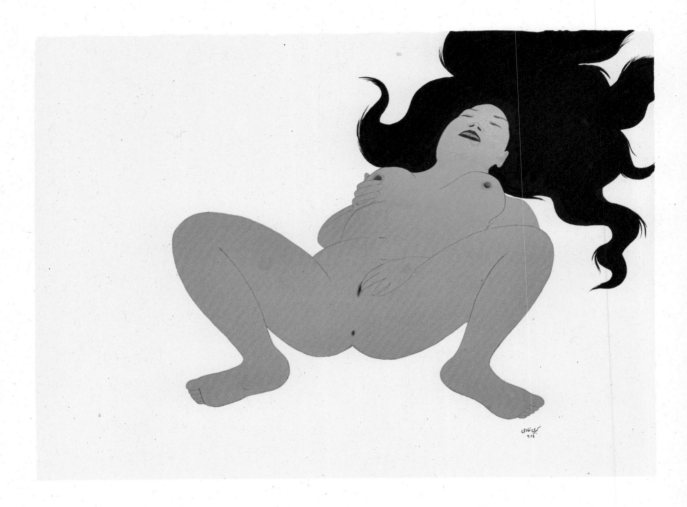

Cat. | Kat. **41** *Untitled (Autoportrait)*, 2020

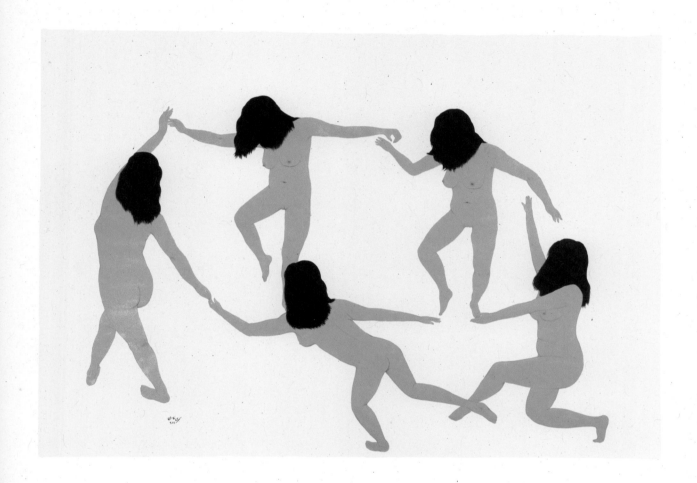

Cat. | Kat. **42** بدون عنوان, *Untitled (Cinq femmes en dansant)*, 2019

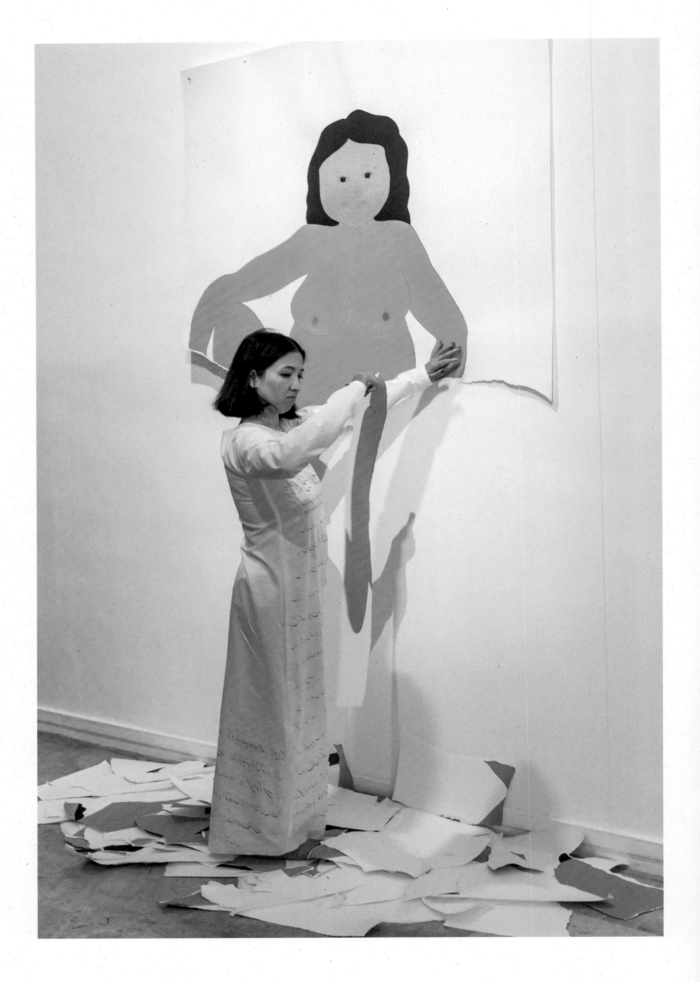

Cat. | Kat. **43** *The Creation – Power and Destruction*, 2021

Cat. | Kat. **44** بدون عنوان, *Untitled*, The Creation – Power and Destruction, 2021

120

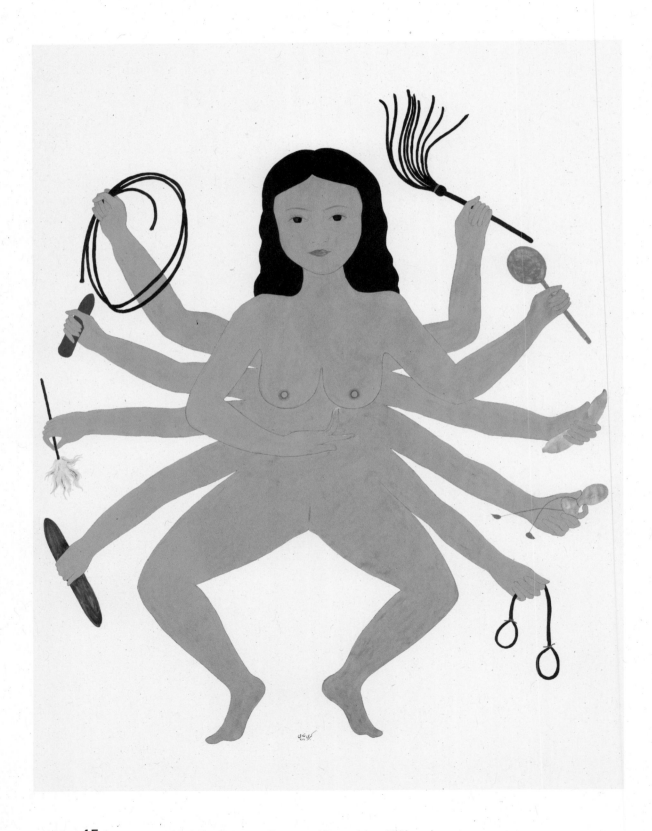

Cat. | Kat. **45** بدون عنوان, *Untitled*, The Creation – Power and Destruction, 2021

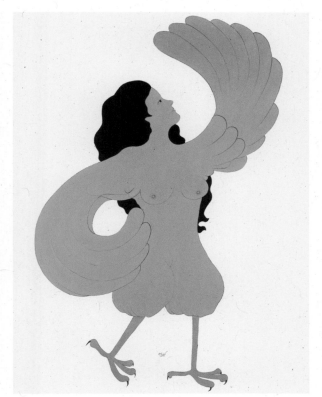 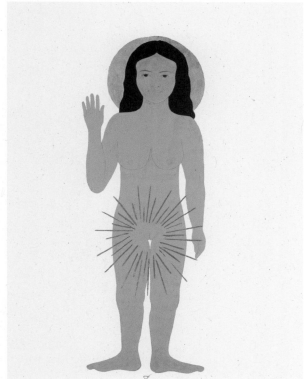

Cat. | Kat. **46** بدون عنوان, *Untitled*, The Creation –
Power and Destruction, 2021

Cat. | Kat. **47** بدون عنوان, *Untitled*, The Creation –
Power and Destruction, 2021

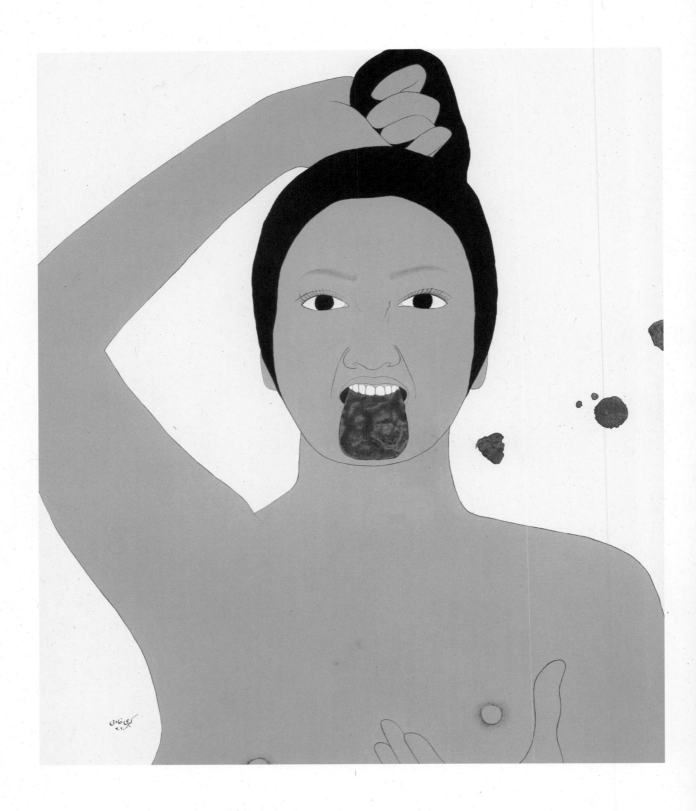

Cat. | Kat. **48** *A woman with red words & her head*, From the Two Page Book, 2020

Cat. | Kat. **49** *A woman and her head*, From the Two Page Book, 2020

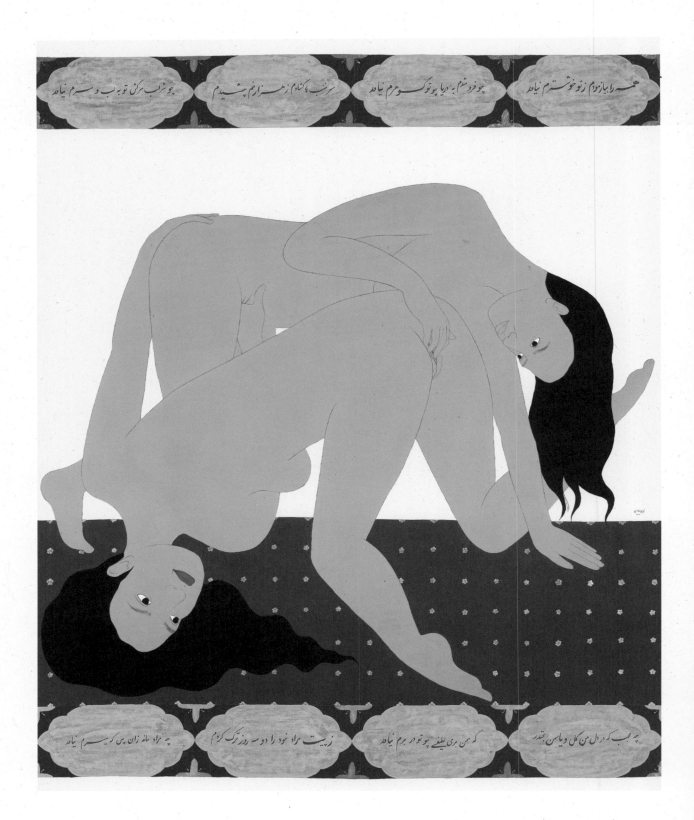

Cat. | Kat. **50** در آستانه, *In the Realm*, From the Two Page Book, 2020

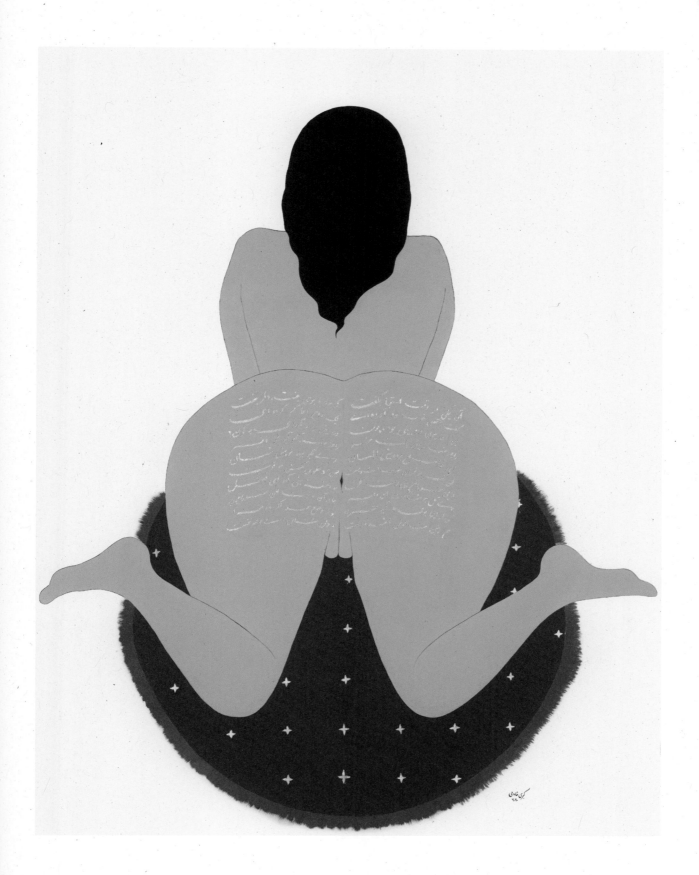

Cat. | Kat. **51** کتاب دو ورقی, *The Two Page Book*, From the Two Page Book, 2020

Cat. | Kat. **53** توشه راه ۲, *Bagage de route #1*, From the Two Page Book, 2020

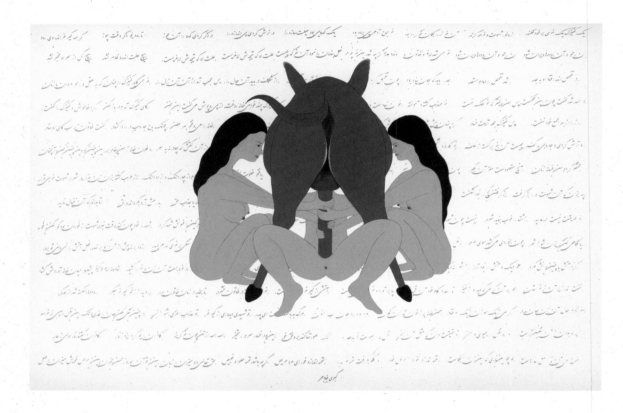

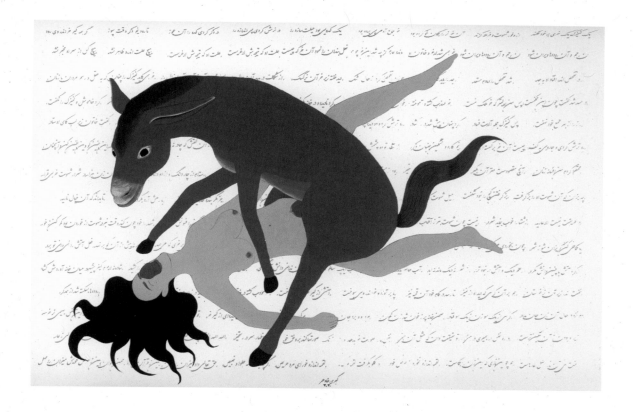

گر بیدل و بی دستم
وز عشق تو پابستم

کبری خادی
۲.۲.

Cat. | Kat. **57** ۳ دید منحرف, *Deviant-Vision #3,*
From the Two Page Book, 2020

Cat. | Kat. **58** ۵ دید منحرف, *Deviant-Vision #5,*
From the Two Page Book, 2020

132

Cat. | Kat. **59** ۶ دید منحرف, *Deviant-Vision #6,*
From the Two Page Book, 2020

Cat. | Kat. **60** ۱۴ دید منحرف, *Deviant-Vision #14,*
From the Two Page Book, 2020

روزیکه عدم جانب اعلا گیرد

روزیکه وجود ما تولد گیرد

تا آتش اقبال کہ بالا گیرد

تا قبضہ شمشیر کہ آلاید خون

کبری خادمی
۲۰۲۱

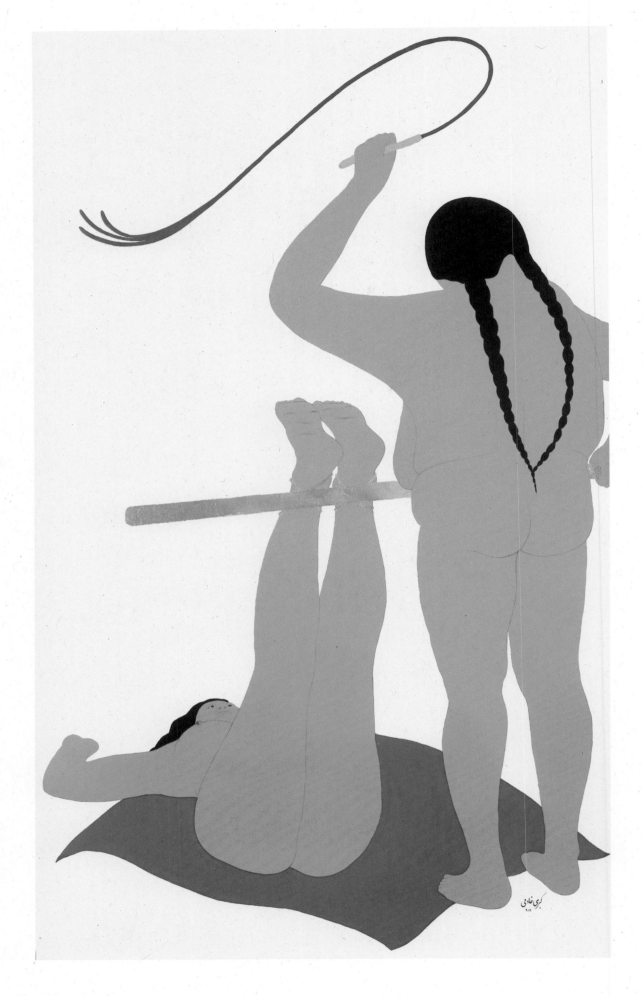

Cat. | Kat. **62** فلک, *Falak*, 2019

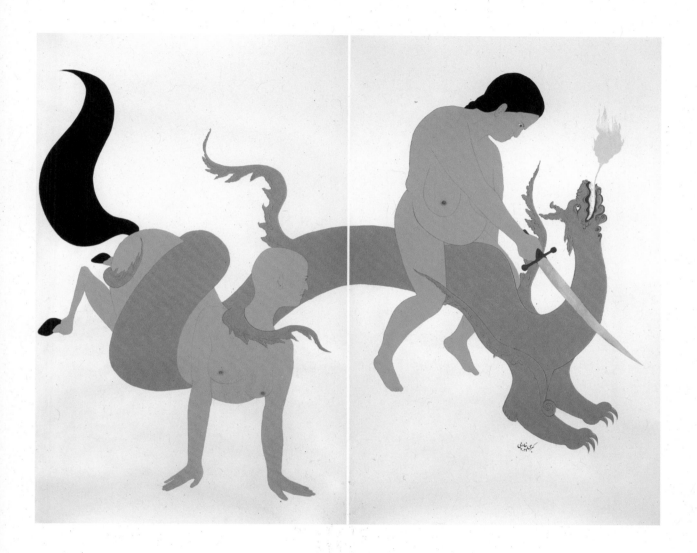

Cat. | Kat. **63** جنگ گرم, *The Warm War*, 2019

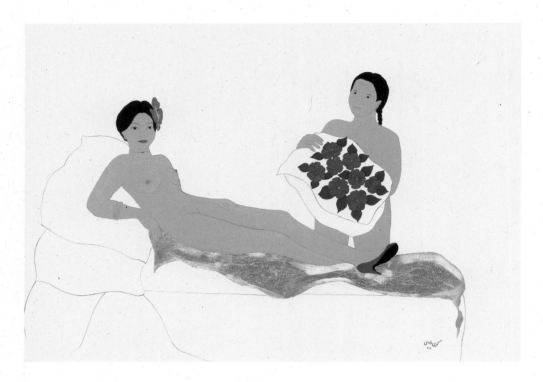

Cat. | Kat. **64** *Portrait of my mother and mine 1*, 2020

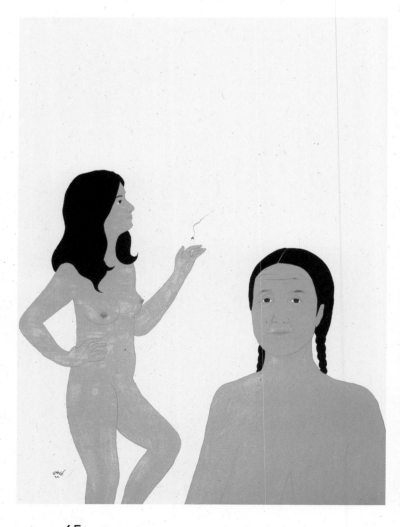

Cat. | Kat. **65** *Portrait of my mother and mine 2*, 2020

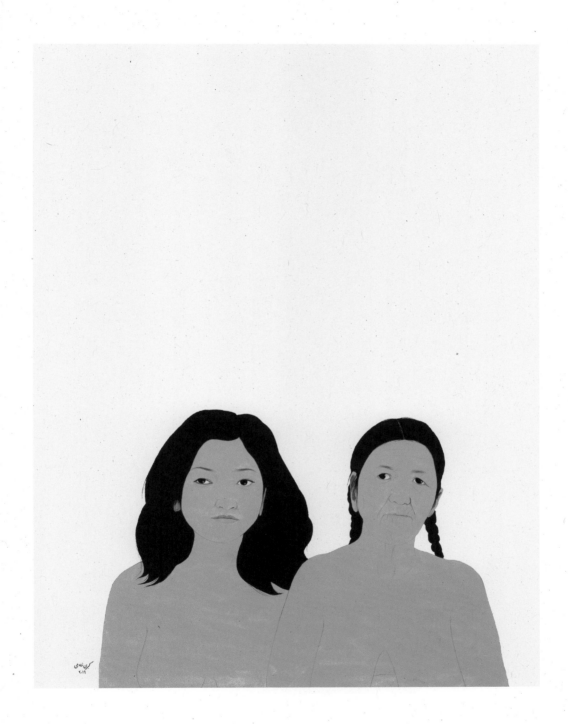

Cat. | Kat. **66** *Passport Photo*, 2019

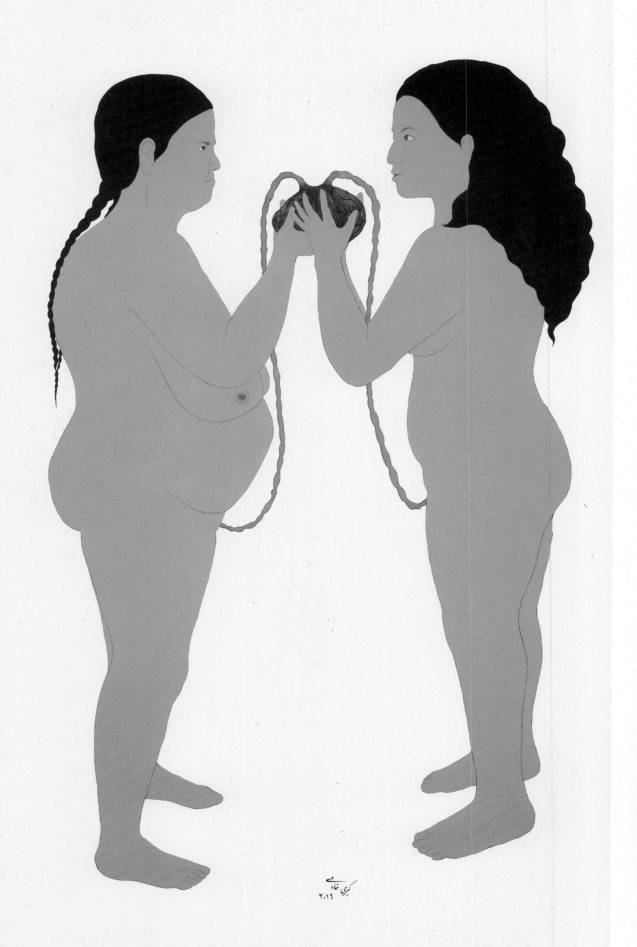

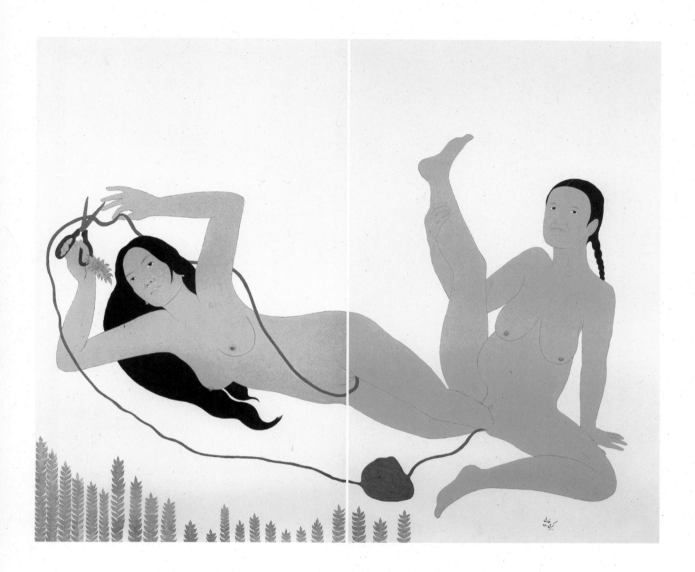

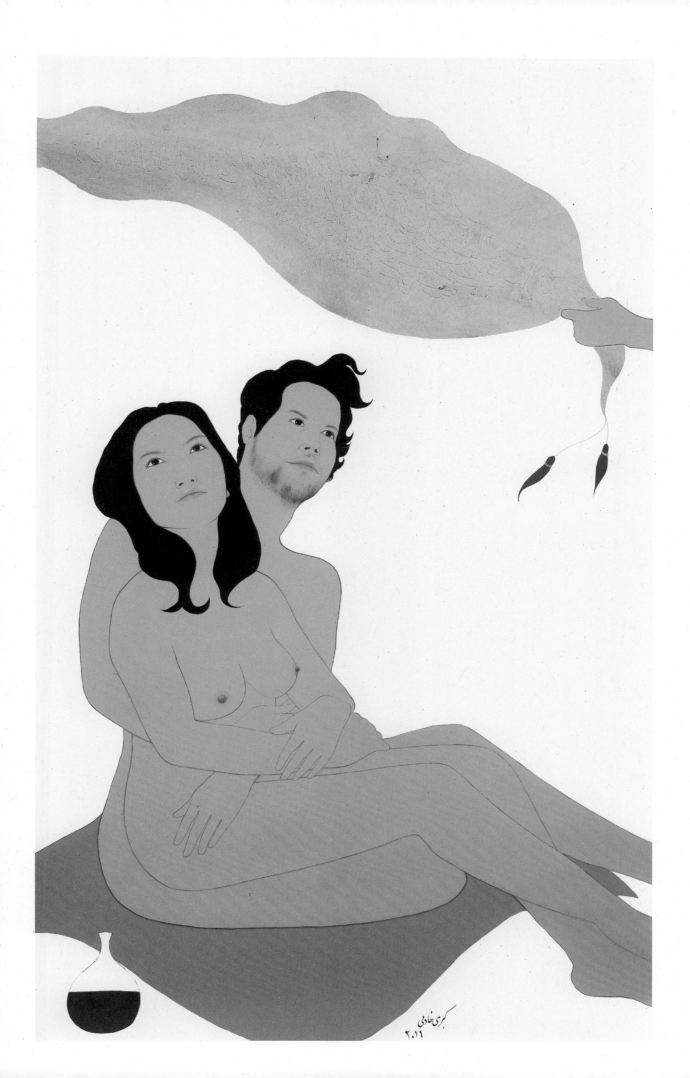

Cat. | Kat. **71** همچون موج در این نشیب, *Like a wave in this slope*, 2020

Cat. | Kat. **72** جليقه (Vests | Westen | Vestes), 2021

144

Cat. | Kat. **73** ۱ بدون عنوان, *Untitled #1*,
ایمان بیاوریم به آغاز فصل داغ, Let us believe in
the beginning of the hot season, 2021

Cat. | Kat. **74** ۲ بدون عنوان, *Untitled #2*,
ایمان بیاوریم به آغاز فصل داغ, Let us believe in
the beginning of the hot season, 2021

Cat. | Kat. **75** ۳ بدون عنوان, *Untitled #3*,
ایمان بیاوریم به آغاز فصل داغ, Let us believe in
the beginning of the hot season, 2021

Cat. | Kat. **76** ۴ بدون عنوان, *Untitled #4*,
ایمان بیاوریم به آغاز فصل داغ, Let us believe in
the beginning of the hot season, 2021

Cat. | Kat. **77** ۵ بدون عنوان, *Untitled #5*,
ایمان بیاوریم به آغاز فصل داغ Let us believe in
the beginning of the hot season, 2021

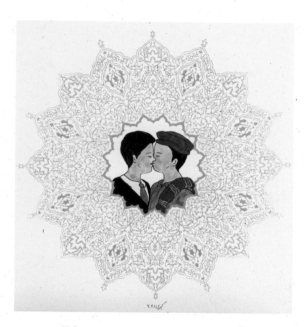

Cat. | Kat. **78** ۶ بدون عنوان, *Untitled #6*,
ایمان بیاوریم به آغاز فصل داغ Let us believe in
the beginning of the hot season, 2021

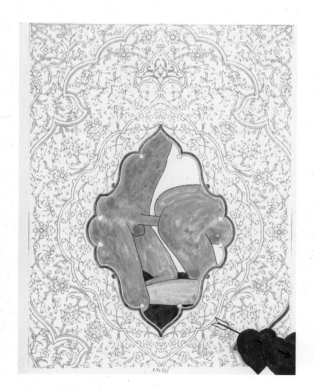

Cat. | Kat. **79** ۷ بدون عنوان, *Untitled #7*,
ایمان بیاوریم به آغاز فصل داغ Let us believe in
the beginning of the hot season, 2021

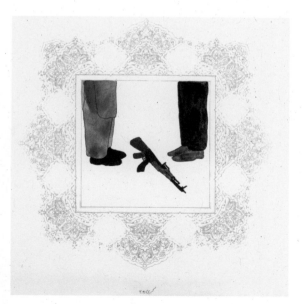

Cat. | Kat. **80** ۸ بدون عنوان, *Untitled #8*,
ایمان بیاوریم به آغاز فصل داغ Let us believe in
the beginning of the hot season, 2021

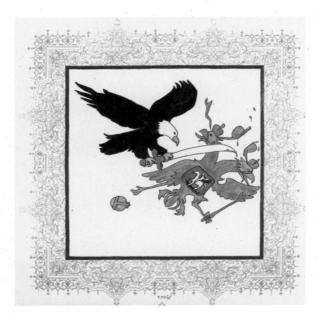

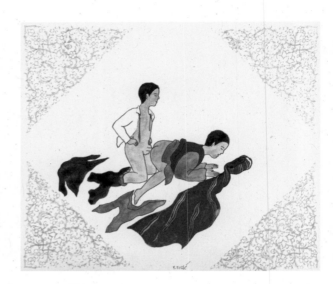

Cat. | Kat. **81** بدون عنوان ۹, *Untitled #9*,
ایمان بیاوریم به آغاز فصل داغ, Let us believe in
the beginning of the hot season, 2021

Cat. | Kat. **82** بدون عنوان ۱۰, *Untitled #10*,
ایمان بیاوریم به آغاز فصل داغ, Let us believe in the
beginning of the hot season, 2021

Cat. | Kat. **83** بدون عنوان ۱۱, *Untitled #11*, ایمان بیاوریم به آغاز فصل داغ,
Let us believe in the beginning of the hot season, 2021

Cat. | Kat. **84** ۱۲ بدون عنوان , *Untitled #12*, ایمان بیاوریم به آغاز فصل داغ,
Let us believe in the beginning of the hot season, 2021

Cat. | Kat. **85** ۱۳ بدون عنوان , *Untitled #13*,
ایمان بیاوریم به آغاز فصل داغ, Let us believe in the
beginning of the hot season, 2021

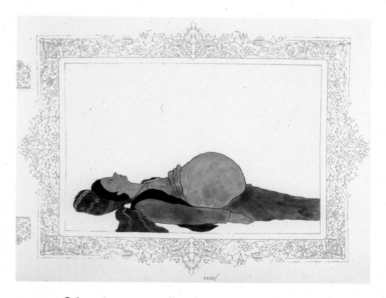

Cat. | Kat. **86** ۱۴ بدون عنوان , *Untitled #14*,
ایمان بیاوریم به آغاز فصل داغ, Let us believe in the
beginning of the hot season, 2021

Kubra Khademi is a multidisciplinary artist based in Paris. She mainly works with gouache paintings on paper and performance art. Based on her biography, her works focus on issues of female identity in a male-dominated society and refugee experiences, among others. She studied art first in Kabul, then in Lahore, where she began creating performances in public spaces. After her performance *Armor* (2015) in Kabul, Kubra Khademi was forced to leave her home country. Today she exhibits internationally: Khademi's works have been included in group exhibitions at Schirn Kunsthalle Frankfurt (2022), Germany; Musée d'Art Moderne de la Ville de Paris (2021), Festival du Théâtre National de Bretagne/Musée de la danse (2018), Musée national de l'histoire de l'immigration and Palais de Tokyo, Paris (2017), France; Bangkok Art Biennale (2020), Thailand; Queens Museum & Knockdown Center in New York (2018), USA; Bandjoun Art Station (2018), Cameroon; and Nexus Arts Gallery (2016), Adelaide, Australia, among others. Her graphic and sculptural works are represented by Galerie Eric Mouchet in Paris, and her performances by Latitudes Contemporaines in Lille.

1989 Born in the rural province of Ghor, Afghanistan; grew up in Afghanistan, Pakistan, and Iran **2008–09** Art studies at Kabul University, Afghanistan **2009** UMISSA Scholarship for the Bachelor of Fine Arts from UNESCO Madanjeet Singh Institute for South Asian Arts, Pakistan **2009–13** Studied art at Beaconhouse National University BNU, Lahore, Pakistan, on a scholarship from the South Asia Foundation and graduated with honors **2015** Performed *Armor*, a performance perceived as scandalous, in Kabul on February 26; subsequently fled to France; Paris becomes her home and place of work **2016** Awarded the title of Chevalier de L'ordre des Arts et des Lettres (Order of Arts and Letters) by the French Ministry of Culture **2017** Member of Atelier des artistes en exil, Paris **2015–19** Various art residencies and fellowships in France, Brazil, Switzerland, the Netherlands, Spain, and New York **2019** Nomination of Révélations Emerige Art prize **2019–20** Studied art history at the Université Paris 1 Panthéon-Sorbonne **2020–21** Scholarship from the Fiminco Foundation, Romainville, France **2020** "1% marché de l'art" prize from the City of Paris and Crédit Municipal de Paris **2021/22** Artist residency in New York, USA, with a grant from the Salomon Foundation **2022** First solo museum exhibition *Kubra Khademi – Political Bodies* (June 25–September 11, 2022) at Museum Pfalzgalerie Kaiserlautern, Germany, and solo exhibition *Kubra Khademi: First but not Last Time in America* (July 2–August 31, 2022), Collection Lambert, Avignon, France

Kubra Khademi ist multidisziplinäre Künstlerin mit Sitz in Paris. Ihre Schwerpunkte sind Malerei auf Papier und Performancekunst. In ihren Werken konzentriert sie sich ausgehend von ihrer Biografie unter anderem auf Fragen der Fluchterfahrung und der weiblichen Identität in einer männerdominierten Gesellschaft. Sie studierte Kunst zunächst in Kabul, dann in Lahore, wo sie begann, Performances im öffentlichen Raum zu kreieren. Nach ihrer Performance *Armor* (2015) in Kabul war Kubra Khademi gezwungen, ihr Heimatland zu verlassen. Heute stellt sie ihre Arbeit international aus: Khademis Werke waren unter anderem in Gruppenausstellungen in der Schirn Kunsthalle Frankfurt (2022), in Frankreich im Musée d'Art Moderne de la Ville de Paris (2021), beim Festival du Théâtre National de Bretagne/Musée de la danse (2018), im Musée national de l'histoire de l'immigration und im Palais de Tokyo, Paris (2017), in Thailand bei der Bangkok Art Biennale (2020), in den USA im Queens Museum & Knockdown Center in New York (2018), in Kamerun in der Bandjoun Art Station (2018) und in Australien in der Nexus Arts Gallery in Adelaide (2016) vertreten. Ihre grafischen und plastischen Werke werden von der Galerie Eric Mouchet in Paris repräsentiert, ihre Performances von Latitudes Contemporaines in Lille.

1989 geboren in der ländlichen Provinz Ghor, Afghanistan; aufgewachsen in Afghanistan, Pakistan und dem Iran **2008/09** Kunststudium an der Universität Kabul, Afghanistan **2009** UMISSA-Stipendium für den Bachelor of Fine Arts des UNESCO Madanjeet Singh Institute for South Asian Arts, Pakistan **2009–2013** Kunststudium an der Beaconhouse National University BNU, Lahore, Pakistan, mit einem Stipendium der South Asia Foundation und Abschluss mit Auszeichnung **2015** Aufführung der als skandalös aufgefassten Performance *Armor* in Kabul am 26. Februar, daraufhin Flucht nach Frankreich; Paris wird Wohn- und Arbeitsort **2016** Verleihung der Auszeichnung „Chevalier de L'ordre des Arts et des Lettres" (Orden der Künste und der Literatur) durch das französische

Kulturministerium **2017** Mitglied des Atelier des artistes en exil, Paris **2015–2019** diverse Kunstresidenzaufenthalte und Stipendien in Frankreich, Brasilien, der Schweiz, den Niederlanden, Spanien und in New York **2019** nominiert für den Révélations Emerige Kunstpreis **2019–2020** Studium der Kunstgeschichte an der Université Paris 1 Panthéon-Sorbonne **2020** Stipendium der Fiminco Foundation, Romainville, Frankreich **2020** „1% marché de l'art"-Preis der Stadt Paris und des Crédit Municipal de Paris **2021/22** Künstlerinnenresidenz mit Arbeitsaufenthalt in New York mit einem Stipendium der Salomon Foundation **2022** Erste museale Einzelausstellung *Kubra Khademi – Political Bodies* (25. Juni – 11. September 2022) im Museum Pfalzgalerie Kaiserlautern und Einzelausstellung *Kubra Khademi. First but not Last Time in America* (2. Juli – 31. August 2022) in der Collection Lambert, Avignon, Frankreich

BIOGRAPHIE DE L'ARTISTE

Kubra Khademi est une artiste multidisciplinaire installée à Paris. Elle travaille principalement la peinture sur papier et l'art de la performance. Ses œuvres, à partir de sa propre biographie, traitent entre autres les questions de l'exil et de l'identité féminine dans une société dominée par les hommes. Elle a étudié l'art d'abord à Kaboul, puis à Lahore, où elle a commencé à créer des performances dans l'espace public. Après sa performance *Armor* (2015) à Kaboul, Kubra Khademi a été contrainte de quitter son pays d'origine. Aujourd'hui, son travail s'expose à l'échelle internationale, ainsi dans des expositions collectives en Allemagne à la Schirn Kunsthalle Frankfurt (2022), en France au Musée d'Art Moderne de la Ville de Paris (2021), au Festival du Théâtre National de Bretagne/ Musée de la danse (2018), au Musée national de l'histoire de l'immigration à Paris (2017) et au Palais de Tokyo (2017), en Thaïlande à la Bangkok Art Biennale (2020), aux États-Unis au Queens Museum & Knockdown Center de New York (2018), au Cameroun à la Bandjoun Art Station (2018) ou en Australie à la Nexus Arts Gallery, Adelaide (2016). Ses œuvres graphiques et plastiques sont représentées par la Galerie Eric Mouchet à Paris, et ses performances par Latitudes Contemporaines à Lille.

1989 Naissance dans la province rurale de Ghor, Afghanistan ; enfance et adolescence en Afghanistan, au Pakistan et en Iran **2008-2009** Études d'art à l'Université de Kaboul, Afghanistan **2009** Bourse UMISSA pour le Bachelor of Fine Arts du UNESCO Madanjeet Singh Institute for South Asian Arts, Pakistan **2009-2013** Études d'art à la Beaconhouse National University BNU, Lahore, Pakistan, avec une bourse de la South Asia Foundation ; diplôme avec mention **2015** Le 26 février, sa performance *Armor* à Kaboul fait scandale ; elle fuit en France et s'installe à Paris **2016** Le ministère français de la Culture l'élève au rang de « Chevalier de L'ordre des Arts et des Lettres » **2017** Membre de l'Atelier des artistes en exil, Paris **2015-2019** Diverses résidences d'artiste et bourses en France, au Brésil, en Suisse, aux Pays-Bas, en Espagne et à New York **2019** Nommée pour la Bourse Révélations Emerige **2019-2020** Études d'histoire de l'art à l'Université Paris 1 Panthéon-Sorbonne **2020** Bourse de la Fondation Fiminco à Romainville (France) **2020** Prix « 1 % marché de l'art » de la Ville de Paris et Crédit Municipal de Paris **2021-2022** Résidence d'artistes et séjour de travail à New York, avec une bourse de la Salomon Foundation **2022** Première exposition personnelle dans un musée : *Kubra Khademi – Political Bodies* (25 juin- 11 septembre) au Museum Pfalzgalerie Kaiserlautern, Allemagne, et exposition personnelle *Kubra Khademi. First but not Last Time in America* (2 juillet-31 août), Collection Lambert, Avignon, France

Philippe Dagen, b. 1959, Montauban, is a French academic, art critic, and novelist. He teaches the history of contemporary art at the University of Paris 1 Panthéon-Sorbonne. He has published an art column in the newspaper *Le Monde* since 1985. He is the author of numerous works on painters such as Cézanne, Kupka, Bacon, and Picasso and is devoted to writing different books about the artistic life during World War I and, mainly, several aspects and contradictions of the so-called primitivism in modern and living art, including two recent volumes at Gallimard. As an independent curator, he is the author of *Charles Ratton: L'invention des arts "primitifs"* (2013) at Musée du Quai Branly and, in the same museum, *Ex Africa: Présences africaines dans l'art d'aujourd'hui* (2021). Currently, he is preparing an exhibition of the artist Ghada Amer in Marseille at MUCEM, FRAC, and the Vieille Charité.

Hanna Gabriela Diedrichs genannt Thormann, b. 1988, Reutlingen, has been a junior researcher and curator of the project *Kubra Khademi – Political Bodies* at the Museum Pfalzgalerie Kaiserslautern since May 2021. From 2015 to 2018 she volunteered at Shedhalle Tübingen – Forum für zeitgenössische Künste e. V. (for example, being involved in the participatory photo project *"Es wachsen keine Blumen in Kabul …"*), and was a curatorial assistant at the Museum für Gestaltung Zürich from 2018 to 2019, as well as a freelancer in art mediation there until 2021. As a founding member of the curatorial group Kollektiv Kollektiv, she codeveloped the participatory project series *Communitas* in 2020/21. After an apprenticeship in photography, she studied art history and cultural studies in Tübingen and Zurich and among other things was a research student at the University of Tübingen from 2017 to 2018 in the DFG-funded research project *Europa nach dem Krieg – Die Potenziale der Kunst in den späten 1940er und den 1950er Jahren*. In her work, she is particularly interested in the interdisciplinary examination of contemporary positions of art in their sociopolitical and local as well as global contexts.

Salima Hashmi, b. 1942, Delhi, is an internationally known artist, curator, and contemporary art historian, as well as a council member of the Human Rights Commission of Pakistan. She was the founding dean at the Mariam Dawood School of Visual Arts and Design at Beaconhouse National University, Lahore, in 2003, where she is now professor emeritus. She taught at the National College of Arts, Lahore, for thirty years. She was also Principal of the College for four years and held the post of professor of fine arts. Among other things, Salima Hashmi was cofounder of Rohtas Gallery in Islamabad (1981) and Rohtas-2 (2001) in Lahore. The government of Pakistan awarded her the President's Medal for Pride of Performance for Art Education in 1999. The Australian Council of Art and Design Schools named her an inaugural International Fellow in 2011 for distinguished service to art and design education. In 2016 she was awarded the Alma Award by the Alma Culture Center, Oslo, Norway, for promoting tolerance through performance. In 2016 she was awarded an honorary doctorate from Bath Spa University, United Kingdom. Salima Hashmi exhibits her paintings in Pakistan and internationally. She is the author and curator of numerous publications and exhibitions of contemporary art and traditional textiles in Pakistan and around the world, including books such as *Unveiling the Visible: Lives and Works of Women Artists of Pakistan* (2002) and *Nazar Ki Umang, the Urdu* translation of *The Eye Still Seeks* for Sang-e-Meel (2020), the exhibition *Hanging Fire* (2009) for the Asia Society Museum in New York, and *This Night-Bitten Dawn* (2016) for the Gujral Foundation and the Devi Art Foundation in Delhi.

Bettina Wohlfarth, b. 1963, Bad Homburg, is an author, journalist, and translator. She has lived in Paris since 1990 and writes regularly for the *Frankfurter Allgemeine Zeitung* about art and the art market in France. She recently published catalogue articles on the artists Eva Jospin and Pierrette Bloch. Her first novel, *Wagfalls Erbe*, was published by Osburg Verlag in 2019 and was shortlisted for the Klaus Michael Grüber Prize for the best German-language debut novel. In 2020 Bettina Wohlfarth was the German laureate of the French-European Festival du premier roman in Chambéry with her novel. The French translation of *Wagfalls Erbe* will soon be published by Liana Levi. She translated artist portraits and text contributions for galleries, exhibition texts for museums, and, among other book publications, the monograph *Delacroix* by Alain Daguerre de Hureaux. Bettina Wohlfarth studied German language and literature, philosophy and theater studies in Frankfurt am Main, graduating with a Magister Artium.

Philippe Dagen, geb. 1959 in Montauban, ist französischer Wissenschaftler, Kunstkritiker und Romanautor. Er lehrt zeitgenössische Kunstgeschichte an der Universität Paris 1 Panthéon-Sorbonne. Seit 1985 veröffentlicht er eine Kunstkolumne in der Zeitung *Le Monde*. Er ist Autor zahlreicher Werke über Maler wie Cézanne, Kupka, Bacon und Picasso. In mehreren Büchern widmet er sich dem künstlerischen Leben während des Ersten Weltkriegs sowie vor allem verschiedenen Aspekten und Widersprüchen des sogenannten Primitivismus in der modernen und aktuellen Kunst, darunter zwei kürzlich bei Gallimard erschienene Bände. Als unabhängiger Kurator hat er die Ausstellungen *Charles Ratton. L'invention des arts „primitifs"* (2013) und *Ex Africa. Présences africaines dans l'art d'aujourd'hui* (2021) im Musée du Quai Branly kuratiert. Derzeit bereitet er eine Ausstellung der Künstlerin Ghada Amer im MUCEM, im FRAC und in der Vieille Charité in Marseille vor.

Hanna Gabriela Diedrichs genannt Thormann, geb. 1988 in Reutlingen, ist seit Mai 2021 wissenschaftliche Volontärin am Museum Pfalzgalerie Kaiserslautern und Kuratorin des Projekts *Kubra Khademi – Political Bodies*. 2015-2018 arbeitete sie ehrenamtlich in der Shedhalle Tübingen – Forum für zeitgenössische Künste e. V. (u. a. Beteiligung am partizipativen Fotoprojekt *„Es wachsen keine Blumen in Kabul…"*) und war 2018-2019 kuratorische Assistentin am Museum für Gestaltung Zürich sowie bis 2021 freie Mitarbeiterin der dortigen Vermittlung. Als Gründungsmitglied der Kuratorinnen-Gruppe „Kollektiv Kollektiv" co-entwickelte sie 2020/21 die partizipative Projektreihe *Communitas*. Nach einer Fotografie-Ausbildung studierte sie Kunstgeschichte und Kulturwissenschaft in Tübingen und Zürich und war an der Universität Tübingen unter anderem 2017-2018 als Forschungsstudentin im von der DFG geförderten Forschungsprojekt *Europa nach dem Krieg – Die Potenziale der Kunst in den späten 1940er und den 1950er Jahren* tätig. In ihrer Arbeit interessiert sie sich besonders für die interdisziplinäre Auseinandersetzung mit aktuellen Positionen der Kunst in ihren gesellschaftspolitischen und lokalen wie globalen Zusammenhängen.

Salima Hashmi, geb. 1942 in Delhi, ist international als Künstlerin, Kuratorin und Wissenschaftlerin für zeitgenössische Kunst tätig sowie Ratsmitglied der Menschenrechtskommission von Pakistan. Sie war 2003 Gründungsdekanin der Mariam Dawood School of Visual Arts and Design an der Beaconhouse National University, Lahore, und ist jetzt Professorin im Ruhestand. Sie lehrte dreißig Jahre lang am National College of Arts in Lahore, war dort vier Jahre lang Direktorin und hatte den Lehrstuhl für Bildende Kunst inne. Salima Hashmi war unter anderem Mitbegründerin der Rohtas-Galerie in Islamabad (1981) und von Rohtas-2 (2001) in Lahore. Die pakistanische Regierung zeichnete sie 1999 mit der „President's Medal for Pride of Performance for Art Education" aus. Der Australian Council of Art and Design Schools ernannte sie 2011 zum Inaugural International Fellow für besondere Verdienste um die Kunst- und Designausbildung. 2016 wurde sie mit dem Alma Award des Alma Culture Center, Oslo, Norwegen, für die Förderung von Toleranz durch Performance ausgezeichnet. Im Jahr 2016 wurde ihr die Ehrendoktorwürde der Bath Spa University, Großbritannien, verliehen. Salima Hashmi stellt ihre Malerei in Pakistan und international aus. Sie ist Autorin und Kuratorin zahlreicher Publikationen und Ausstellungen zeitgenössischer Kunst und traditioneller Textilien in Pakistan und der ganzen Welt. Unter ihren Veröffentlichungen sind Bücher wie *Unveiling the Visible – Lives and Works of Women Artists of Pakistan* (2002) und *Nazar Ki Umang*, die Urdu-Übersetzung von *The Eye Still Seeks* für den Verlag Sang-e-Meel (2020), außerdem realisierte sie unter anderem die Ausstellung *Hanging Fire* (2009) für das Asia Society Museum in New York sowie *This Night-Bitten Dawn* für die Gujral Foundation und die Devi Art Foundation in Delhi.

Bettina Wohlfarth, geb. 1963 in Bad Homburg, ist Autorin, Journalistin und Übersetzerin. Sie lebt seit 1990 in Paris und schreibt regelmäßig für die *Frankfurter Allgemeine Zeitung* über Kunst und Kunstmarkt in Frankreich. Zuletzt veröffentlichte sie Katalogbeiträge zu den Künstlerinnen Eva Jospin und Pierrette Bloch. Ihr erster Roman *Wagfalls Erbe* erschien 2019 im Osburg Verlag und stand auf der Shortlist des Klaus-Michael-Grüber-Preises für den besten deutschsprachigen Debütroman. 2020 war Bettina Wohlfarth mit ihrem Roman deutsche Laureatin des französisch-europäischen Festival du premier roman in Chambéry. Demnächst erscheint die französische Übersetzung von *Wagfalls Erbe* im Verlag Liana Levi. Sie übersetzte Künstlerporträts und Textbeiträge für Galerien, Ausstellungstexte für Museen oder, unter anderen Buchpublikationen, die Monografie *Delacroix* von Alain Daguerre de Hureaux. Bettina Wohlfarth studierte in Frankfurt am Main Germanistik, Philosophie und Theaterwissenschaft mit Abschluss Magister Artium.

BIOGRAPHIES DES AUTRICES

Philippe Dagen, né en 1959 à Montauban, est un universitaire, critique d'art et romancier français. Il enseigne l'histoire de l'art contemporain à l'université de Paris 1 Panthéon-Sorbonne et tient une chronique artistique dans le journal *Le Monde* depuis 1985. Auteur de nombreux ouvrages sur des peintres comme Cézanne, Kupka, Bacon et Picasso, il s'est consacré notamment à la vie artistique pendant la Première Guerre mondiale et à plusieurs aspects et contradictions du soi-disant « primitivisme » dans l'art moderne et actuel ; deux volumes ont paru récemment chez Gallimard à ce sujet. En tant que commissaire indépendant, il a réalisé *Charles Ratton, L'invention des arts « primitifs »* (2013) au musée du Quai Branly, et, dans ce même musée, *Ex Africa, Présences africaines dans l'art d'aujourd'hui* (2021). Pour le MUCEM de Marseille, le FRAC et la Vieille Charité, il prépare actuellement une exposition de l'artiste Ghada Amer.

Hanna Gabriela Diedrichs genannt Thormann, née en 1988 à Reutlingen, est, depuis mai 2021, chercheuse junior et curatrice du projet *Kubra Khademi – Political Bodies* au Museum Pfalzgalerie Kaiserslautern. De 2015 à 2018, elle s'est engagée bénévolement à la Shedhalle Tübingen – Forum für zeitgenössische Künste e. V. (avec contribution entre autres au projet photographique participatif « *Es wachsen keine Blumen in Kabul…* »), et a été assistante curatoriale au Museum für Gestaltung Zürich de 2018 à 2019, puis collaboratrice indépendante à la médiation dans ce même musée jusqu'en 2021. En tant que membre fondatrice de *Kollektiv Kollektiv* (qui regroupe plusieurs curatrices), elle a codéveloppé la série de projets participatifs *Communitas* en 2020-2021. Après une formation dans le domaine de la photographie, elle a étudié l'histoire de l'art et les études culturelles à Tübingen et Zurich. En 2017-2018, elle a été titulaire d'un contrat de recherche à l'Université de Tübingen, dans le cadre d'un financement par la DFG du projet *Europa nach dem Krieg – Die Potenziale der Kunst in den späten 1940er und den 1950er Jahren*. Son travail porte tout particulièrement sur l'approche interdisciplinaire des positions artistiques actuelles dans leur contexte sociopolitique, local et mondial.

Salima Hashmi, née en 1942 à Delhi, est une artiste, conservatrice et historienne d'art contemporain de renommée internationale. Membre du conseil de la Commission des droits humains du Pakistan et doyenne fondatrice en 2003 de la Mariam Dawood School of Visual Arts and Design de l'université nationale Beaconhouse, à Lahore, elle est aujourd'hui professeure émérite. Elle a enseigné pendant trente ans au National College of Arts de Lahore, où elle a occupé la chaire des beaux-arts et qu'elle a dirigé pendant quatre ans. Salima Hashmi a cofondé la galerie Rohtas à Islamabad (1981) et Rohtas-2 (2001) à Lahore. Le gouvernement pakistanais lui a décerné en 1999 la President's Medal for Pride of Performance for Art Education. Le Australian Council of Art and Design Schools l'a nommée Inaugural International Fellow en 2011 pour ses mérites éminents en faveur de l'éducation artistique et du design. En 2016, elle a reçu le prix Alma du Alma Culture Center, à Oslo, en Norvège, pour avoir promu la tolérance par la performance. En 2016, l'université de Bath Spa, au Royaume-Uni, lui a décerné le titre de Docteure honoris causa. Salima Hashmi expose ses peintures au Pakistan et dans le monde entier. Autrice et commissaire de nombreux ouvrages et expositions d'art contemporain et textiles traditionnels, dans son pays comme à l'étranger, elle a publié notamment : *Unveiling the Visible – Lives and Works of Women Artists of Pakistan* (2002) et *Nazar Ki Umang*, la traduction en ourdou de *The Eye Still Seeks* pour Sang-e-Meel (2020) ; elle a monté aussi l'exposition *Hanging Fire* (2009) pour l'Asia Society Museum de New York, ainsi que *This Night-Bitten Dawn* (2016) pour la Gujral Foundation et la Devi Art Foundation à Delhi.

Bettina Wohlfarth, née en 1963 à Bad Hombourg, est autrice, journaliste et traductrice. Elle vit à Paris depuis 1990 et écrit régulièrement pour la *Frankfurter Allgemeine Zeitung* sur l'art et le marché de l'art en France. Elle a récemment publié des contributions sur les artistes Eva Jospin et Pierrette Bloch. Son premier roman, *Wagfalls Erbe* (L'héritage de Wagfall), a été publié par Osburg Verlag en 2019 et présélectionné pour le prix Klaus-Michael-Grüber du meilleur premier roman en langue allemande. En 2020, Bettina Wohlfarth a été la lauréate allemande du Festival franco-européen du premier roman de Chambéry. *Wagfalls Erbe* paraîtra sous peu en français aux Éditions Liana Levi. Traductrice pour des galeries, expositions, musées ou publications, elle a traduit notamment la monographie *Delacroix* d'Alain Daguerre de Hureaux. Bettina Wohlfarth a étudié la germanistique, la philosophie et le théâtre à Francfort-sur-le-Main, où elle a obtenu son Magister Artium.

LIST OF WORKS WERKLISTE LISTE DES ŒUVRES

For all works that are not marked otherwise, the following applies | Für alle Werke, die nicht anderweitig gekennzeichnet sind, gilt | Sauf mention autre, toutes les œuvres sont: Property of the artist | Eigentum der Künstlerin | propriété de l'artiste; painterly and three-dimensional work represented by | malerisches und plastisches Werk vertreten durch | œuvre picturale et plastique représentée par Galerie Eric Mouchet, Paris; performative work represented by | performatives Werk vertreten durch | œuvre performative représentée par Latitudes Contemporaines, Lille, France | Frankreich

1 خط مقدم , *Front Line* (Quadriptych | Quadriptychon | Quadriptyque), 2020, from the series | aus der Serie | série *From the Two Page Book*, gouache and gold foil on paper, four parts | Gouache und Blattgold auf Papier, vier Teile | gouache et feuille d'or sur papier, quatre parties, each | je | chacune 250,5 × 150,5 cm

2 زره , *Armor*, 2015, Walking performance in Kabul with galvanized iron armor | Gehperformance in Kabul mit Rüstung aus verzinktem Eisen | performance à Kaboul avec armure en fer galvanisé, 73 × 36 × 36 cm, terminated after approx. 8 min. | Abbruch nach ca. 8 min. | abandon au bout d'environ 8 min

3 پارلمان افغانستان , *Parliament Scene*, 2021, gouache and gold foil on paper | Gouache und Blattgold auf Papier | gouache et feuille d'or sur papier, 180 × 250 cm

4 بدون عنوان , *Untitled*, 2020, from the series | aus der Serie | série *From the Two Page Book*, gouache and gold foil on paper | Gouache und Blattgold auf Papier | gouache et feuille d'or sur papier, 250 × 150 cm, private collection | Privatsammlung | collection privée, Paris, France | Frankreich

5 *The Thousands Pussy*, *La Mille Chattes*, 2021, from the series | aus der Serie | série *Thousands Pussies & the Dragon*, *Mille Chattes et le Dragon*, photomontage | Fotomontage | montage photo, dimensions variables | Maße variabel | dimensions variables, photography and digital editing | Fotoaufnahme und -bearbeitung | prise de vue et traitement: Robin Lopvet

6 اژدها , *Dragon*, 2021, from the series | aus der Serie | série *Thousands Pussies & the Dragon, Mille Chattes et le Dragon*, photomontage | Fotomontage | montage photo, dimensions variable | Maße variabel | dimensions variables, photography and digital editing | Fotoaufnahme und -bearbeitung | prise de vue et traitement: Robin Lopvet

7 هفت اژدها , *The Seven Baby Dragons*, 2021, from the series | aus der Serie | série *Thousands Pussies & the Dragon, Mille Chattes et le Dragon*, photomontage | Fotomontage | montage photo, dimensions variable | Maße variabel | dimensions variables, photography and digital editing | Fotoaufnahme und -bearbeitung | prise de vue et traitement: Robin Lopvet

8 بدون عنوان , *Untitled*, 2020, from the series | aus der Serie | série *Birth Giving*, gouache on paper | Gouache auf Papier | gouache sur papier, 29 × 23 cm, private collection | Privatsammlung | collection privée, Paris, France | Frankreich

9 بدون عنوان , *Untitled*, 2020, from the series | aus der Serie | série *Birth Giving*, gouache on paper | Gouache auf Papier | gouache sur papier, 25 × 22 cm, private collection | Privatsammlung | collection privée, Paris, France | Frankreich

10 بدون عنوان , *Untitled*, 2020, from the series | aus der Serie | série *Birth Giving*, gouache on paper | Gouache auf Papier | gouache sur papier, 33 × 28 cm, private collection | Privatsammlung | collection privée, Paris, France | Frankreich

11 بدون عنوان , *Untitled*, 2020, from the series | aus der Serie | série *Birth Giving*, gouache on paper | Gouache auf Papier | gouache sur papier, 26,4 × 24,4 cm, private collection | Privatsammlung | collection privée, Paris, France | Frankreich

12 زاییدن , *The birth giving #01*, 2021, from the series | aus der Serie | série *Birth Giving*, mixed media, embroidery, and silk print on tissue | Mischtechnik, Stickerei und Siebdruck auf Gewebe | technique mixte, broderie et sérigraphie, 200 × 150 cm

13 زاییدن , *The birth giving #04*, 2021, from the series | aus der Serie | série *Birth Giving*, mixed media, embroidery, and silk print on tissue | Mischtechnik, Stickerei und Siebdruck auf Gewebe | technique mixte, broderie et sérigraphie, 200 × 150 cm

14 زاییدن , *The birth giving #03*, 2021, from the series | aus der Serie | série *Birth Giving*, mixed media, embroidery, and silk print on tissue | Mischtechnik, Stickerei und Siebdruck auf Gewebe | technique mixte, broderie et sérigraphie, 200 × 150 cm

15 زاییدن , *The birth giving #08*, 2021, from the series | aus der Serie | série *Birth Giving*, mixed media, embroidery, and silk print on tissue | Mischtechnik, Stickerei und Siebdruck auf Gewebe | technique mixte, broderie et sérigraphie, 200 × 150 cm

154

16 الخواتون, *Al-Khatoon*, 2021, site-specific performance | ortsspezifische Performance | performance *in situ*, Gallerie delle Prigioni, Treviso | Trévise, Italy | Italien | Italie

17 بدون عنوان, *Untitled*, 2021, from the series | aus der Serie | série جرایم زنانه, *Female Crimes*, gouache and gold foil on paper | Gouache und Blattgold auf Papier | gouache et feuille d'or sur papier, site-specific installation | orts-spezifische Installation | installation *in situ*, Gallerie delle Prigioni, Treviso | Trévise, Italy | Italien | Italie, private collection | Privatsamm-lung | collection privée, Germany | Deutsch-land | Allemagne

18 بدون عنوان, *Untitled*, 2021, from the series | aus der Serie | série جرایم زنانه, *Female Crimes*, gouache on paper | Gouache auf Papier | gouache sur papier, site-specific installation | ortsspezifische Installation | installation *in situ*, Gallerie delle Prigioni, Treviso | Trévise, Italy | Italien | Italie

19 بیست سال گناه, *Twenty Years of Sin*, 2016, gouache on paper | Gouache auf Papier | gouache sur papier, 42 × 48 cm, private collection | Privatsammlung | collection privée, Lille, France | Frankreich

20 *Washing the Sins*, 2019, gouache on paper | Gouache auf Papier | gouache sur papier, 65 × 100 cm, Collection | Sammlung Thélo Maufroy, Lille, France | Frankreich

21 *Relaxed*, 2019, gouache on paper | Gouache auf Papier | gouache sur papier, 56,5 × 76,5 cm, private collection | Privat-sammlung | collection privée, Stuttgart, Germany | Deutschland | Allemagne

22 بدون عنوان, *Untitled #9*, 2020, from the series | aus der Serie | série *Ordinary Women*, gouache on paper | Gouache auf Papier | gouache sur papier, 57 × 76 cm, private collection | Privatsammlung | collection privée, Dijon, France | Frankreich

23 بدون عنوان, *Untitled #8*, 2020, from the series | aus der Serie | série *Ordinary Women*, gouache on paper | Gouache auf Papier | gouache sur papier, 76 × 57 cm, private collection | Privatsammlung | collection privée, Paris, France | Frankreich

24 بدون عنوان, *Untitled #13*, 2020, from the series | aus der Serie | série *Ordinary Women*, gouache on paper | Gouache auf Papier | gouache sur papier, 76 × 57 cm, private collection | Privatsammlung | collection privée, France | Frankreich

25 بدون عنوان, *Untitled #16*, 2020, from the series | aus der Serie | série *Ordinary Women*, gouache on paper | Gouache auf Papier | gouache sur papier, 57 × 76 cm, private collection | Privatsammlung | collection privée, Paris, France | Frankreich

26 بدون عنوان, *Untitled #17*, 2020, from the series | aus der Serie | série *Ordinary Women*, gouache on paper | Gouache auf Papier | gouache sur papier, 76 × 57 cm

27 بدون عنوان, *Untitled #20*, 2020, from the series | aus der Serie | série *Ordinary Women*, gouache on paper | Gouache auf Papier | gouache sur papier, 76 × 57 cm

28 بدون عنوان, *Untitled #21*, 2020, from the series | aus der Serie | série *Ordinary Women*, gouache on paper | Gouache auf Papier | gouache sur papier, 57 × 76 cm, private collection | Privatsammlung | collection privée, Nice | Nizza, France | Frankreich

29 بدون عنوان, *Untitled (Pietà)*, 2019, gouache and gold foil on paper | Gouache und Blatt-gold auf Papier | gouache et feuille d'or sur papier, 60 × 80 cm, private collection | Privatsammlung | collection privée, Stuttgart, Germany | Deutschland | Allemagne

30 بدون عنوان, *Untitled*, 2018, from the series | aus der Serie | série پرقچه ها, *Paraqcha Ha*, gouache on paper | Gouache auf Papier | gouache sur papier, 55,8 × 76 cm, Collec-tion | Sammlung Ronan Grossiat, Neuilly-sur-Seine, France | Frankreich

31 بدون عنوان, *Untitled*, 2019, from the series | aus der Serie | série پرقچه ها, *Paraqcha Ha*, gouache on paper | Gouache auf Papier | gouache sur papier, 55,8 × 75,9 cm, Lettre International, Berlin, Germany | Deutschland | Allemagne

32 بدون عنوان, *Untitled*, 2018, from the series | aus der Serie | série پرقچه ها, *Paraqcha Ha*, gouache on paper | Gouache auf Papier | gouache sur papier, 55,8 × 76 cm, Lettre International, Berlin, Germany | Deutschland | Allemagne

33 بدون عنوان, *Untitled*, 2018, from the series | aus der Serie | série پرقچه ها, *Paraqcha Ha*, gouache on paper | Gouache auf Papier | gouache sur papier, 55,8 × 75,8 cm, private collection | Privatsammlung | collection privée, Paris, France | Frankreich

34 یائسگی, *Menopause*, 2019, from the series | aus der Serie | série پرقچه ها *Paraqcha Ha*, gouache on paper | Gouache auf Papier | gouache sur papier, 76,5 × 56,5 cm, private collection | Privatsammlung | collection privée, Paris, France | Frankreich

35 مهریه, *Dowry*, 2019, from the series | aus der Serie | série پرقچه ها, *Paraqcha Ha*, gouache and gold foil on paper | Gouache und Blattgold auf Papier | gouache et feuille d'or sur papier, 76,5 × 56,5 cm, private collection | Privatsammlung | collection privée, Paris, France | Frankreich

36 بدون عنوان, *Untitled*, 2018, from the series | aus der Serie | série پرقچه ها, *Paraqcha Ha*, gouache on paper | Gouache auf Papier | gouache sur papier, 55,8 × 76 cm, private collection | Privatsammlung | collection privée, Lille, France | Frankreich

37 *Girl licking lollipop*, 2019, gouache on paper | Gouache auf Papier | gouache sur papier, ca. 23,5 × 17,5 cm, private collection | Privatsammlung | collection privée, Lille, France | Frankreich

38 *Bloody girl*, 2019, gouache and gold foil on paper | Gouache und Blattgold auf Papier | gouache et feuille d'or sur papier, 21 × 26 cm, private collection | Privatsammlung | collection privée, Lille, France | Frankreich

39 بدون عنوان, *Untitled*, 2020, gouache on paper | Gouache auf Papier | gouache sur papier, 40 × 50 cm, private collection | Privatsammlung | collection privée, France | Frankreich

40 فرش قرمز, *Red carpet*, 2019, from the series | aus der Serie | série پرقچه ها, *Paraqcha Ha*, gouache on paper | Gouache auf Papier | gouache sur papier, 56,5 × 76,5 cm, private collection | Privatsammlung | collection privée, Paris, France | Frankreich

41 *Untitled (Autoportrait)*, 2020, gouache on paper | Gouache auf Papier | gouache sur papier, 57 × 76 cm, private collection | Privatsammlung | collection privée, France | Frankreich

42 بدون عنوان, *Untitled (Cinq femmes en dansant)*, 2019, gouache on paper | Gouache auf Papier | gouache sur papier, 70 × 100 cm, private collection | Privatsammlung | collection privée, France | Frankreich

43 *The Creation – Power and Destruction*, 2021, performance with 15 paintings at | Performance mit 15 Malereien im | performance avec 15 peintures, Musée d'Art Moderne de Paris

44 بدون عنوان, *Untitled*, 2021, from the series | aus der Serie | série *The Creation – Power and Destruction*, gouache on paper | Gouache auf Papier | gouache sur papier, 190 × 150 cm, destroyed in the context of a performance | zerstört im Rahmen einer Performance | détruit dans le cadre d'une performance

45 بدون عنوان, *Untitled*, 2021, from the series | aus der Serie | série *The Creation – Power and Destruction*, gouache on paper | Gouache auf Papier | gouache sur papier, 190 × 150 cm, destroyed in the context of a performance | zerstört im Rahmen einer Performance | détruit dans le cadre d'une performance

46 بدون عنوان, *Untitled*, 2021, from the series | aus der Serie | série *The Creation – Power and Destruction*, gouache on paper | Gouache auf Papier | gouache sur papier, 190 × 150 cm, destroyed in the context of a performance | zerstört im Rahmen einer Performance | détruit dans le cadre d'une performance

47 بدون عنوان, *Untitled*, 2021, from the series | aus der Serie | série *The Creation – Power and Destruction,* gouache and gold foil on paper | Gouache und Blattgold auf Papier | gouache et feuille d'or sur papier, 190 × 150 cm, destroyed in the context of a performance | zerstört im Rahmen einer Performance | détruit dans le cadre d'une performance

48 *A woman with red words & her head*, 2020, from the series | aus der Serie | série *From the Two Page Book*, gouache and gold foil on paper | Gouache und Blattgold auf Papier | gouache et feuille d'or sur papier, 70 × 57 cm, private collection | Privatsammlung | collection privée, Milan | Mailand, Italy | Italien | Italie

49 *A woman and her head*, 2020, from the series | aus der Serie | série *From the Two Page Book*, gouache on paper | Gouache auf Papier | gouache sur papier, 70 × 57 cm, Collection | Sammlung Kadist

50 در آستانه, *In the Realm*, 2020, from the series | aus der Serie | série *From the Two Page Book*, gouache and gold foil on paper | Gouache und Blattgold auf Papier | gouache et feuille d'or sur papier, 188 × 150,5 cm, private collection | Privatsammlung | collection privée, France | Frankreich

51 دو ورقی کتاب, *The Two Page Book*, 2020, from the series | aus der Serie | série *From the Two Page Book*, gouache and gold foil on paper | Gouache und Blattgold auf Papier | gouache et feuille d'or sur papier, 150 × 114 cm, private collection | Privatsammlung | collection privée, Outremont, Canada | Kanada

52 توشه راه ۲, *Bagage de route #2*, 2020, from the series | aus der Serie | série *From the Two Page Book*, gouache and gold paint on paper | Gouache und Goldfarbe auf Papier | gouache et peinture dorée sur papier, 100 × 57 cm, private collection | Privatsammlung | collection privée, Paris, France | Frankreich

53 توشه راه ۱, *Bagage de route #1*, 2020, from the series | aus der Serie | série *From the Two Page Book*, gouache and gold paint on paper | Gouache und Goldfarbe auf Papier | gouache et peinture dorée sur papier, 100 × 57 cm, Lettre International, Berlin, Germany | Deutschland | Allemagne

74 بدون عنوان ۲, *Untitled #2*, 2021,
from the series | aus der Serie | série
داغ ایمان بیاوریم به آغاز فصل, *Let us believe in the beginning of the hot season*, gouache and gold paint on paper | Gouache und Goldfarbe auf Papier | gouache et peinture dorée sur papier, 19,5 × 20 cm

75 بدون عنوان ۳, *Untitled #3*, 2021,
from the series | aus der Serie | série
داغ ایمان بیاوریم به آغاز فصل, *Let us believe in the beginning of the hot season*, gouache and gold paint on paper | Gouache und Goldfarbe auf Papier | gouache et peinture dorée sur papier, 19,5 × 19,5 cm

76 بدون عنوان ۴, *Untitled #4*, 2021,
from the series | aus der Serie | série
داغ ایمان بیاوریم به آغاز فصل, *Let us believe in the beginning of the hot season*, gouache and gold paint on paper | Gouache und Goldfarbe auf Papier | gouache et peinture dorée sur papier, 19,5 × 21 cm

77 بدون عنوان ۵, *Untitled #5*, 2021,
from the series | aus der Serie | série
داغ ایمان بیاوریم به آغاز فصل, *Let us believe in the beginning of the hot season*, gouache and gold paint on paper | Gouache und Goldfarbe auf Papier | gouache et peinture dorée sur papier, 20,5 × 19 cm

78 بدون عنوان ۶, *Untitled #6*, 2021,
from the series | aus der Serie | série
داغ ایمان بیاوریم به آغاز فصل, *Let us believe in the beginning of the hot season*, gouache and gold paint on paper | Gouache und Goldfarbe auf Papier | gouache et peinture dorée sur papier, 21 × 19,5 cm

79 بدون عنوان ۷, *Untitled #7*, 2021,
from the series | aus der Serie | série
داغ ایمان بیاوریم به آغاز فصل, *Let us believe in the beginning of the hot season*, gouache and gold paint on paper | Gouache und Goldfarbe auf Papier | gouache et peinture dorée sur papier, 25 × 20 cm

80 بدون عنوان ۸, *Untitled #8*, 2021,
from the series | aus der Serie | série
داغ ایمان بیاوریم به آغاز فصل, *Let us believe in the beginning of the hot season*, gouache and gold paint on paper | Gouache und Goldfarbe auf Papier | gouache et peinture dorée sur papier, 20,5 × 21,5 cm

81 بدون عنوان ۹, *Untitled #9*, 2021,
from the series | aus der Serie | série
داغ ایمان بیاوریم به آغاز فصل, *Let us believe in the beginning of the hot season*, gouache and gold paint on paper | Gouache und Goldfarbe auf Papier | gouache et peinture dorée sur papier, 20,5 × 20 cm

82 بدون عنوان ۱۰, *Untitled #10*, 2021,
from the series | aus der Serie | série
داغ ایمان بیاوریم به آغاز فصل, *Let us believe in the beginning of the hot season*, gouache and gold paint on paper | Gouache und Goldfarbe auf Papier | gouache et peinture dorée sur papier, 20 × 24 cm

83 بدون عنوان ۱۱, *Untitled #11*, 2021,
from the series | aus der Serie | série
داغ ایمان بیاوریم به آغاز فصل, *Let us believe in the beginning of the hot season*, gouache and gold paint on paper | Gouache und Goldfarbe auf Papier | gouache et peinture dorée sur papier, 19 × 19 cm

84 بدون عنوان ۱۲, *Untitled #12*, 2021,
from the series | aus der Serie | série
داغ ایمان بیاوریم به آغاز فصل, *Let us believe in the beginning of the hot season*, gouache and gold paint on paper | Gouache und Goldfarbe auf Papier | gouache et peinture dorée sur papier, 19 × 19,8 cm

85 بدون عنوان ۱۳, *Untitled #13*, 2021,
from the series | aus der Serie | série
داغ ایمان بیاوریم به آغاز فصل, *Let us believe in the beginning of the hot season*, gouache and gold paint on paper | Gouache und Goldfarbe auf Papier | gouache et peinture dorée sur papier, 24 × 19,4 cm

86 بدون عنوان ۱۴, *Untitled #14*, 2021,
from the series | aus der Serie | série
داغ ایمان بیاوریم به آغاز فصل, *Let us believe in the beginning of the hot season*, gouache and gold paint on paper | Gouache und Goldfarbe auf Papier | gouache et peinture dorée sur papier, 20,5 × 26,5 cm

mpk
MUSEUM PFALZGALERIE KAISERSLAUTERN

This catalogue is published in conjunction with the exhibition | diese Publikation erscheint anlässlich der Ausstellung | ce catalogue est publié à l'occasion de l'exposition

**KUBRA KHADEMI
POLITICAL BODIES**

June 25 – September 11 | 25. Juni – 11. September | 25 juin – 11 septembre 2022

Museum Pfalzgalerie Kaiserslautern
Museumsplatz 1, 67657 Kaiserslautern
www.mpk.de

EXHIBITION | AUSSTELLUNG | EXPOSITION

Director of mpk | Direktor des mpk | Directeur du mpk
Steffen Egle

Deputy Director | Stellvertretende Direktorin | Directrice adjointe
Annette Reich

Curator of the exhibition and project management | Kuratorin der Ausstellung und Projektleitung | Commissaire de l'exposition et direction du projet
Hanna G. Diedrichs genannt Thormann

Conservation support | Konservatorische Betreuung | Suivi de la conservation
Andreas Kusch

Construction and technical support | Aufbau und Technik | Montage et technique
Markus Heid, Stefan Kraft, Bernd Riehmer

Secretarial and administrative service | Sekretariat und Verwaltung | Secrétariat et administration
Natalie Rothmann, Margarete Schneider with | mit | et Harald Lange

Marketing and public relations | Marketing und Öffentlichkeitsarbeit | Marketing et relations publiques
Svenja Kriebel

Printed matter | Drucksachen | Imprimés
Daniela Spinelli, Studio Final Final, Vera Zell

Educational department | Kunstvermittlung | Médiation culturelle
Benjamin Košar with | mit | et Hanna G. Diedrichs genannt Thormann and the freelance art mediators | und den freischaffenden Kunstvermittlerinnen | et les médiatrices artistiques indépendantes Nadine Choim, Anna Hach, Bea Roth

Collections management | Sammlungsleitungen | Direction des collections
Sören Fischer, Svenja Kriebel, Annette Reich

Library | Bibliothek | Bibliothèque
Reinhard Müller

Visitor services | Besucherinnenservice | Service sécurité
Wach- und Schließgesellschaft Karl Liebrich GmbH

Housekeeping | Reinigungsservice | Entretien
Mira Bungert

Volunteering | Ehrenamtliche Mitarbeit | Bénévolat
Sarah Machate

CATALOGUE | KATALOG | CATALOGUE

Editing and project management of mpk | Herausgeberin und Projektleitung für das mpk | Direction du projet pour le mpk
Hanna G. Diedrichs genannt Thormann

Image rights | Bildbeschaffung | Recherche images et droits
Marguerite Courtel & Michael Honecker, Galerie Eric Mouchet; Hanna G. Diedrichs genannt Thormann, mpk

Project supervision Hirmer | Projektleitung Hirmer | Responsable éditoriale Hirmer
Kerstin Ludolph

Translations | Übersetzungen | Traductions
Martine Passelaigue (E/D–F) for the texts by | für die Texte von | pour les textes de: Britta E. Buhlmann, Hanna G. Diedrichs genannt Thormann, Steffen Egle, Salima Hashmi, Bettina Wohlfarth; Bernadette Ott (E/F–D) for the texts by | für die Texte von | pour les textes de: Philippe Dagen, Salima Hashmi; Robert McInnes (D/F–E) for the texts by | für die Texte von | pour les textes de: Britta E. Buhlmann, Philippe Dagen, Hanna G. Diedrichs genannt Thormann, Steffen Egle, Bettina Wohlfarth

Copy-editing | Lektorat | Suivi éditorial
Martine Passelaigue (F), Keonaona Peterson (E), Annette Siegel (D)

Text management | Textmanagement | Responsable rédaction
Hanna G. Diedrichs genannt Thormann, Annette Siegel

Design | Gestaltung | Conception graphique
Petra Ahke, Berlin

Production and project management | Herstellung und Projektmanagement | Production et gestion du projet
Katja Durchholz

Fonts | Schriften | Police
Avenir

Lithography | Lithografie | Lithographie
REPROMAYER Medienproduktion GmbH,
Reutlingen

Paper | Papier | Papier
Cover | Umschlag | Couverture: enviro®polar
300 g/qm; Interior | Inhalt | Contenue:
enviro®polar 135 g/qm

Printing and binding | Druck und Bindung |
Impression et reliure
Beltz Grafische Betriebe GmbH,
Bad Langensalza

Printed in Germany

www.hirmerverlag.de
www.hirmerpublishers.com

ISBN 978-3-7774-4002-6

© 2022 Museum Pfalzgalerie Kaiserslautern;
Hirmer Verlag GmbH, Munich | München;
artists, photographers, authors and trans-
lators | Künstlerinnen, Fotografinnen, Auto-
rinnen und Übersetzerinnen | artistes, photo-
graphes, autrices et traductrices

© VG Bild-Kunst, Bonn 2022, and | und | et
ADAGP for all works by | für alle Werke von |
pour toutes les œuvres de Kubra Khademi

With friendly support by | mit freundlicher
Unterstützung von | avec le soutien de

We thank the lenders and | wir danken den
Leihgeberinnen und | nous remercions les
prêteurs et: Galerie Eric Mouchet, Latitudes
Contemporaines, Stiftung Rheinland-Pfalz
für Kultur, Freunde des Museums Pfalzgalerie
Kaiserslautern, ZukunftsRegion Westpfalz e. V.,
Bureau des arts plastiques des Institut fran-
çais Deutschland, Gleichstellungsbüro des
Bezirksverbands Pfalz, Rotary Club Kaisers-
lautern-Sickinger-Land, G&M Systemtechnik